BEAUTIFUL LEGO

BEAUTIFUL LEGO®

MIKE DOYLE

San Francisco

Printed in China
First printing

17 16 15 14 13 1 2 3 4 5 6 7 8 9
ISBN-10: 1-59327-508-0
ISBN-13: 978-1-59327-508-2

Publisher
William Pollock
Production Editor
Serena Yang
Cover and Interior Design
Mike Doyle
Photo Retouching
Mike Doyle
Developmental Editor
Tyler Ortman
Copyeditor
Pam Schroeder
Proofreaders
Laurel Chun and Alison Law

Featured on the cover

FRONT *Contact 1: The Millennial Celebration of the Eternal Choir at K'al Yne, Odan*, Mike Doyle

FLAP *Signet, Dragon Jade Seal*, Eric Mok
Astral Body, Cole Blaq
Angkor Wat, Arthur Gugick

BACK *Greetings in Hanbok*, K. Amida Na
Westie, Huang Shin-Kai
Shakespeare, Guy Himber
Downtown 3, Alvin Tseng
Rotary Phone, Chris McVeigh
Friends, A. Anderson
U.E.F. Battle Fleet, Andrew Becraft

FLAP *Cry of Dreams*, Nannan Zhang
Baal – Camel Spider, Lino Martins
Stairway, Nathan Sawaya

For information on distribution, translations, or bulk sales, please contact No Starch Press, Inc. directly:

No Starch Press, Inc.
38 Ringold Street, San Francisco, CA 94103
phone: 415.863.9900; fax: 415.863.9950
info@nostarchpress.com; www.nostarch.com

Library of Congress Cataloging-in-Publication Data
A catalog record of this book is available from the Library of Congress.

To my incredible wife, Stephanie, and
our two wonderful sons, Ian and Caeden

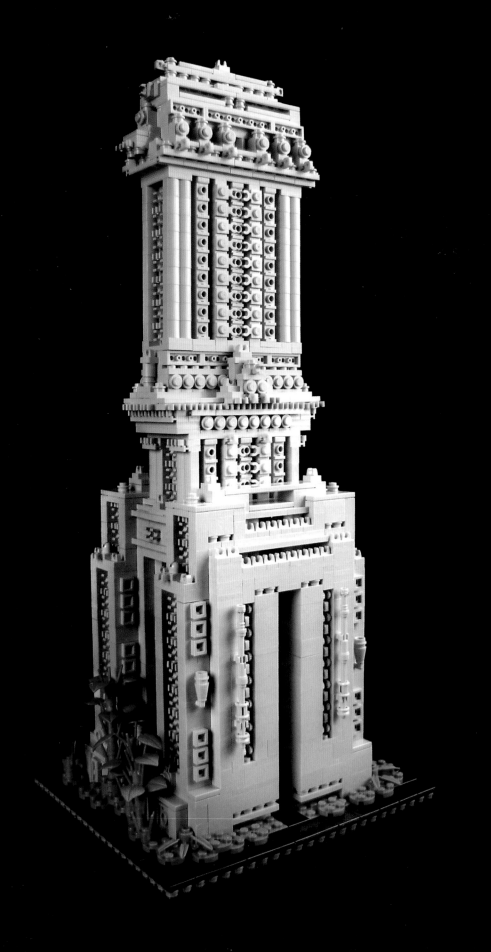

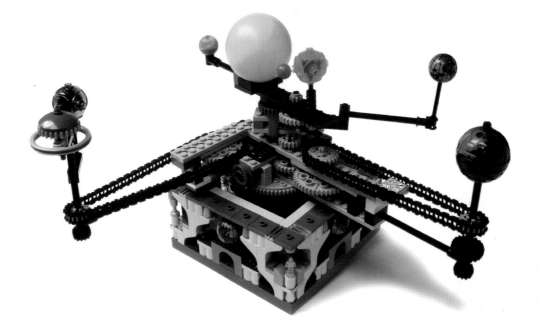

ACKNOWLEDGMENTS

This book is possible only through the amazing
work created by the LEGO building community.
Their work—shared online and at events—
brings endless inspiration.

(opposite)
Mike Doyle
Dawn's Light Residential Tower from Contact 1:
The Millennial Celebration of the Eternal Choir at K'al Yne, Odan 2013

(above)
Guy Himber
Orrery 2011

Contents

Mihai Marius Mihu
The Fortune Demon 2012

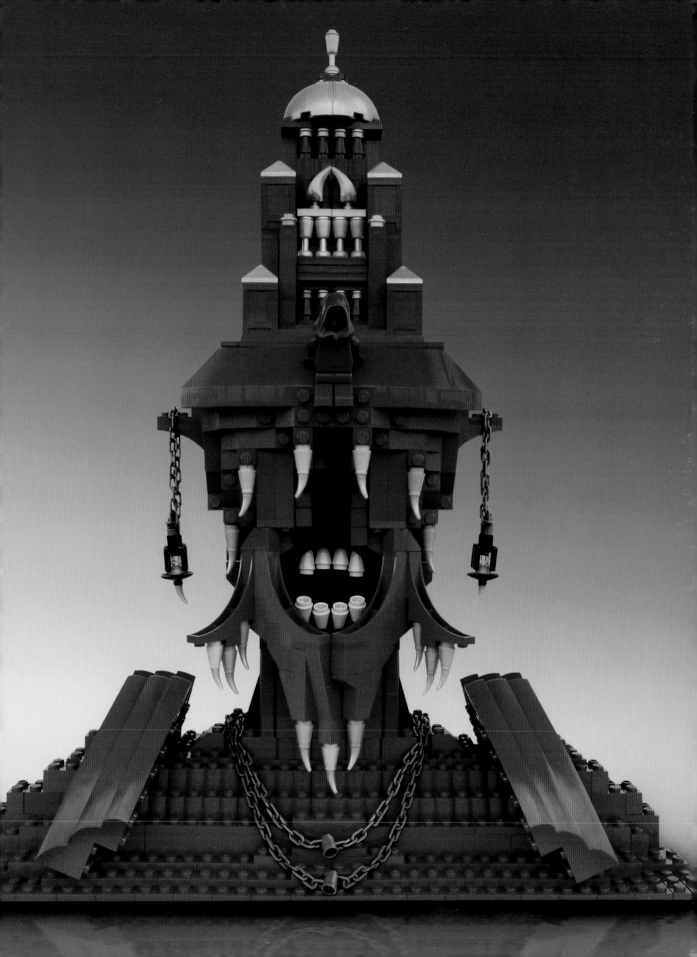

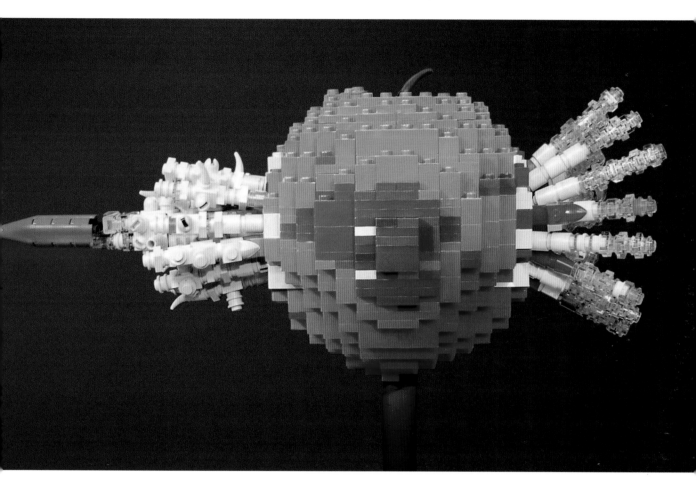

Tom Simon
Doc Edgerton 2010

Preface

When I first discovered the kinds of LEGO art-work that people were creating, I was astonished. I had no idea that a little toy could go so far. That was just three years ago. Since then, the level of craftsmanship in the LEGO building community has only increased. Builders share their creations and techniques online, which inspires others and pushes them to do even more incredible things with LEGO. This book is a small collection of some of the impressive models that I have come across in my time.

For practical reasons, I was unable to include every awesome build or artist whose work deserves to be showcased, but it's my sincere hope that this book gives newcomers a representative sample of the work being done. For those in the hobby, I hope to offer a new perspective on familiar builds. Whether you're seeing these models for the first time or the hundredth, I hope this book inspires you to new creativity.

Shannon Sproule
Midnight in the Forest (after Ernest) 2009

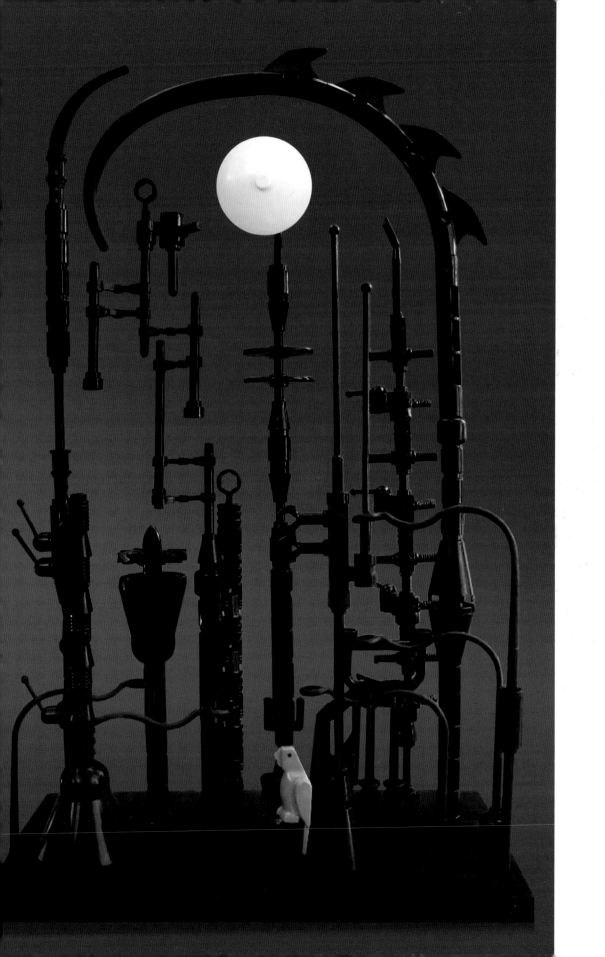

Ramón and Amador Alfaro Marcilla

Why LEGO? We have many reasons. LEGO is the only medium we know of that can be completely reused with no loss in function. This is a great advantage to us and is of primary importance. In addition, the result of your work is almost immediate, and changes can be made at any time. To build, you don't need much: just a few bricks, a light, a table, and a chair—although, in our case, we often build on a bed!

Being able to physically touch the model and observe your progress carefully, choosing the next piece—these are the joys that keep us inspired to imagine new constructions.

Could you tell us a little about yourselves?

We are brothers: Ramón is the younger and Amador, the elder. We come from Albacete, Spain, a little city between Madrid and Valencia. Until recently, we lived together. Now, our lives are separate due to jobs, family, and such. We have always had hobbies we could share, despite our age difference: video games, comics, music, movies, and of course, LEGO.

How long have you been building? Did you both catch the LEGO bug simultaneously?

We began building as children and then stopped during our university years (the famous Dark Age) only to restart the hobby again seven or eight years after graduating. Girlfriends and LEGO were a strange combination.

Although we began building again at the same time, during those first years, we didn't work together on the same models. Our interests, techniques, and styles were different. But video games changed everything! Our first collaborative build was an homage to the classic arcade game *Operation Wolf*. (LEGO is perfect for mixing hobbies!)

Your works are often so intricate. It is hard to imagine how two people can collaborate, particularly separated by distance. How does this work for you? Do you build separately and then meet to fit parts together? How often might you meet?

We always say that four eyes can see better than two (though that isn't always true).

Each build is a bit different. Sometimes, one of us shapes the model's general outlines, and the other handles the details. Other times, when the size of the model allows it, we work on different parts. For example, in the *Iron Man* model, we were able to build the head and the feet at the same time.

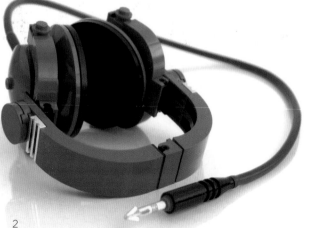

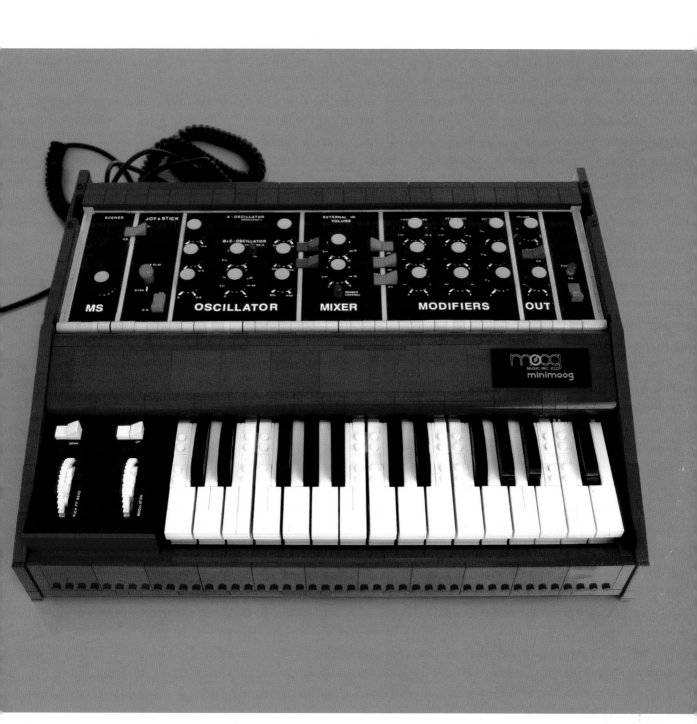

(opposite) Headphones 2007 (above) Minimoog 2011

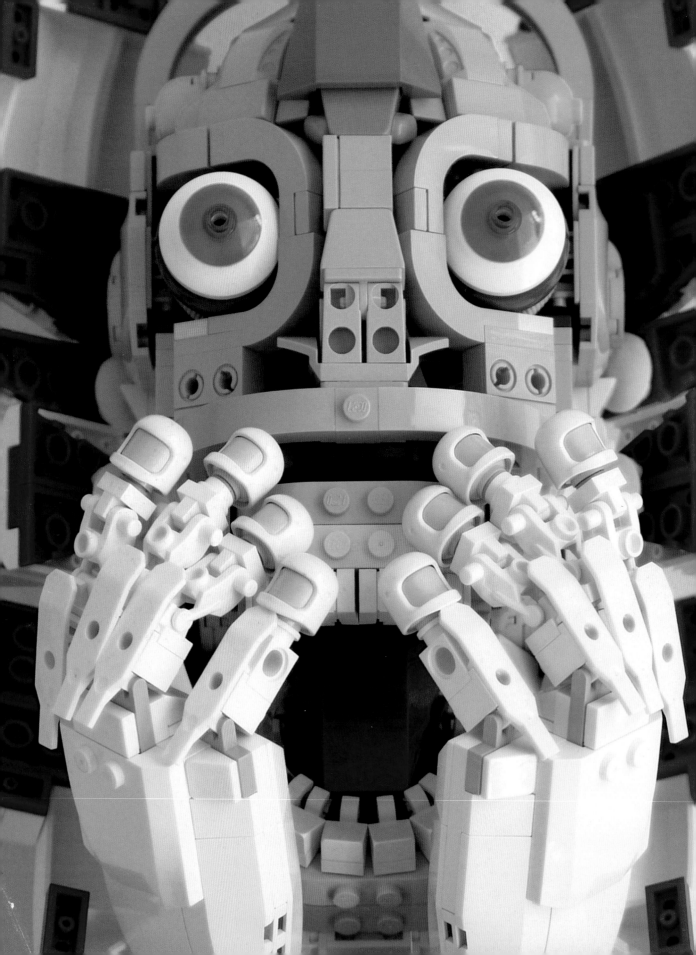

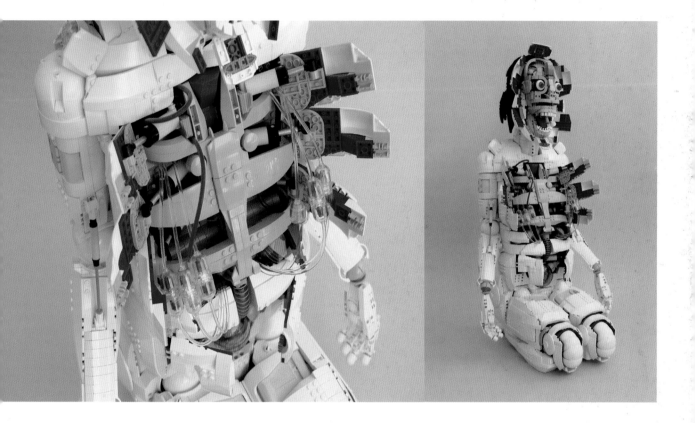

The Doll 2008

Today, we live apart (at a great distance), and as you say, it's very difficult. Before, we could build together easily, but now it is absolutely necessary to find new ways to collaborate. We try to meet once per month. Playing with LEGO is a great excuse to get together. Because we have to travel to meet, playing with LEGO becomes something of an odyssey.

How long do you suppose some of your more intricate pieces take?

The model that took the most time was *The Doll*. We spent eight months on it, working three hours per day—almost every day! So it took perhaps about 720 hours in total. But normally, we build medium-sized models. Building cars, we spend two or three weeks, depending on the details that we want to introduce. And, there are exceptions. For example, we are redesigning an old model. We began more than a year ago, and we are just finishing it now.

Do you do much planning before building? How does that work? Do you each come up with a basic approach and then pick the best before starting? Do you sketch models first?

Yes, it's absolutely necessary to do some planning before building. We watch movies, pore over images from the Web, and sometimes even make our own sketches to better understand a model (comics and drawings are our passions too).

And it goes beyond the visual. For us, it is very important to evoke the correct feeling; the mood may be the most important aspect of a build. And how do we do that? As we build, we talk about our memories, share our thoughts about the model, discuss the reasons why we're building . . . and all the while, we listen to music that we think has some kind of connection to the model. Our ears are as important as our eyes.

How do your building styles differ? How are they alike? Do you each specialize in a particular facet of building?

Our styles are similar, but we have specialized in different disciplines. Our visions are absolutely complementary. We need one another. *The Doll* is the best example. This model is composed of many small models within a bigger one. On one hand, we have a human sculpture in a certain position; on the other hand, we have a lot of details full of colors and forms—two very different ways of approaching the model but entirely necessary to one another.

Your works have great diversity, from the technical aspects of Minimoog *to more sculptural look of* Iron Man. *You even do some microscale building. Is there a type of subject matter or building style that comes easiest to you?*

For us, there isn't a big difference among building styles or themes. We only see challenges. Of course, it's easier to make something small, but our build decisions aren't impacted by the question of time. When we are looking for the best result, the difficulty is to find something new, the scale that fits the subject. The difference between a small model and a big one is the quantity of time that we need to find these combinations.

We love any model that allows us to combine technical and cosmetic aspects into the same construction. The *Minimoog* is the perfect example. We needed to combine all the technical mechanisms (knobs, faders, joystick, wheels, and keys) in combination with the typical Moog aesthetic using our own building style.

Is there any LEGO piece that you like in particular and why?

All curved parts, wedges, or any part that allows for reproducing smooth lines or forms attracts us. These bricks allow for a whole new way to build.

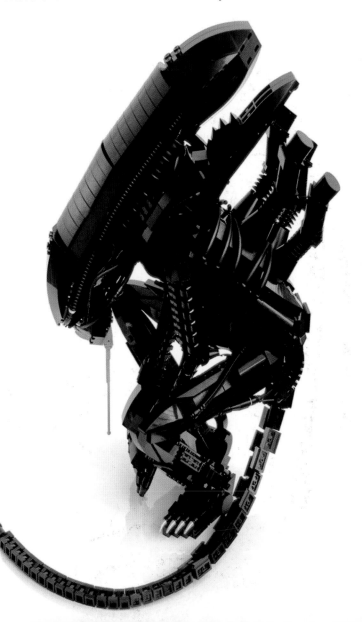

(opposite) Calypso 2007 (right) Alien 2007

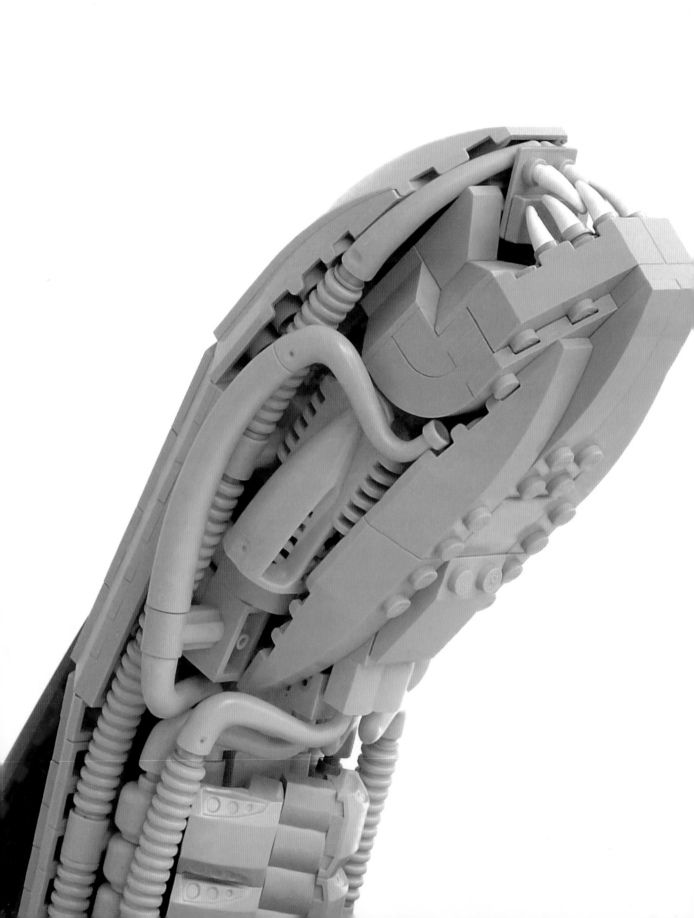

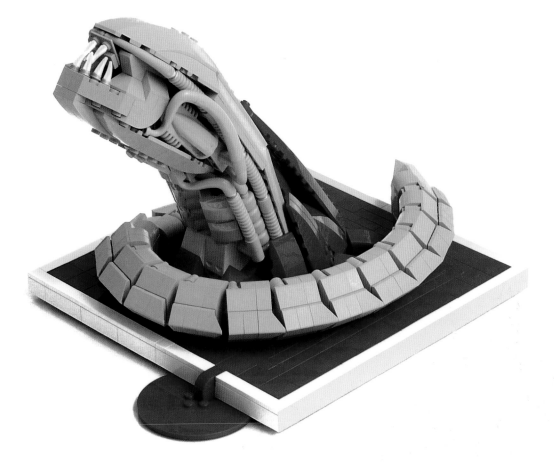

Alien Chestburster 2007

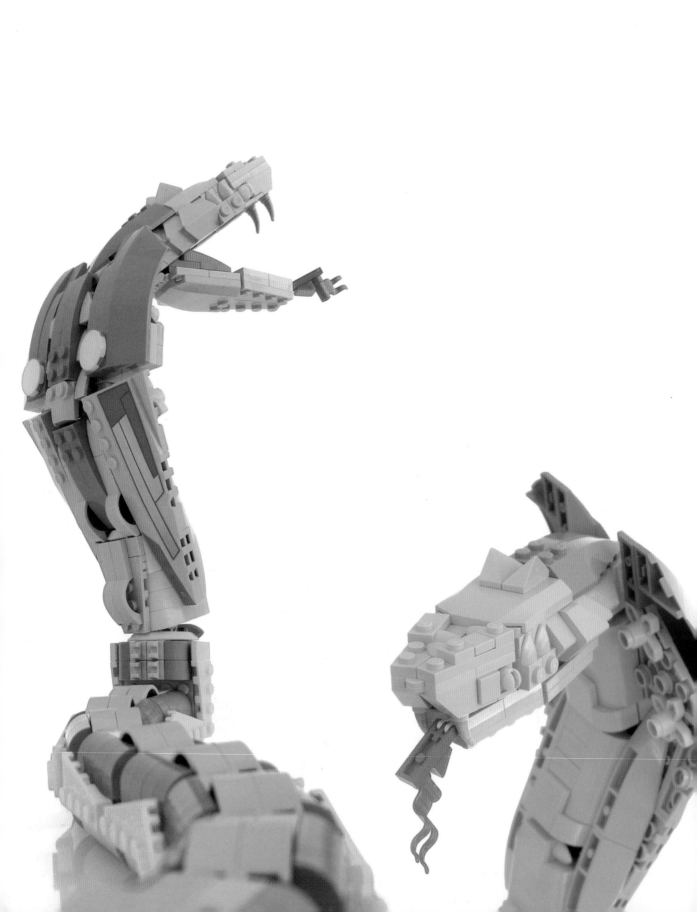

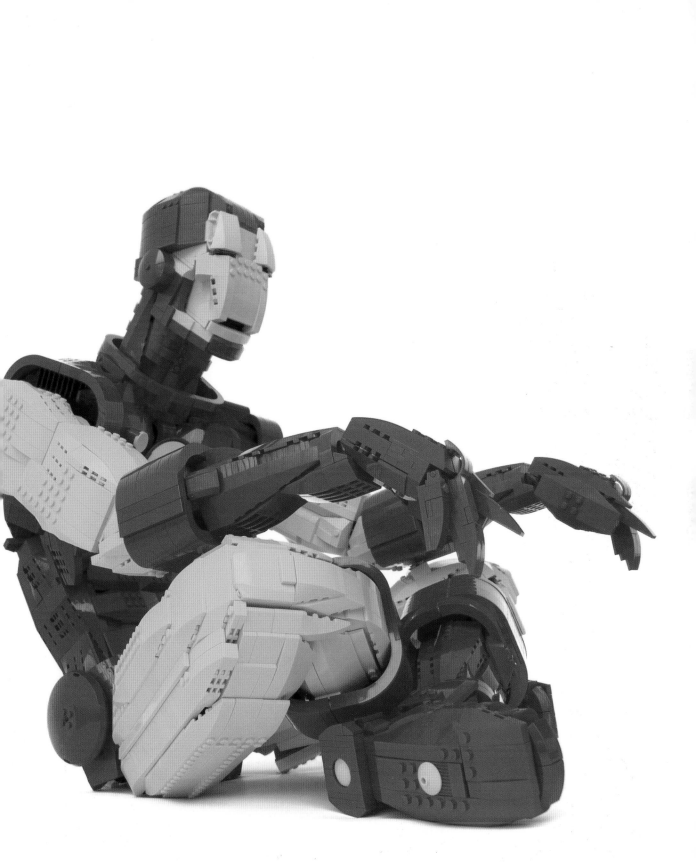

(opposite) Snake 2009 (above) Iron Man 2007

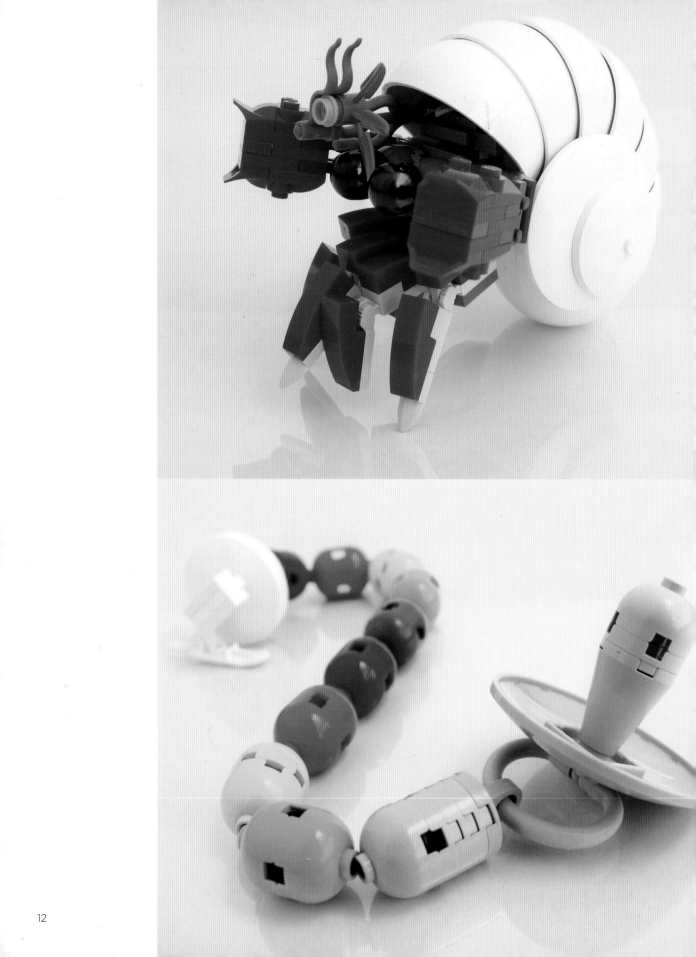

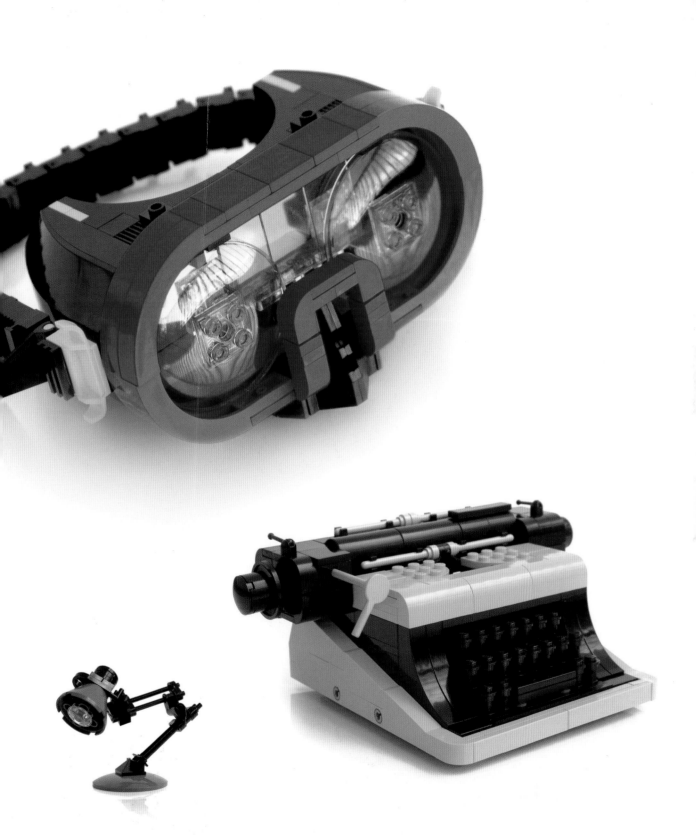

(opposite top) Hermit Crab 2008
(opposite bottom) Pacifier 2009

(top) Diving Mask 2007
(right) Typewriter 2006
(left) Reading Lamp 2007

13

Mmmmm

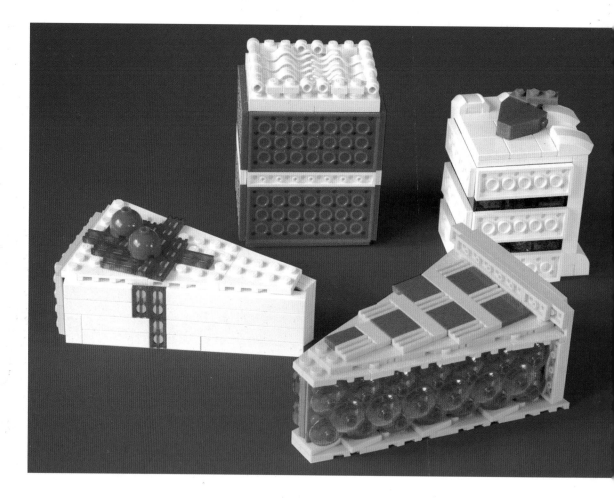

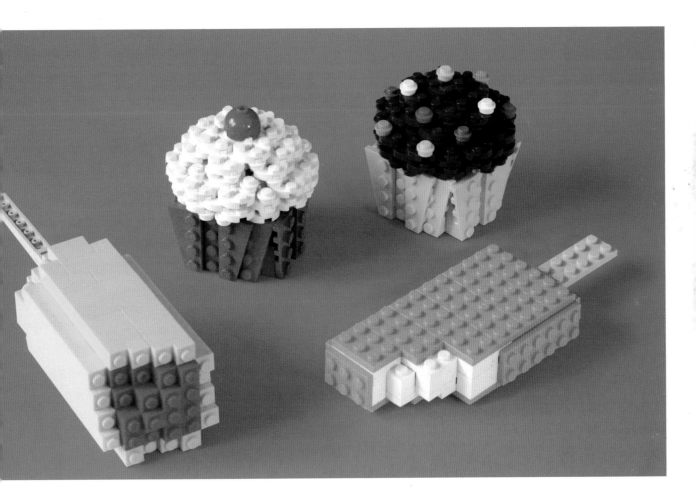

Eric Constantino

(opposite) LEGO Desserts 2010
(above) LEGO Treats (cupcakes, corndog, creamsicle) 2010

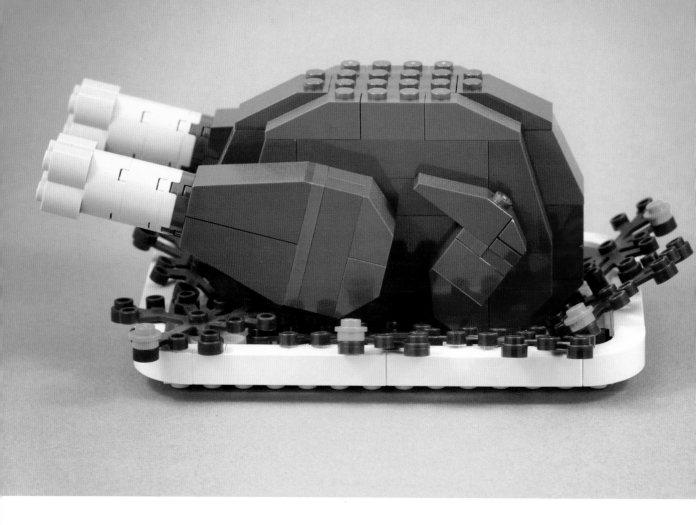

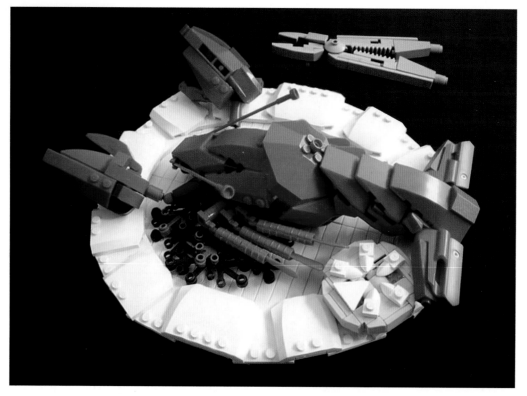

Chris McVeigh
(opposite top) Thanksgiving Turkey 2010

Sven Junga
(opposite bottom) Lobster 2011

Bruce Lowell
(top) Taco 2010
(bottom) Sandwich 2011

Everyday Wonderful

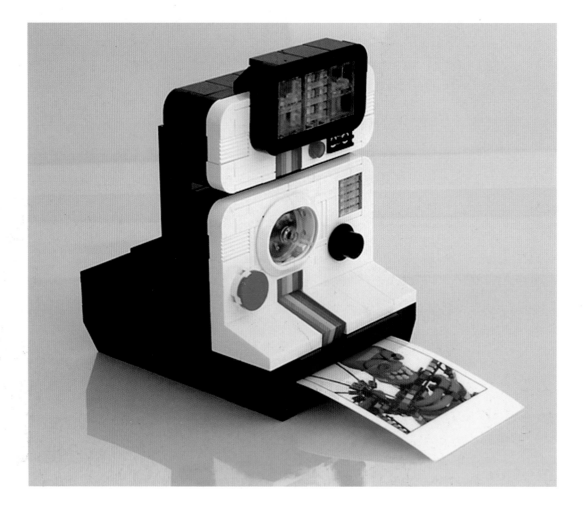

(above)
Ramón and Amador Alfaro Marcilla
Polaroid 2007

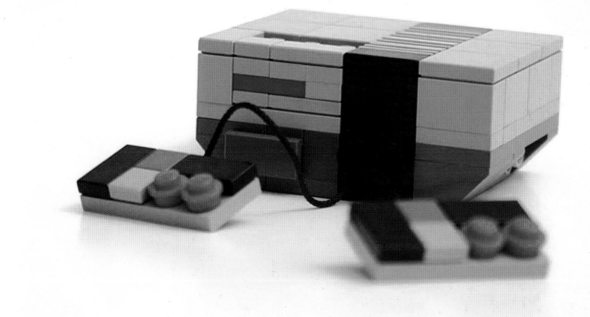

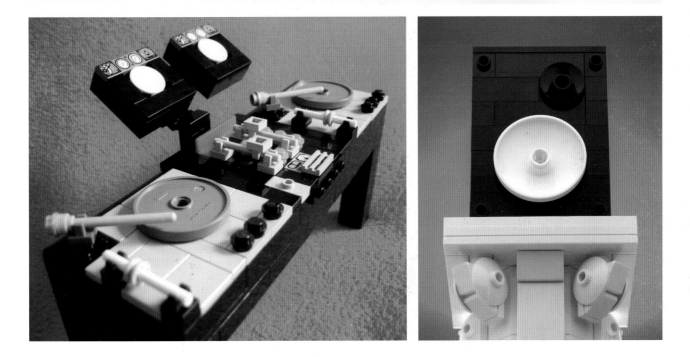

(top)
Micah Berkoff
Nintendo Entertainment System 2009

(bottom left)
Kevin Guoh
DJ Console 2007

(bottom right)
Chris McVeigh
Classic Speaker 2010

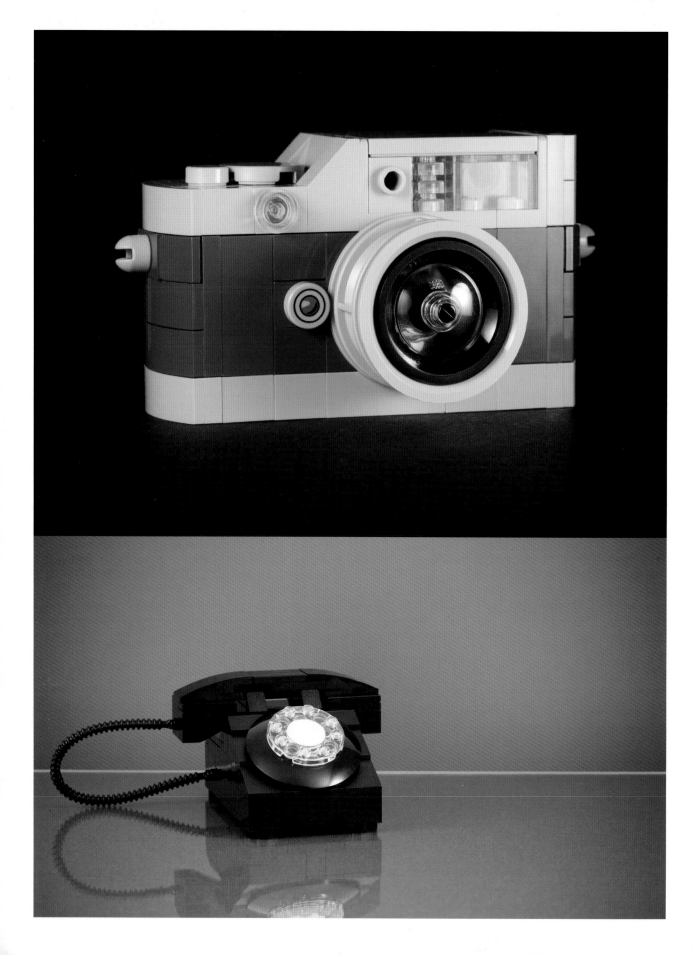

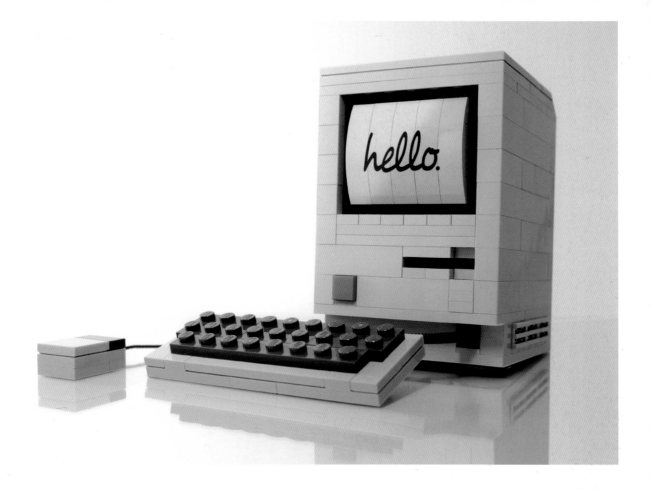

Chris McVeigh

(opposite top) Mini Hermes Leica M9 2013
(opposite bottom) Rotary Phone 2012
(above) Hello 2013

Attic Treasures by Matt Armstrong

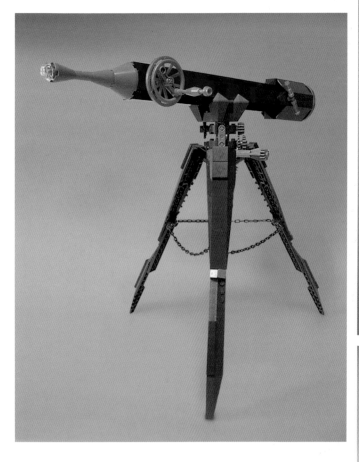

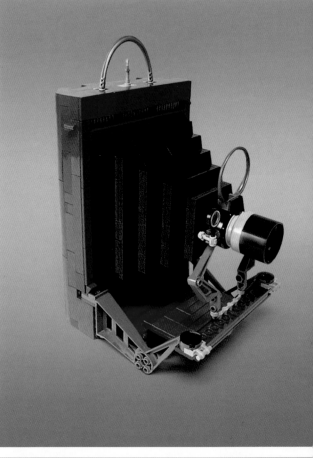

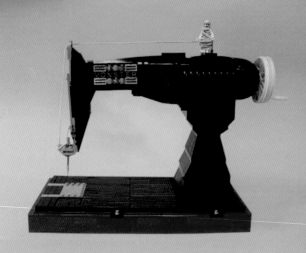

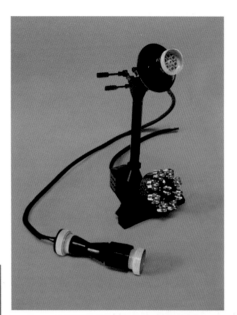

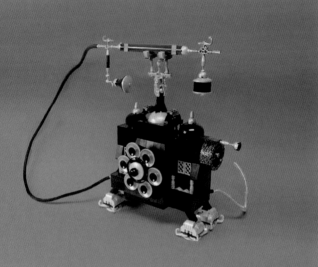

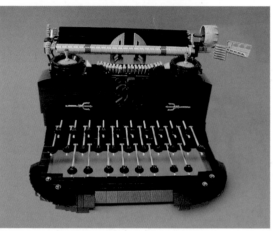

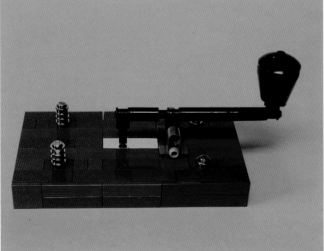

(opposite left) Telescope 2011
(opposite top right) Camera 2011
(opposite bottom right) Sewing Machine 2011

(top right) Candlestick Phone 2011
(middle left) Antique Phone 2011
(middle right) Typewriter 2011
(bottom) Morse Code Key 2011

Jordan Schwartz

Why LEGO? In all of my years of building, including the hazy years of my childhood and not-hazy-enough years of young adulthood, I am not sure that I have ever been asked this question.

LEGO has always been in my life. It is something of a given. . . .

I can trace the origins of my affection back to my days as a youngster in the suburbs of Rhode Island. Although I can't recall the occasion, my oldest brother was presented with a small LEGO boat set as a gift. My brother's boat was the first LEGO set in my household. Naturally, at that age, I looked up to him. And so, I wanted those neat building blocks too.

As I grew up, my parents often purchased three of the same set—one to satisfy me and one for each of my two brothers. So, as you can imagine, I was fortunate that there were always plenty of LEGO bricks to slake my thirst for building. But of course, that's only in retrospect—back then, there was no such thing as enough! LEGO was the only toy I ever wanted or ever bought. Eventually, both my brothers grew out of the habit. I inherited their LEGO collections, and my building became more ambitious.

A few years before joining the online community in 2006, I started to really appreciate LEGO for its technical and artistic merits. I stopped building for the fun of the creation; instead I was building just for the fun of building.

And, as soon as I was able to start sharing my work with other builders with more experience, the quality of my models began to improve. I was fortunate to be able to travel across the United States, going to events to meet fellow enthusiasts and share my work.

In mid-2010, I was told by friends at a LEGO event in Chicago that the LEGO Group was looking to hire new product designers. That was always my dream job. I have scrawly drawings from my early elementary school days of me building with LEGO—a big, simple smiley face for a head with the words "I want to work for The LEGO Company" written at the top.

But I was only 17 years old at the time, and the thought of actually being hired seemed like a far-off and inaccessible dream. Thankfully, my friends encouraged me to try—it was free to apply, after all, except for postage costs to get my portfolio and résumé to Denmark (just under $100). But, it was worth it. Shortly after applying, I was called to an interview and workshop in Billund. At that point, even if they didn't end up hiring me, it was my first trip to Europe, and it had only cost me $100.

I went to the workshop in August, 2010—it was me against 40 others, and I was the youngest. It was intimidating, to say the least. I did my best, met some great people, and returned home. By this time, I had begun studying architecture in Boston. And, to my surprise, one week into my first semester of college, I got an email from Denmark—with an offer for a position! It was for an internship, although I was considered a full-time employee and treated the same as any other designer. In the end, I wound up designing a handful of sets for the Creator and Direct/Expert lines.

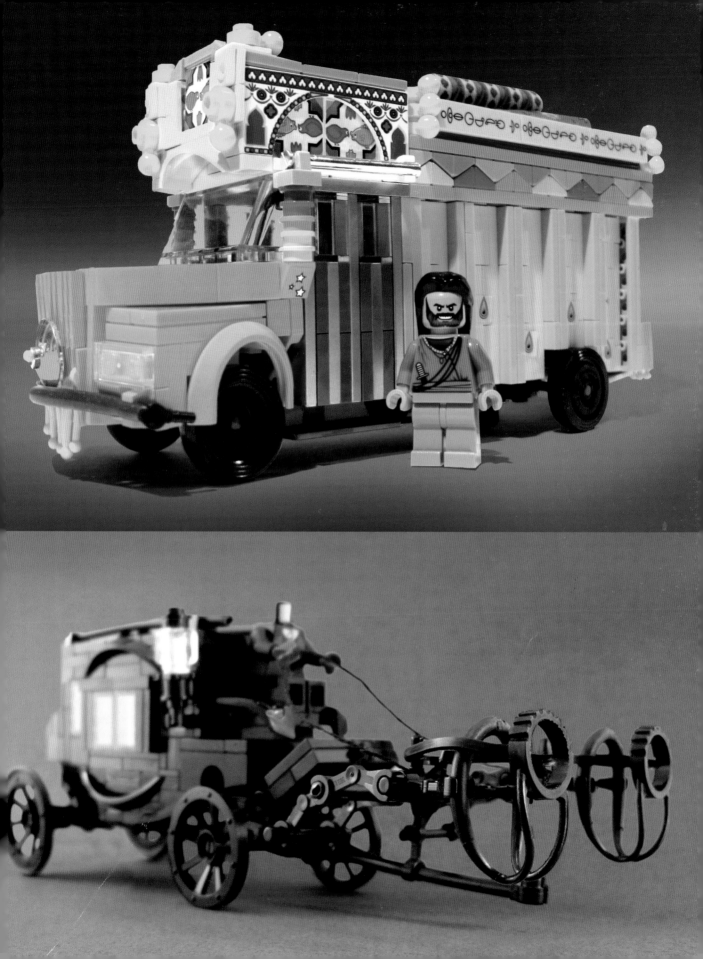

Billund, where LEGO headquarters continues operation today, is in the middle of nowhere. Walking to work from the company apartments 20 minutes each way, most days through the freezing, rainy dark, was not what I expected. I found dark humor in the juxtaposition of Billund itself and the fun of the workplace. Working as a LEGO designer is every bit as fun as it sounds. But as a resident of the United States who lived not far from several major cities with a limitless number of things to do, the move to Denmark created some real culture shock. It's something that many people don't consider when they think about the job. Many employees simply have a hard time adjusting to the place, especially when they come from moderately sized or major cities.

I suppose the ultimate payoff is being able to see the sets you design in person. My first model was an alternate model, a Brachiosaurus, for Creator Set #6914, and when I saw it for the first time in the box, it was very fulfilling. Being stateside now, whenever I go to a toy store, it's satisfying to see any product I worked on there on the shelf. It's especially satisfying to see the store sold out of it or to watch my models being ogled by kids.

In the end, all of my love for LEGO has finally paid off. Many children want to be LEGO designers (I hear that all the time via email and in person at events), but of course, very few become one. It's hard to see the dream through and very nearly as hard to make the move to the tiny Danish farming town that is Billund.

And so, when I finally realized my dream, I felt like I conquered it all—the LEGO community, the LEGO Group, and the whole process of building models. As much as I have enjoyed LEGO products over the years, I feel liberated now that I've achieved my dream. I feel free to explore other endeavors.

But, my fondest memories still revolve around LEGO products. They are also the most vivid—the feel of opening the cardboard box, the sound of the bags of elements rattling to the floor, and even the smell of the fresh plastic stick in my mind. And so, to answer the question, "Why LEGO?" I ask another question: Is it because I am still a child who never grew out of his affection for one of his grandest joys? For the sake of brevity, let's just say that I am nostalgic—very, very, nostalgic.

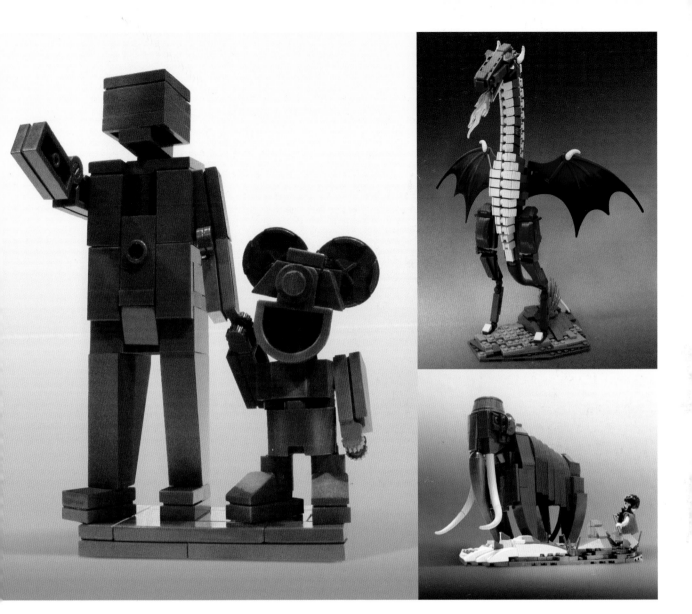

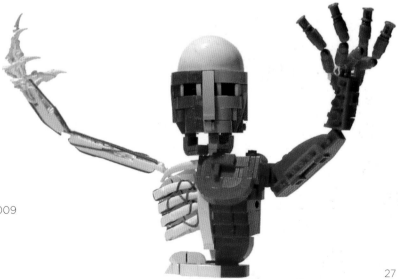

(previous spread)
(top) Nepali Tata Truck 2010
(bottom) Ghost Coach 2010

(opposite) Mary Blair Face (It's a Small World) 2009

(left) Partners 2009
(top right) Wyvern 2010
(bottom right) Woolly Mammoth 2009
(bottom) Plastic Anatomy 2009

27

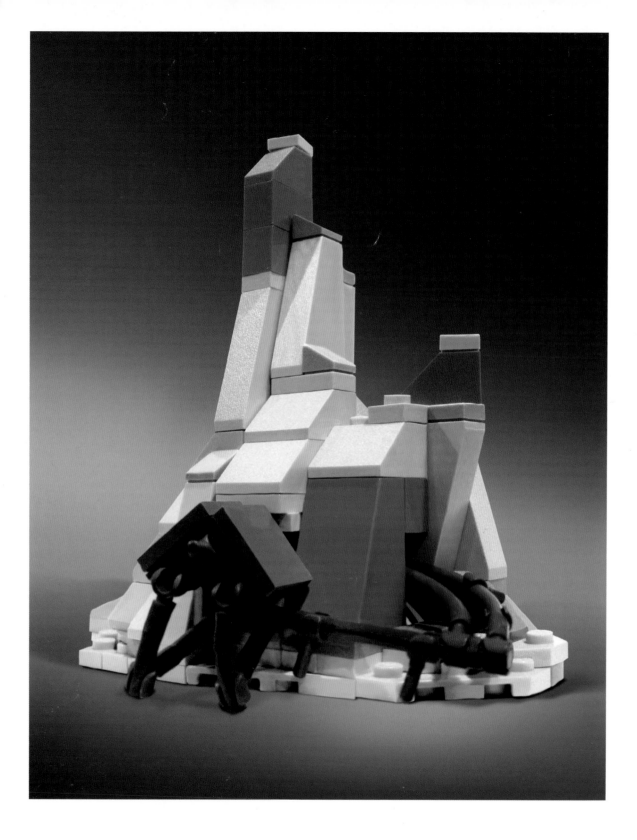

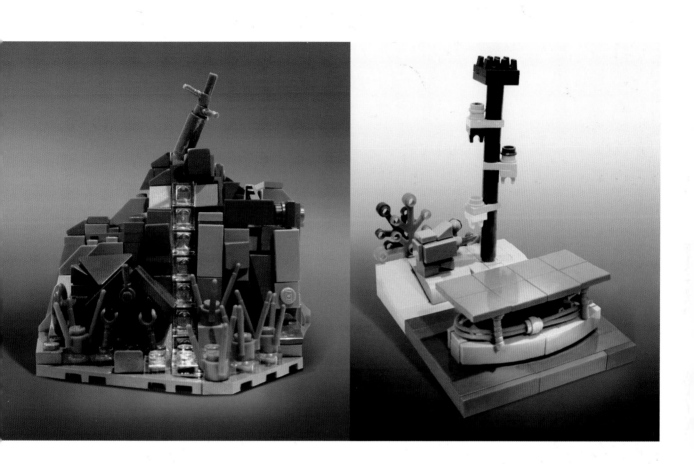

(opposite) Big Thunder Mountain Railroad 2009

(above left) Splash Mountain 2009
(above right) Jungle Cruise 2009

CubeDudes™ by Angus MacLane

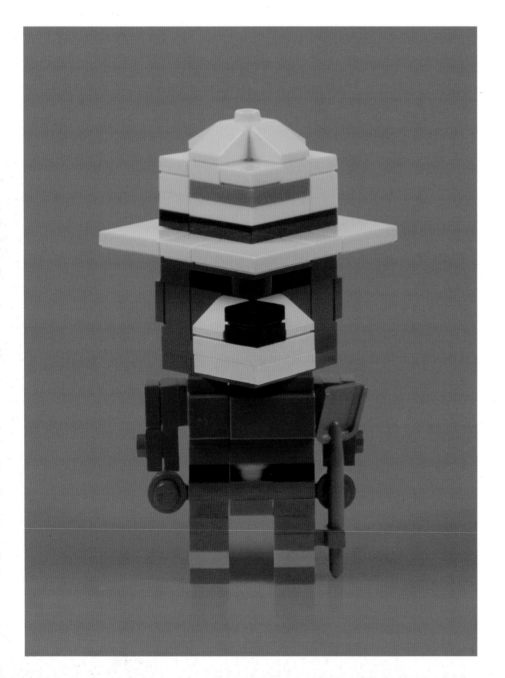

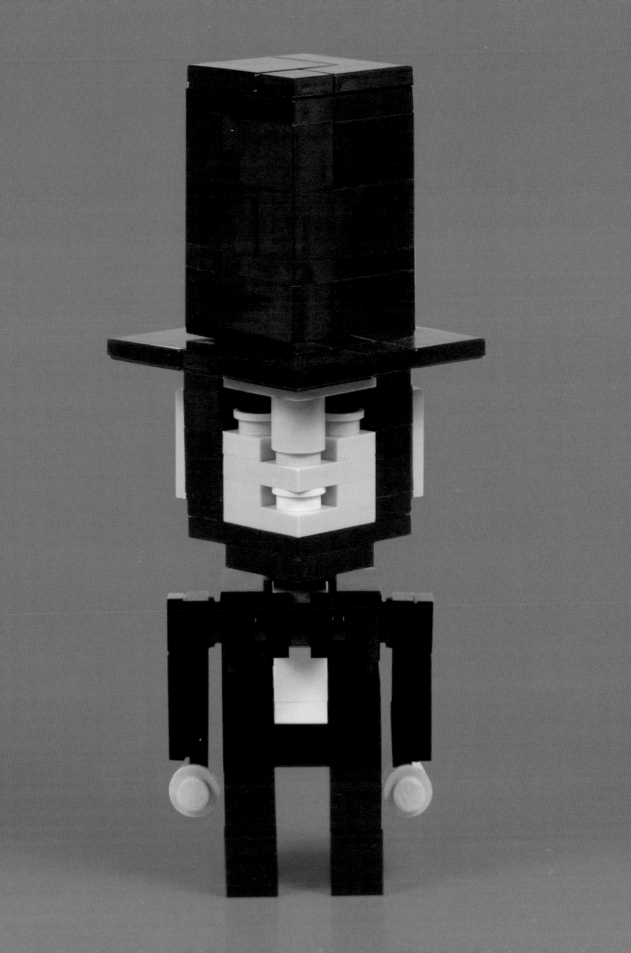

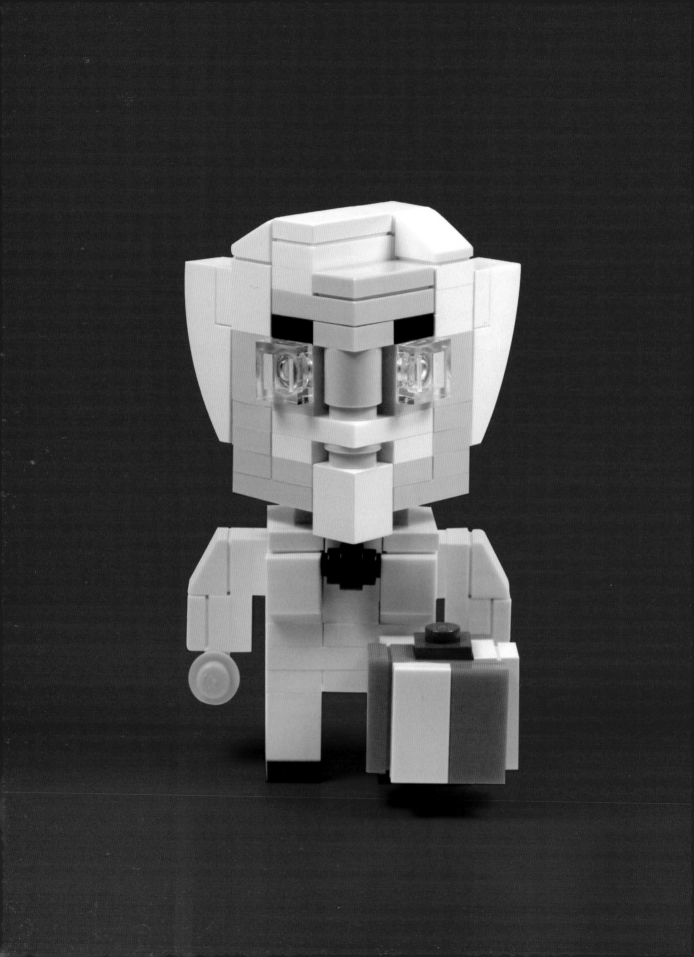

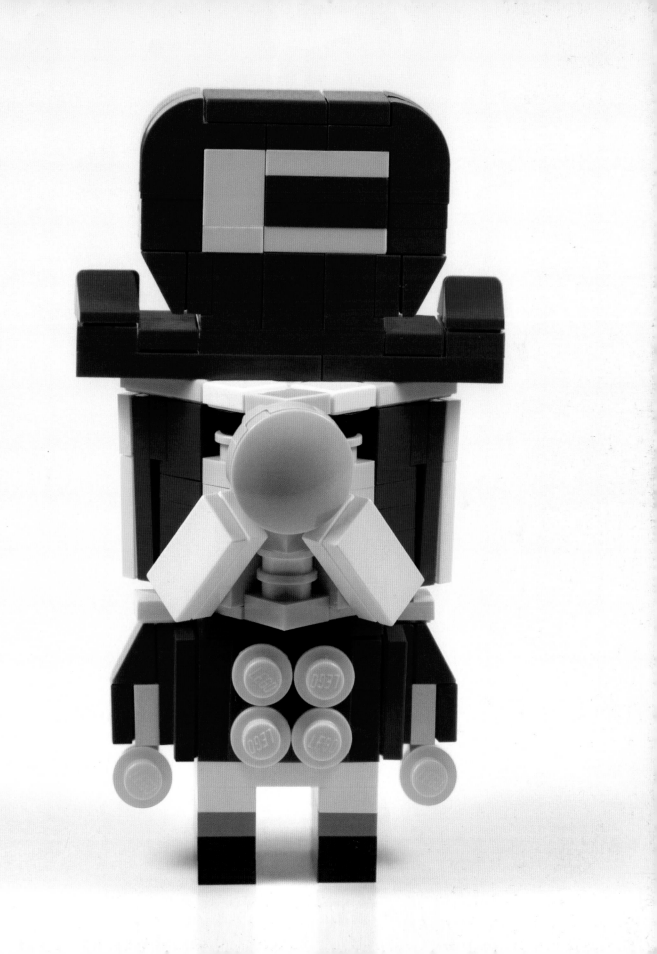

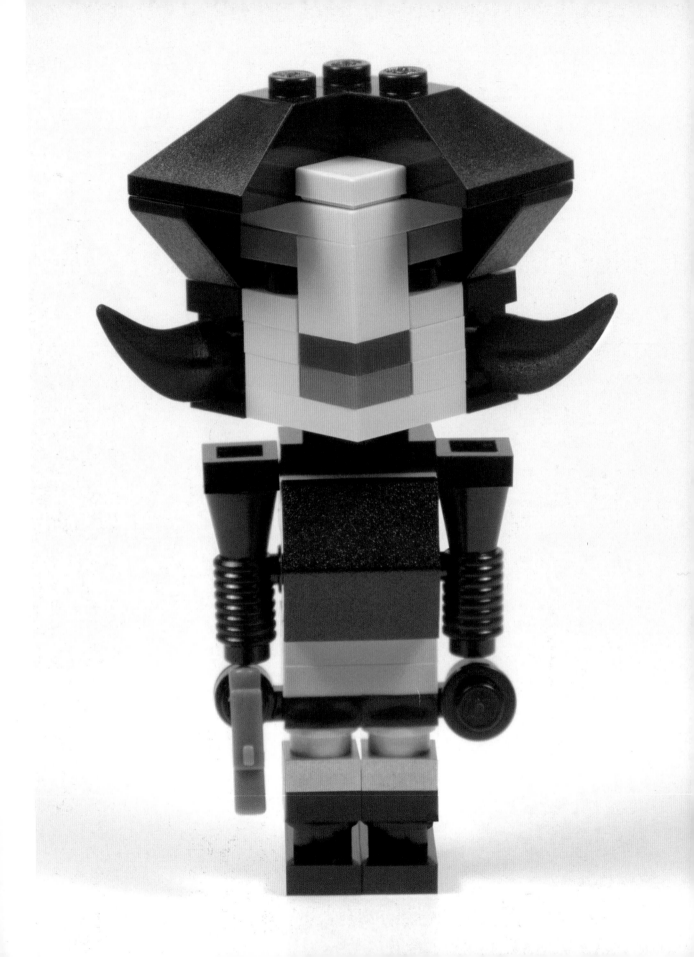

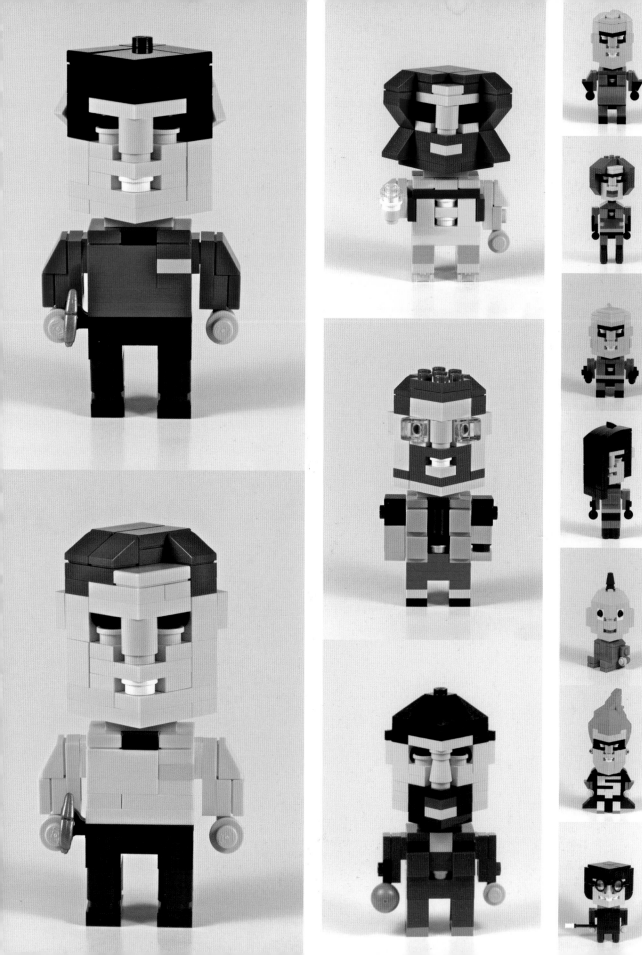

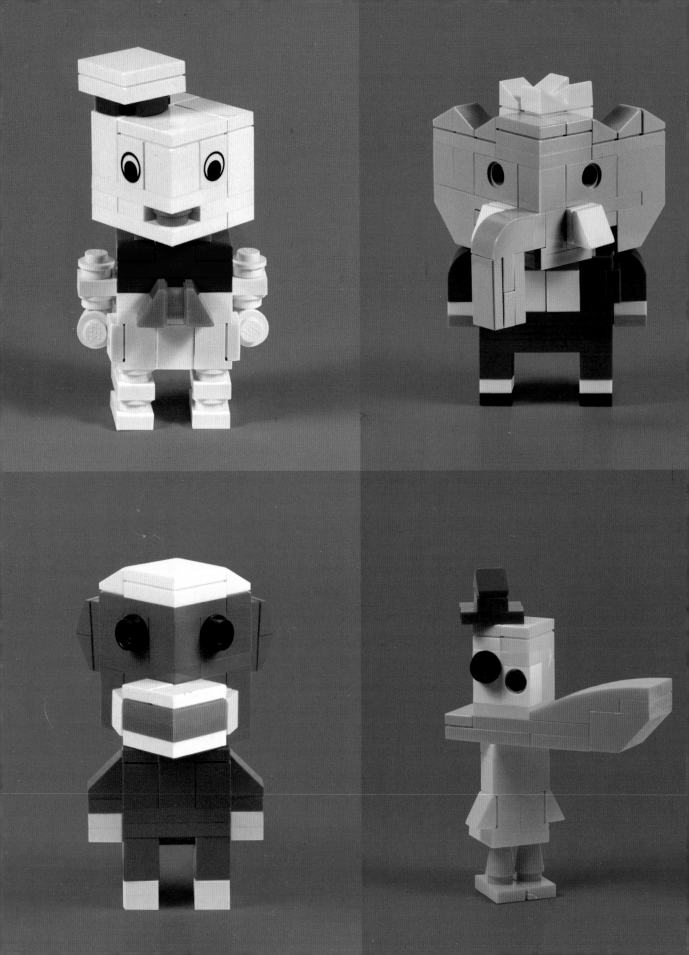

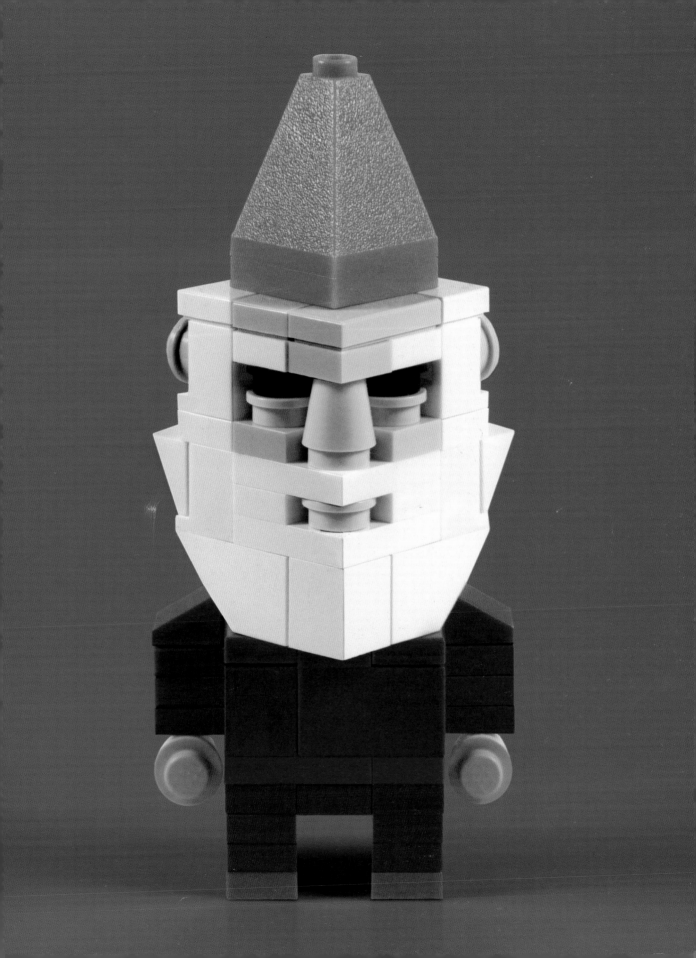

Go Ask Alice

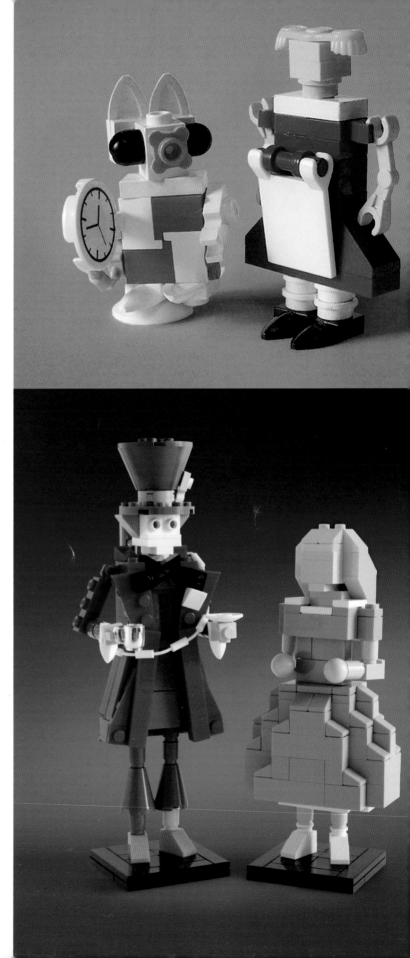

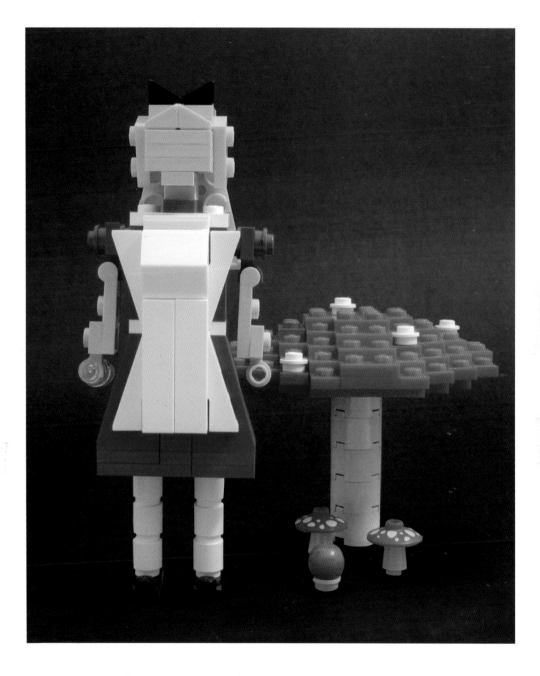

(opposite top)
Matt Armstrong
Look Who Fell Through the Keyhole 2010

(opposite bottom)
Tommy Williamson
Alice & Hatter 2010

(above)
Jason Heltebridle
Alice in Miniland 2011

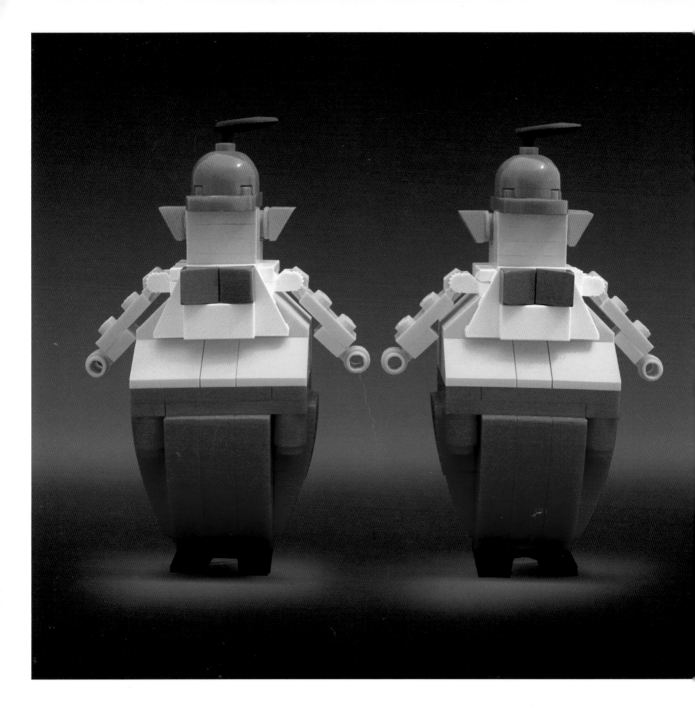

(above)
Jason Heltebridle
Tweedle Dee & Tweedle Dum 2011

(opposite top)
Angus MacLane
CubeDude Caterpillar 2010

(opposite bottom)
Tyler Clites
Alice in LEGOLAND 2009

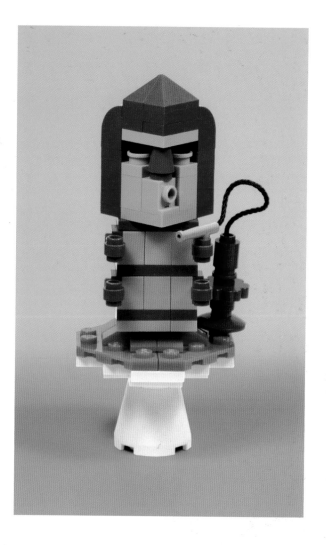

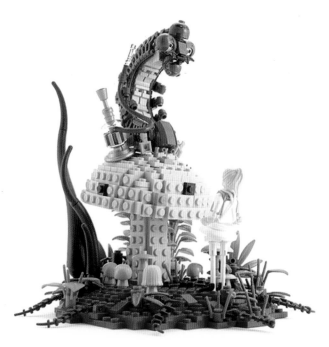

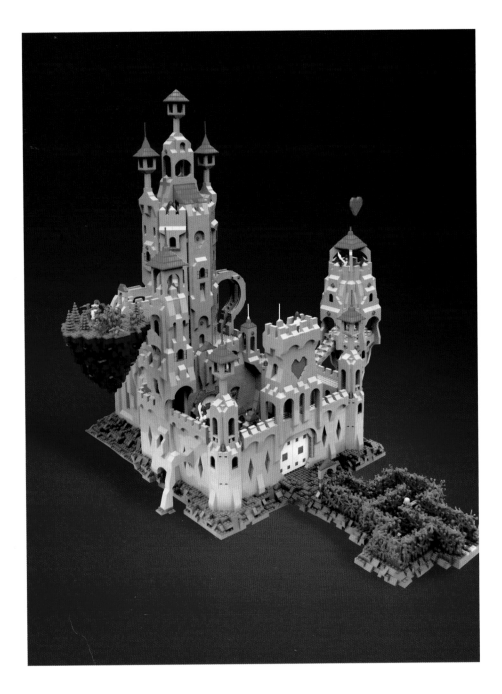

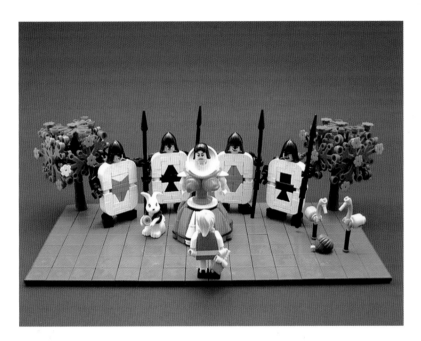

(opposite)
Edward Conquest
Queen of Hearts Castle 2009

(above)
Tyler Clites
Do You Play Croquet? 2009

Nathan Sawaya

Why LEGO? There are many reasons, but foremost for me is that LEGO bricks let me create anything I can imagine.

I had LEGO bricks growing up, and when I was about 10 years old, I asked my parents if I could get a pet dog. They said no, so what did I do? I created a life-size dog for myself out of LEGO bricks. It was my first aha moment when I realized that this toy could be every toy. If I wanted to pretend to be a rock star one day, I could build myself a guitar. If I wanted to be an astronaut, I'd build myself a rocket. There were no limits.

When I decided to become an artist, I was determined to elevate this simple childhood toy to a place it had never been before: fine art galleries and museums. And now I have exhibitions, called The Art of the Brick, that tour the world.

I like using LEGO bricks as a medium because I enjoy seeing people's reactions to artwork created from something with which they are familiar. Everyone can relate to it because it is a toy that many children have at home. People can appreciate a marble statue at a museum, but when they go home that night, it is very doubtful they will have a slab of marble they can start chipping away at. But people have LEGO bricks, and when they go home after seeing my exhibitions, they are inspired to grab their own bricks and start creating.

I also appreciate the cleanliness of LEGO bricks—the right angles, the distinct lines. As is the case so often in life, it is a matter of perspective. Up close, the shape of each brick is distinctive. But from a distance, those right angles and distinct lines change to curves. That is what drew me to the bricks. I celebrate the fact that my sculptures are constructed out of LEGO. There is no hiding the LEGO in my creations. I want people to see the individual bricks creating the larger form.

And because there are no boundaries to what can be created, there are no rules to LEGO.

LEGO has taken me to places I'd only dreamed of. I never imagined I would be showcasing my art all over the world. Who knew that I would have art on display in Hong Kong, Paris, Cape Town, Melbourne, New York, Los Angeles, and even Topeka, Kansas? Or who would have guessed that I would be meeting the likes of Andre Agassi, Conan O'Brien, David Copperfield, Warren Beatty, and President Clinton, all because of my LEGO art? LEGO truly has no limits. Who knows where it can take you?

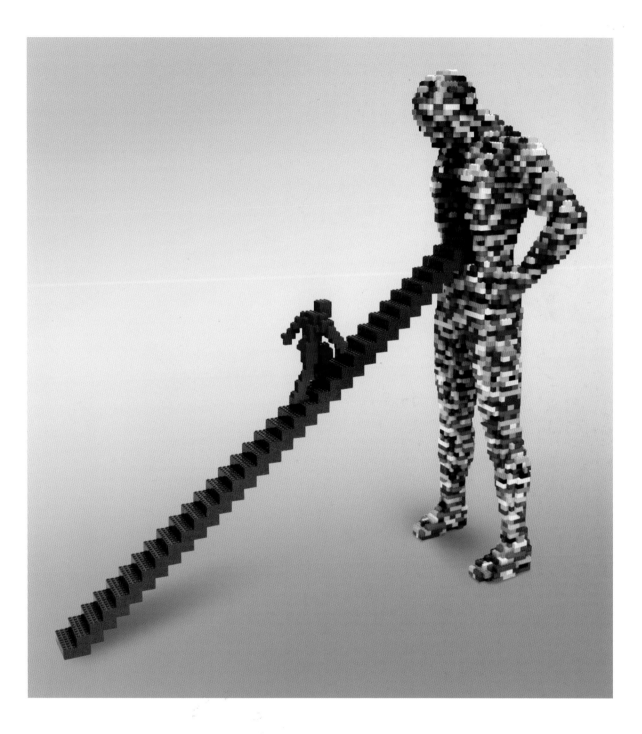

Stairway 2009

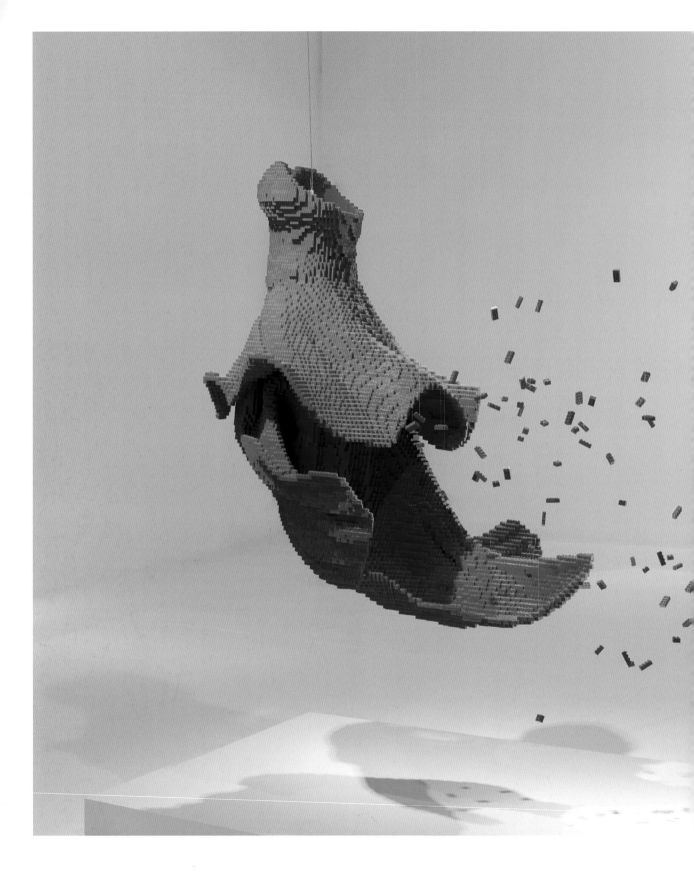

Red Dress 2013

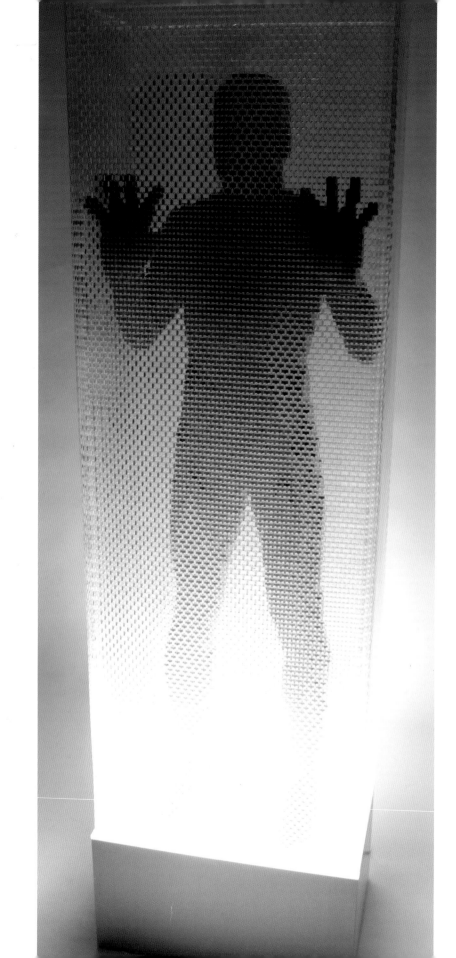

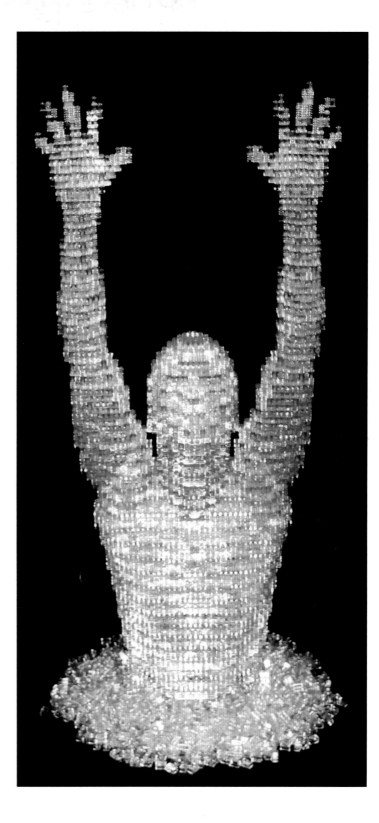

(opposite) Frozen Figure 2011 (right) Melting Man 2011

Monsters, Aliens, and Creatures

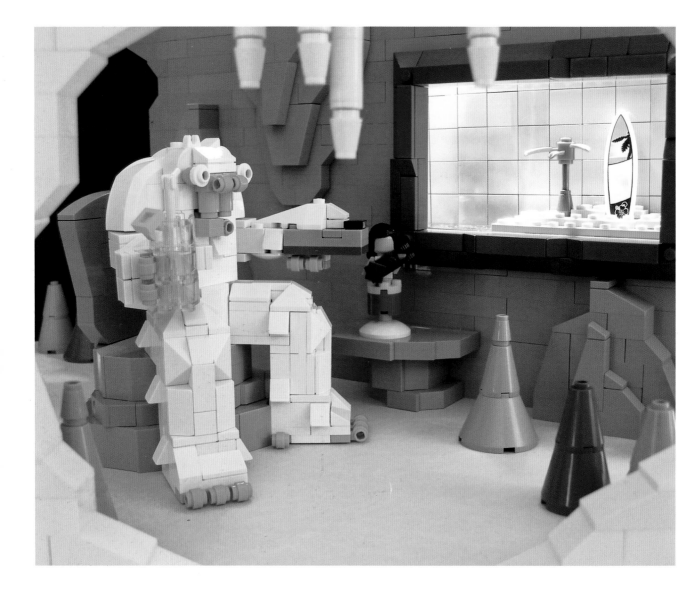

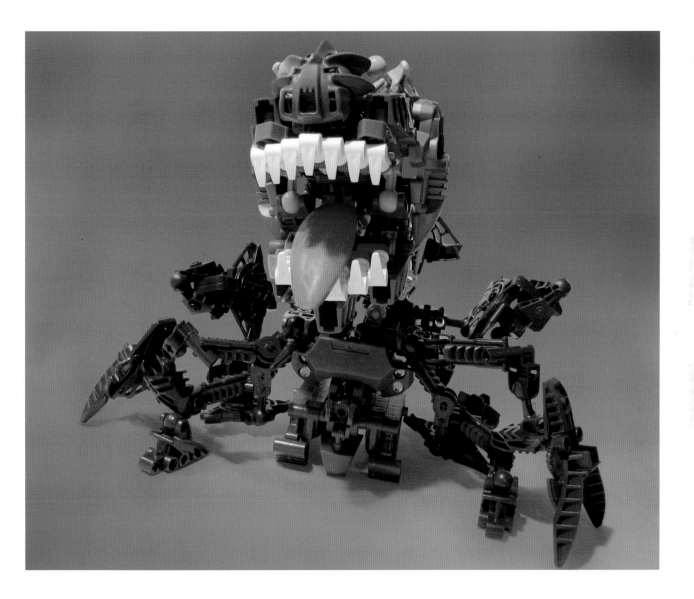

(opposite)
Tyler Clites
Paradise Frost 2012

(above)
Nathan Proudlove
Audrey2 2008

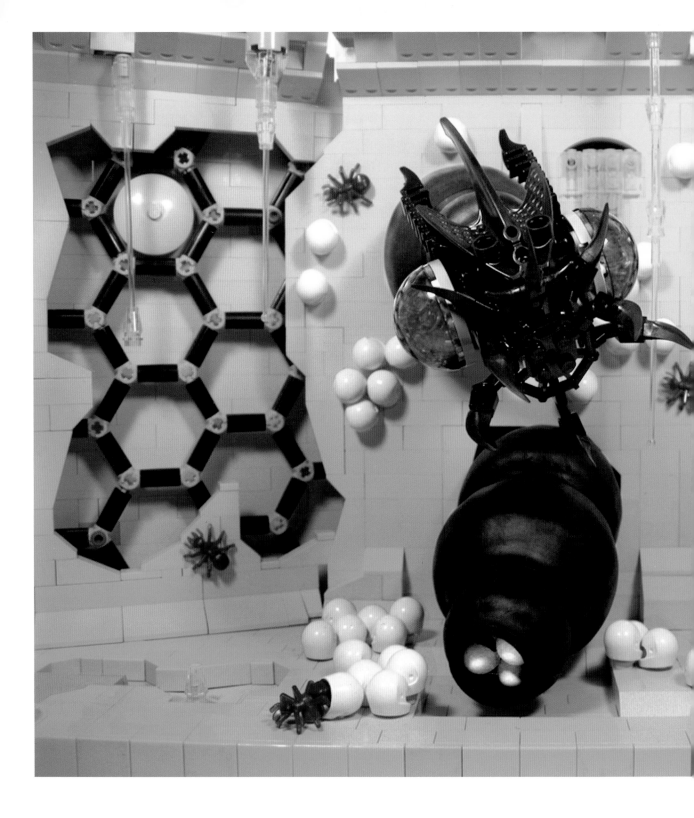

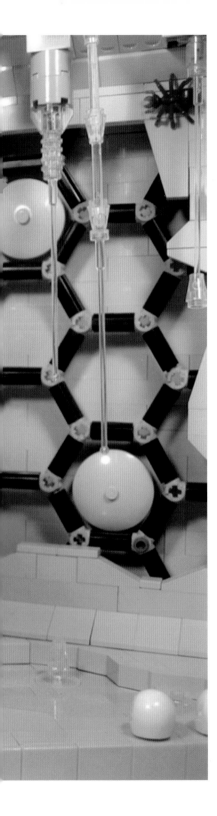

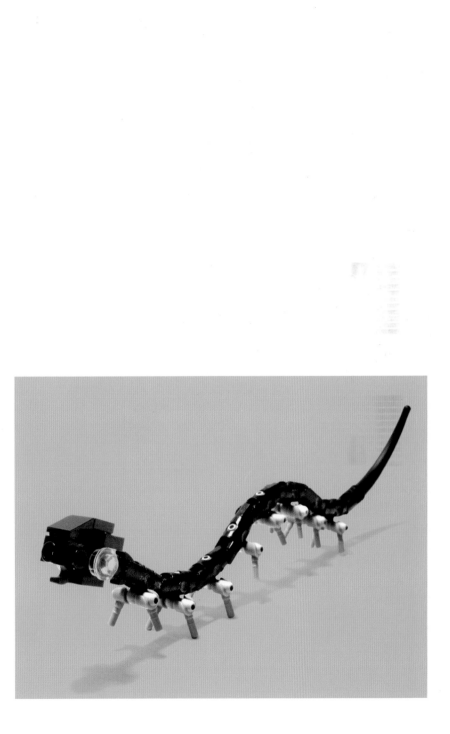

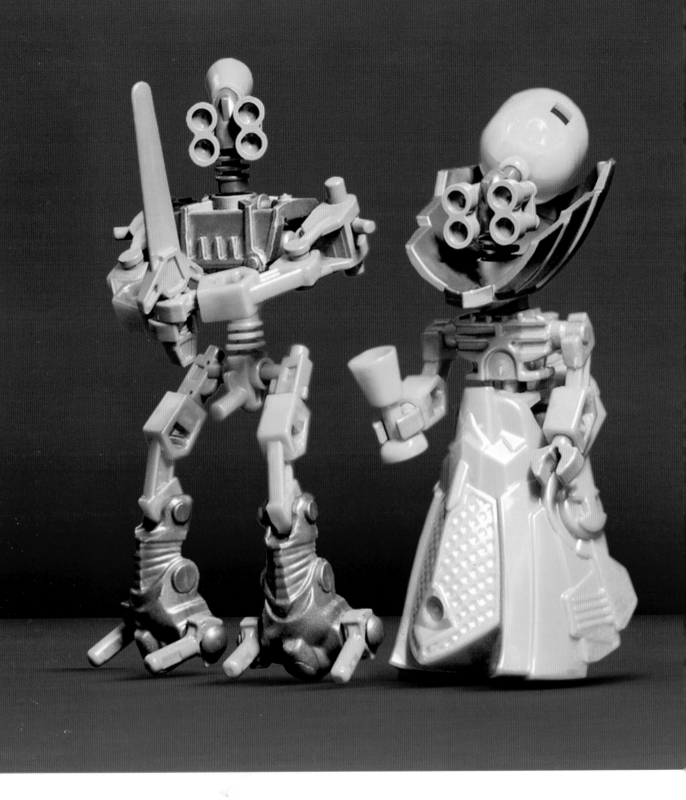

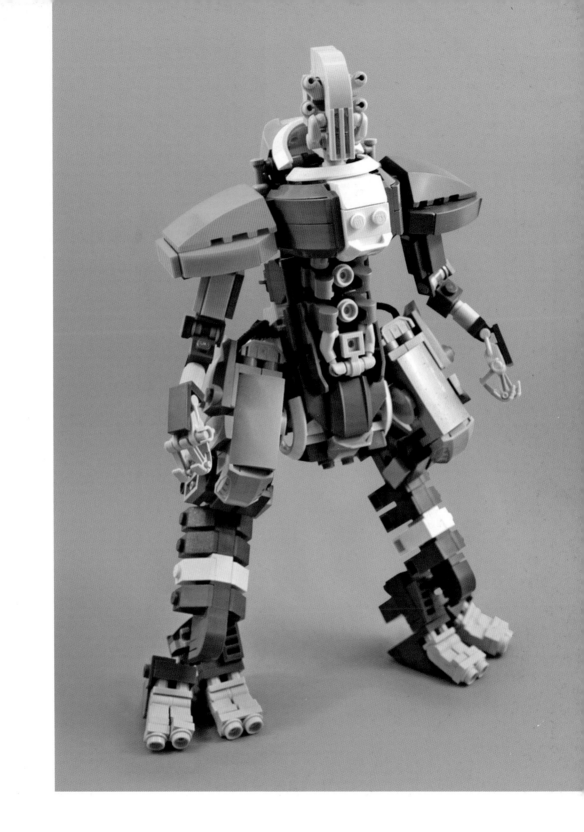

(opposite)
Robert Heim
Royal Robots 2011

(above)
Rayland Libero
Tsu-Ka Technician 2011

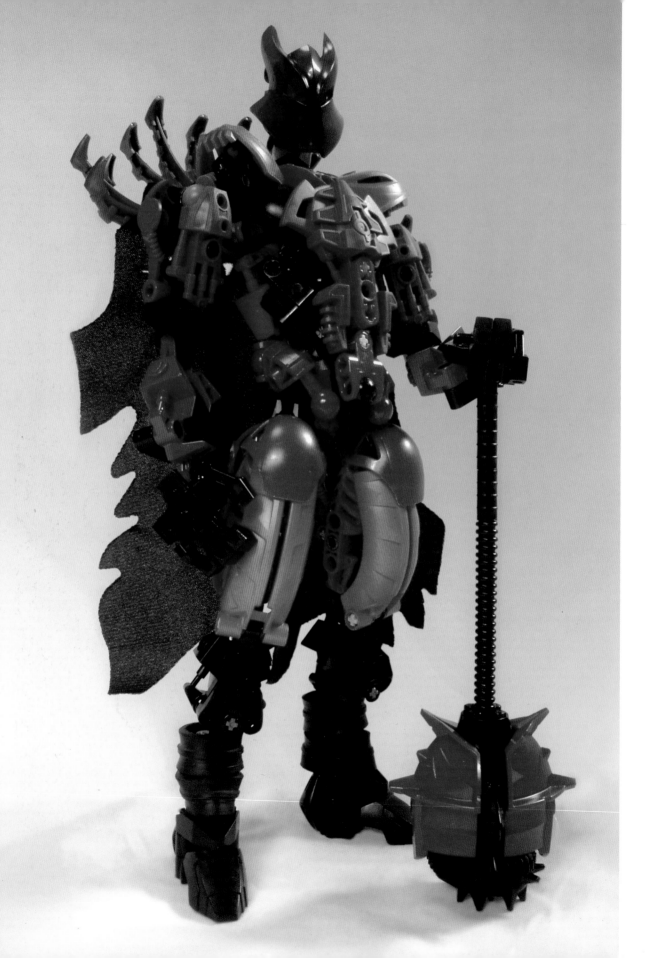

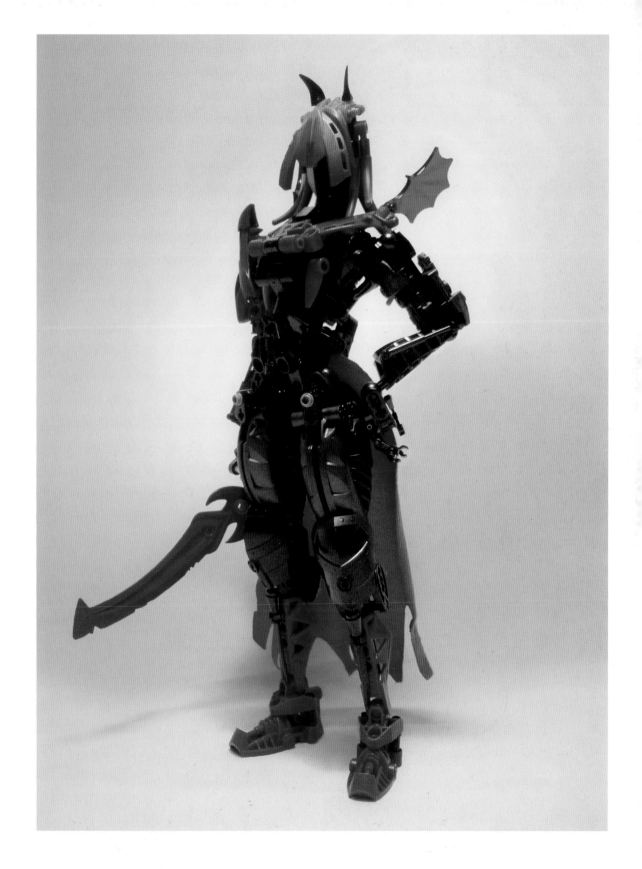

Eero Okkonen

(opposite) Gortrund 2011
(above) Karmenna 2010

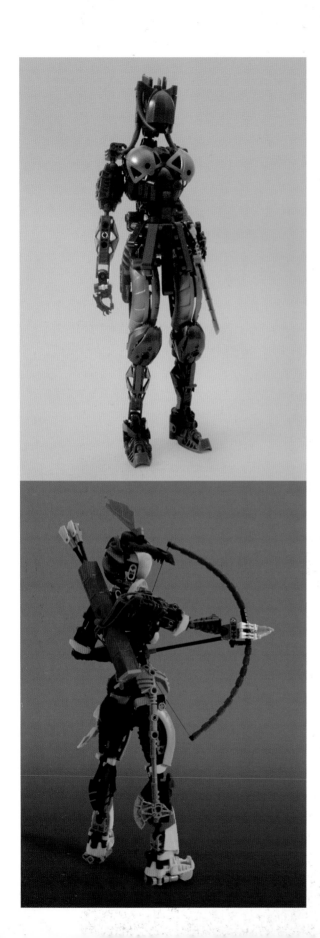

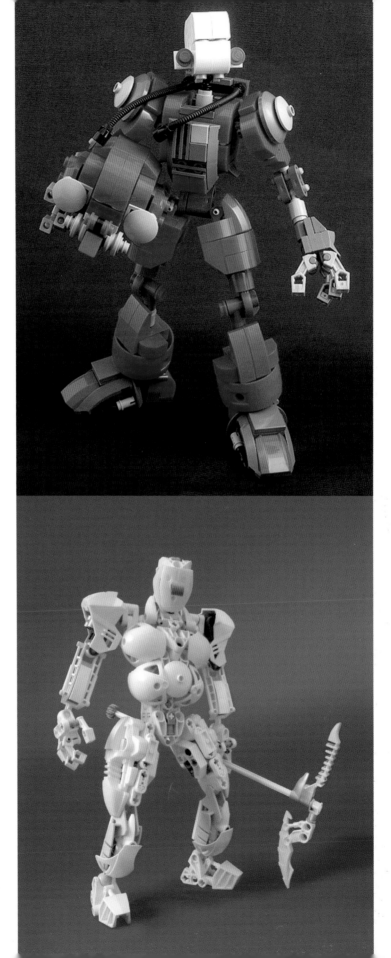

Eero Okkonen
(opposite top) Neyva 2010
(opposite bottom) Kathrienna 2011
(bottom) The Snowman 2010

A. Anderson
(top) Alien Cyborg Astronaut 2010

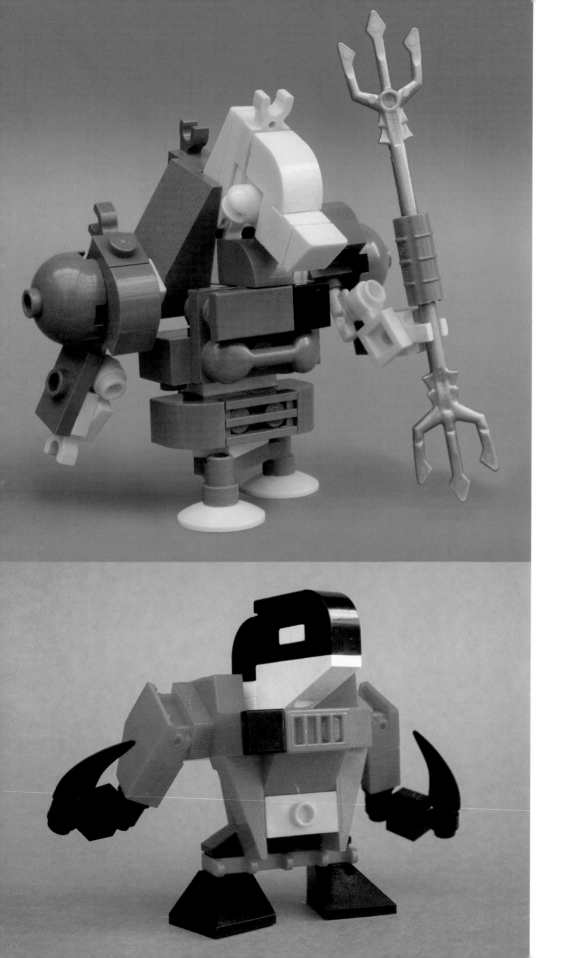

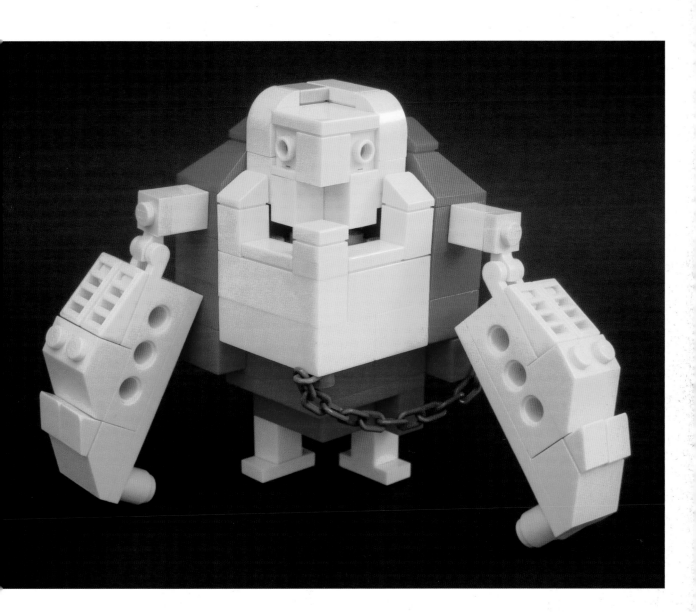

Shannon Sproule

(opposite top) "Secret Seahorse" Battle Beast 2010
(opposite bottom) "Thriller Whale" Battle Beast 2010
(above) Mongrol ABC Warrior CubeDude 2009

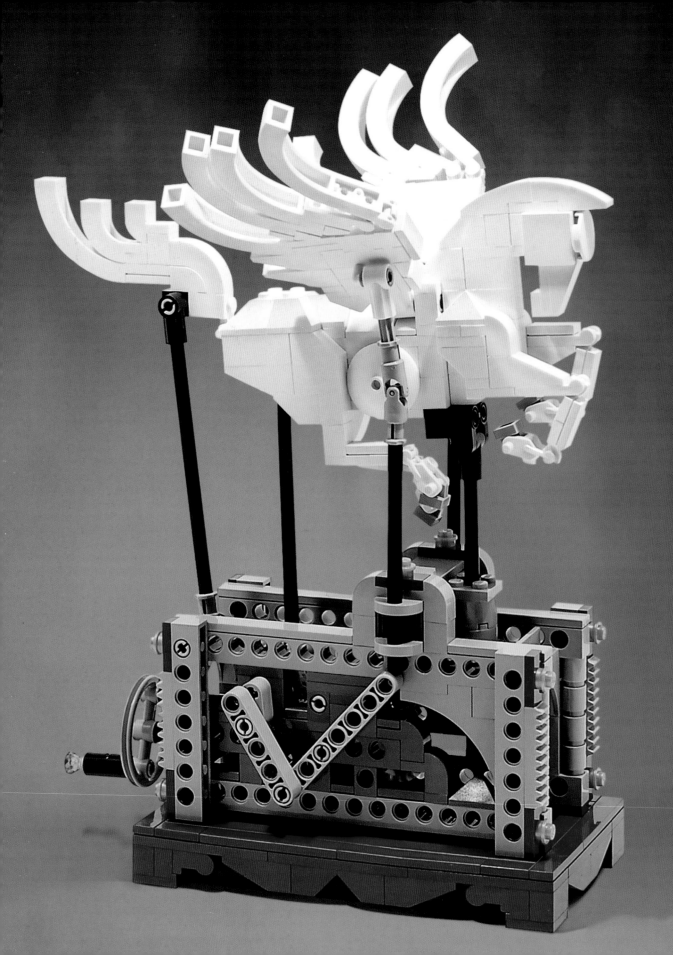

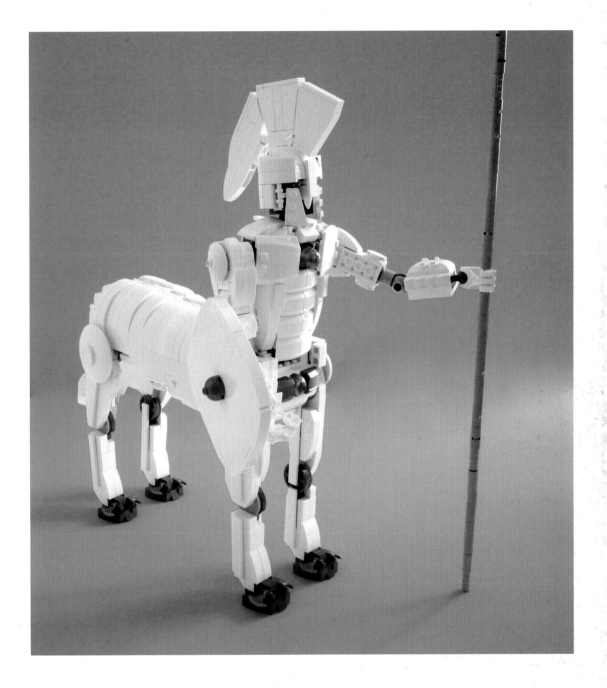

(opposite)
K. Amida Na
Pegasus Automaton 2011

(above)
Lino Martins
Centaur - Ajax the Great 2010

Tweets by Thomas Poulsom

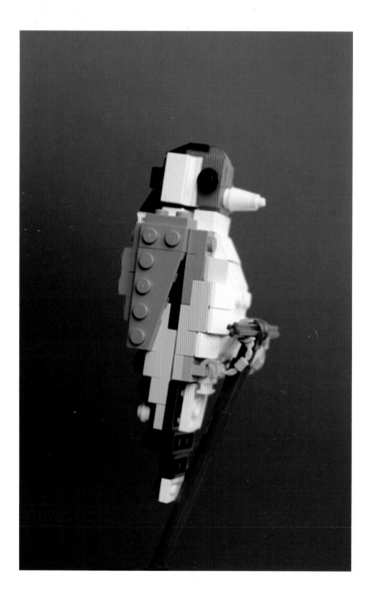

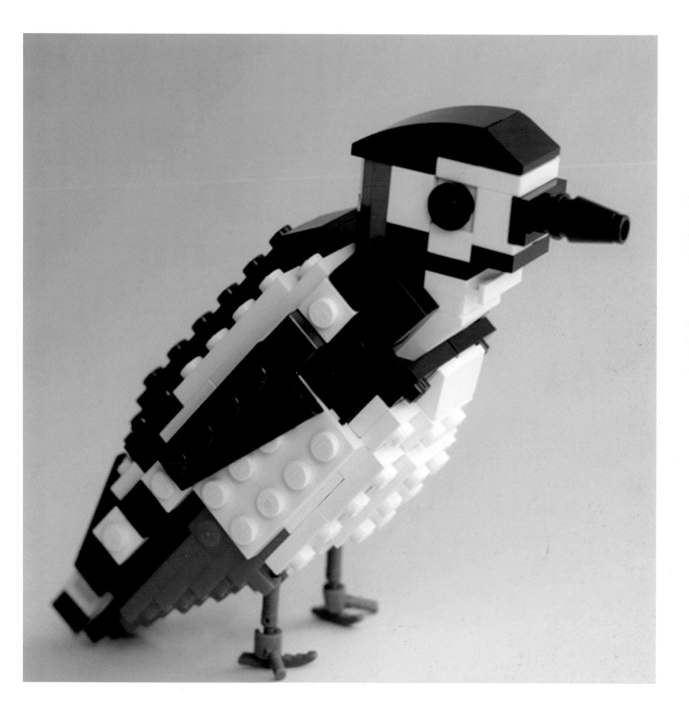

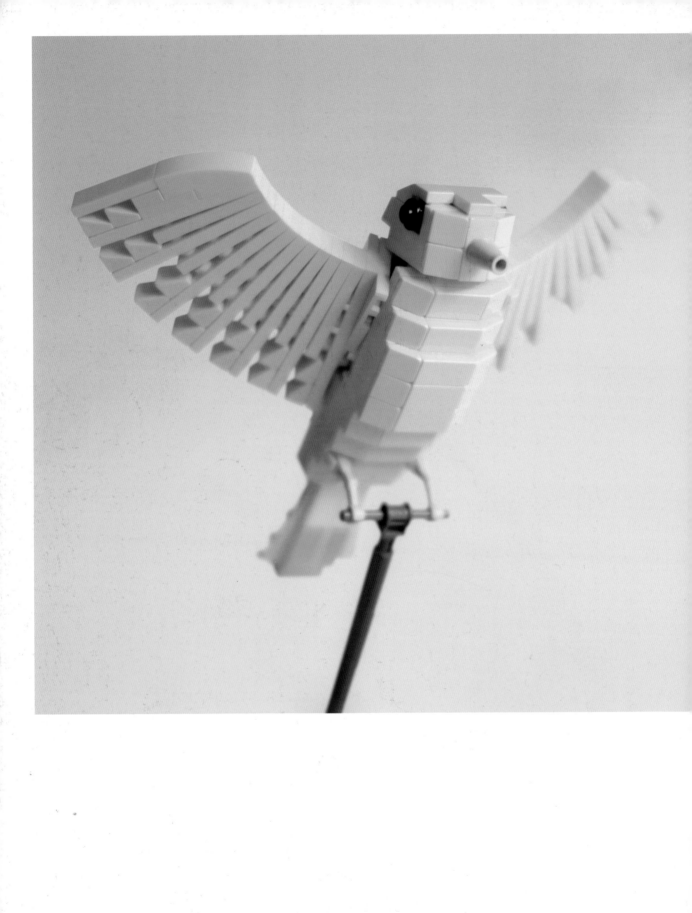

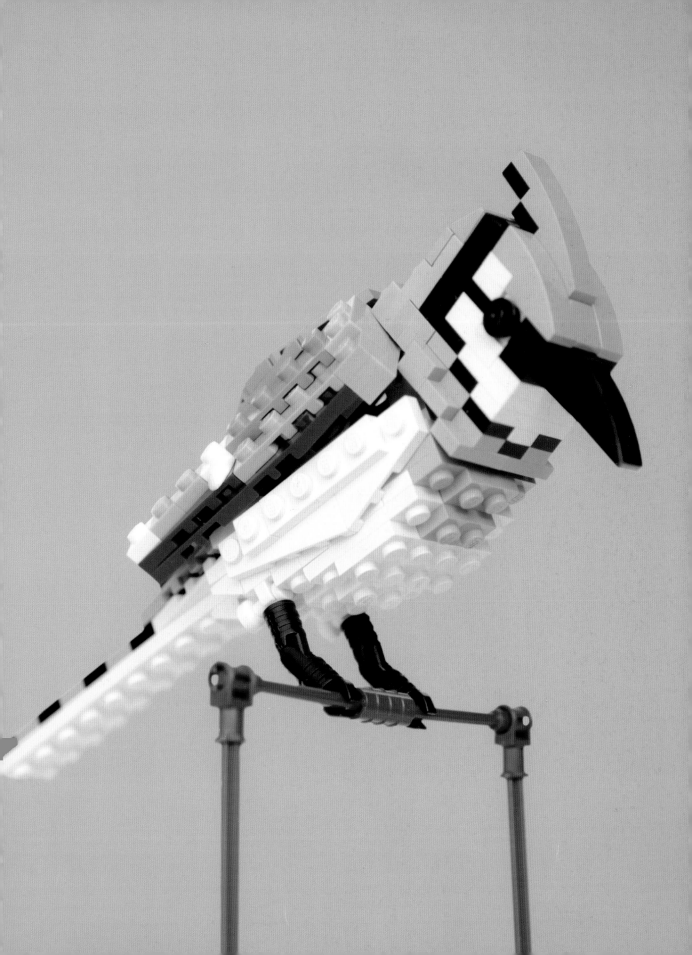

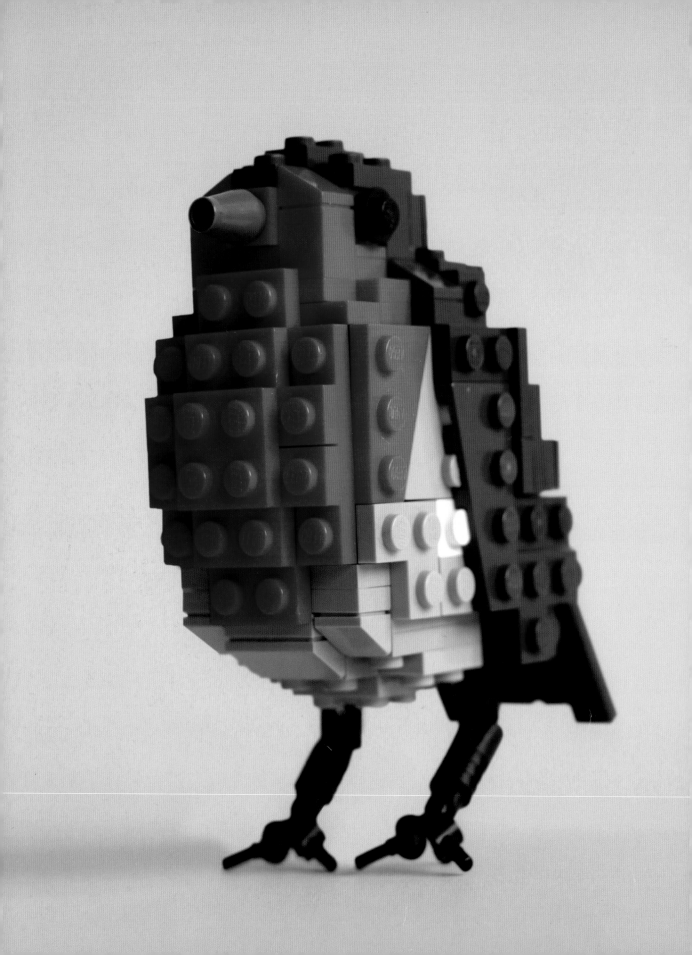

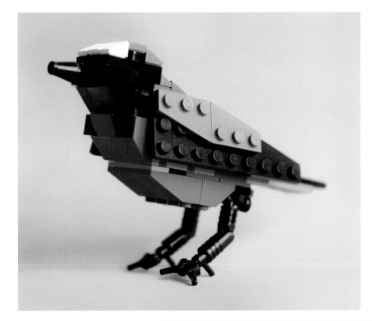

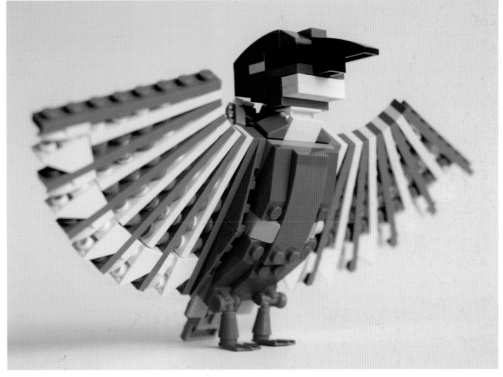

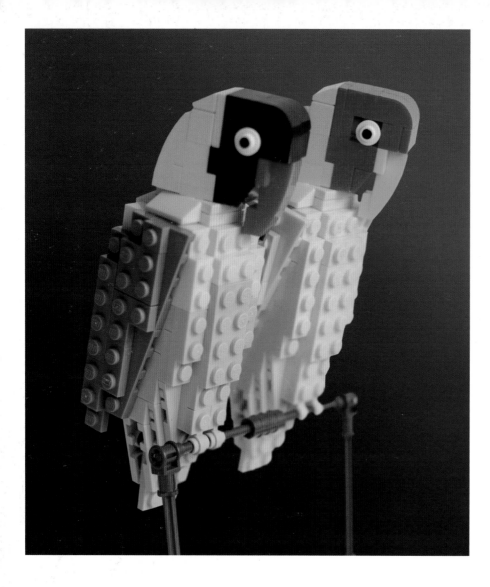

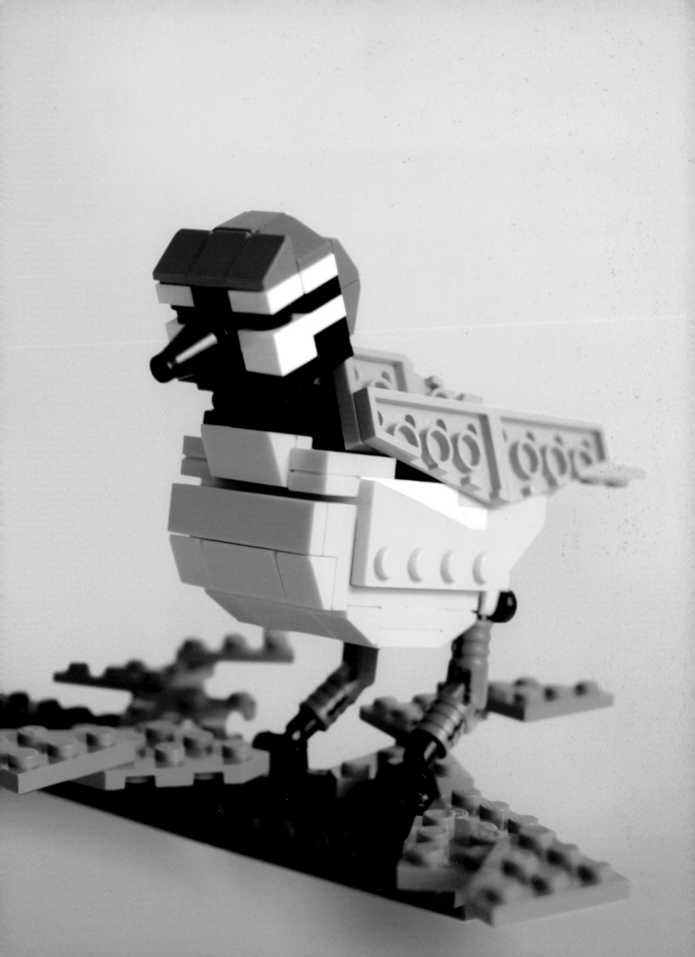

Plastic Menagerie

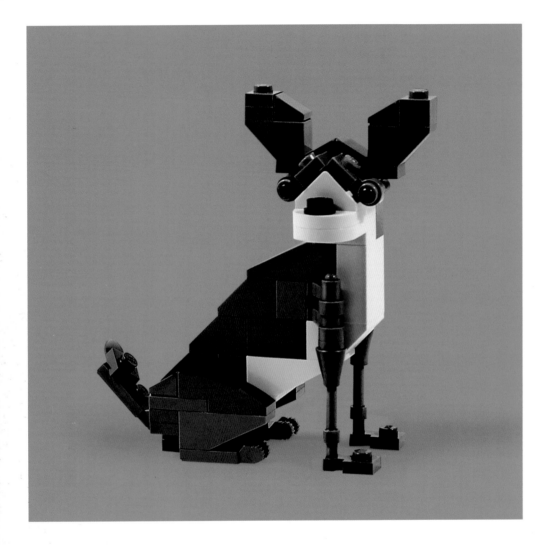

(above)
K. Amida Na
Chihuahua 2011

(opposite)
Huang Shin-Kai 黃信凱
Westie 2012

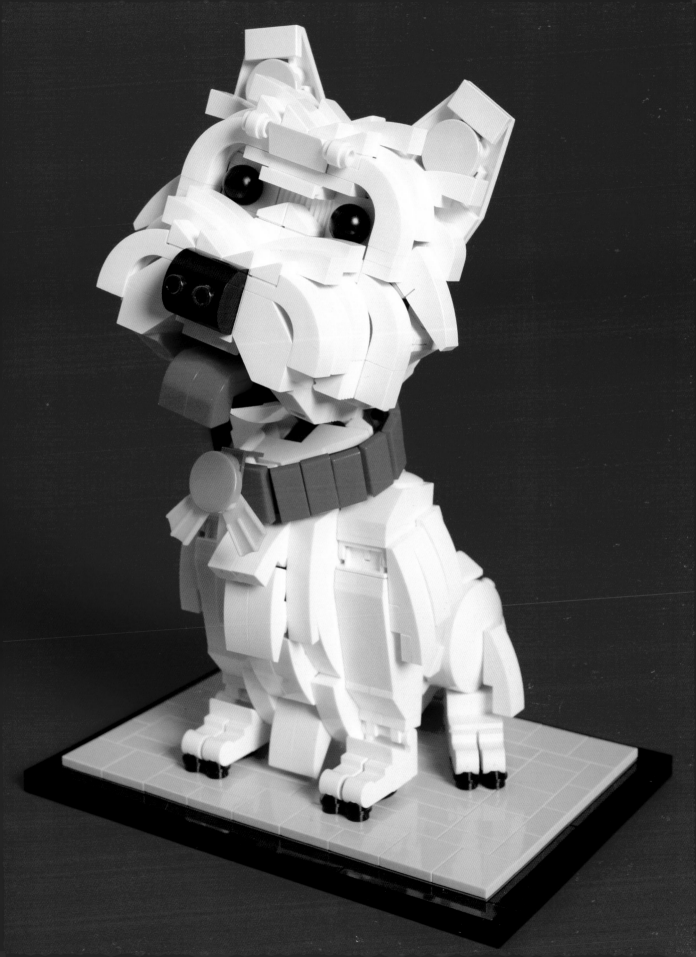

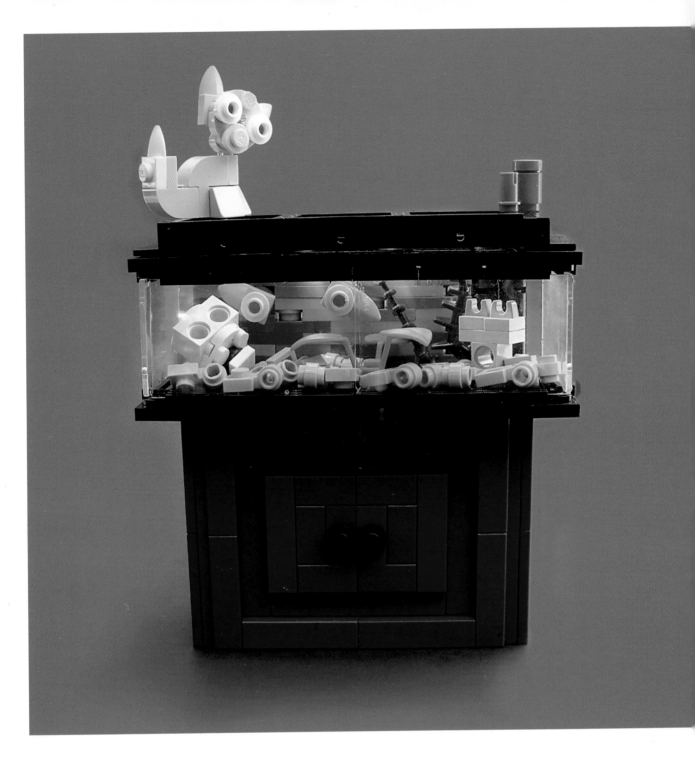

(above)
Tyler Clites
Midnight Snack 2012

(opposite)
K. Amida Na
Clown Anemone Fish 2011

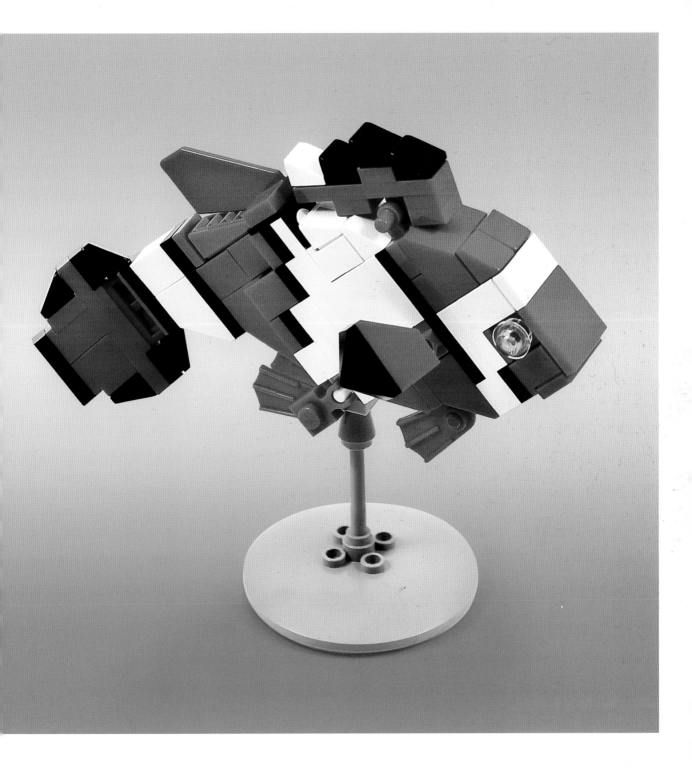

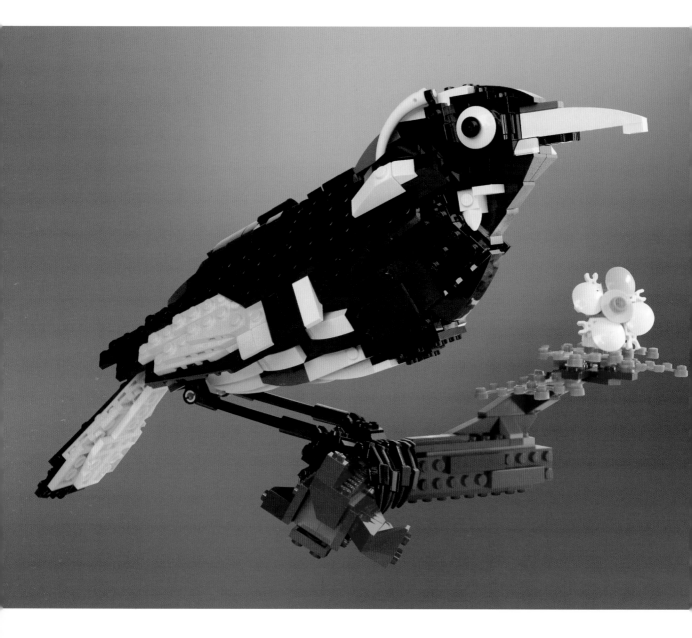

Gabriel Thomson
(opposite) New Holland Honeyeater 2011

Eric Constantino
(left) Big Eyed LEGO Duck 2006
(right) Big Eyed LEGO Peacock 2011

MisaQa
(bottom) Birds 2005

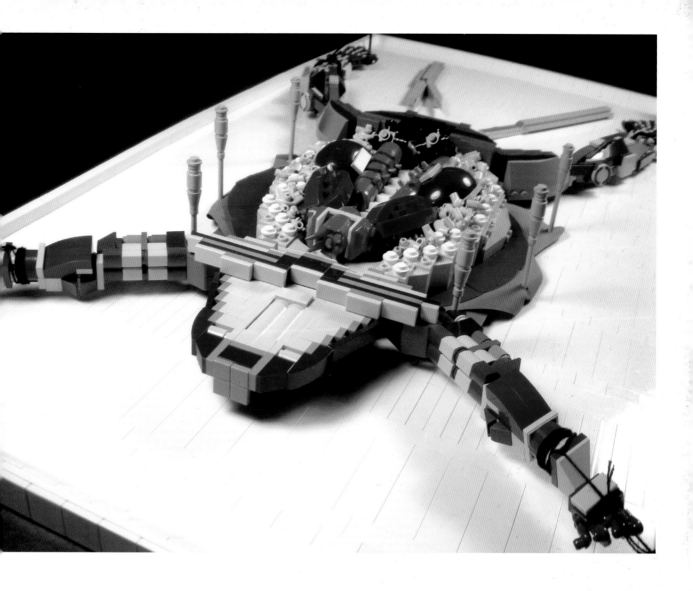

Dave Kaleta
It's Not Easy Being Green (Dissected Frog) 2010

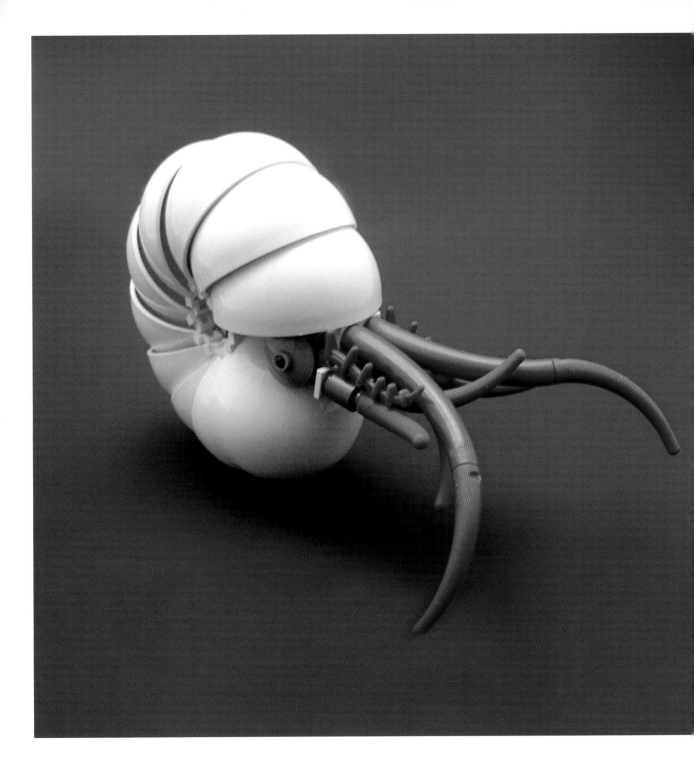

 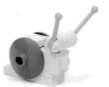

 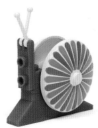

 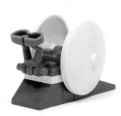

(opposite)
Tyler Clites
Great White Nautilus 2009

(above)
MisaQa
Snails 2004

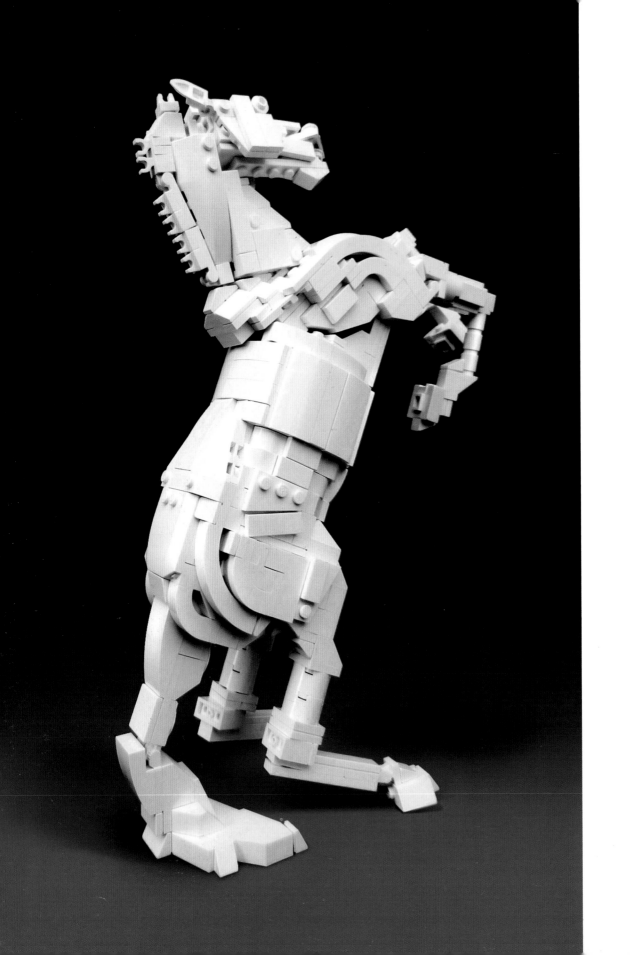

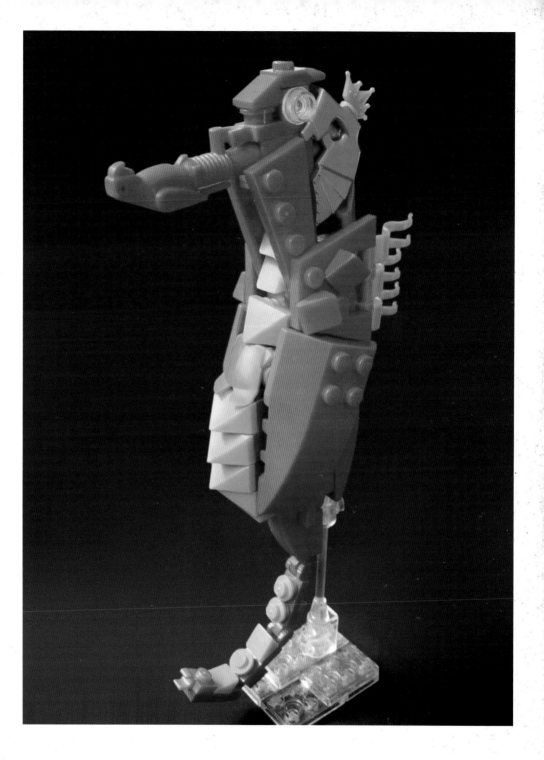

(opposite)
Tim Goddard
Rearing Stallion 2011

(above)
Sven Junga
Seahorse 2011

Mike Nieves

Why LEGO? I love building. Ever since I was a kid, I've enjoyed creating new things. Out of all the mediums in which I could express my creativity, LEGO stood out. Even as a child, I saw its benefits. It is completely recyclable: You can use any piece over and over. Any money you spend on this hobby means your collection grows, which isn't the case with painting or most other artistic endeavors. Mistakes are always fixable, and you don't have to start your project from scratch. And, cleaning up is fairly simple. It is perfect for me. I enjoy both the complexity and simplicity of what I do.

I like to build somewhat small. (If I build anything too big, then my supply of pieces starts to dwindle!) My favorite themes are animals, characters, and creatures. The details required for these kinds of models means I can't build too small, otherwise the features become vague. So over the last few years, I have created a style that allows for a balance of size and detail.

I mesh all that LEGO has to offer, using Technic for strength, Bionicle and Hero Factory for movement, and System for detail. To streamline their integration, I use only specific System pieces so that they match the patterns and shapes of the Bionicle and Hero Factory parts. The style is simple, deliberately so. The hard part is trying to combine these very different systems—but by now, I've had a lot of experience.

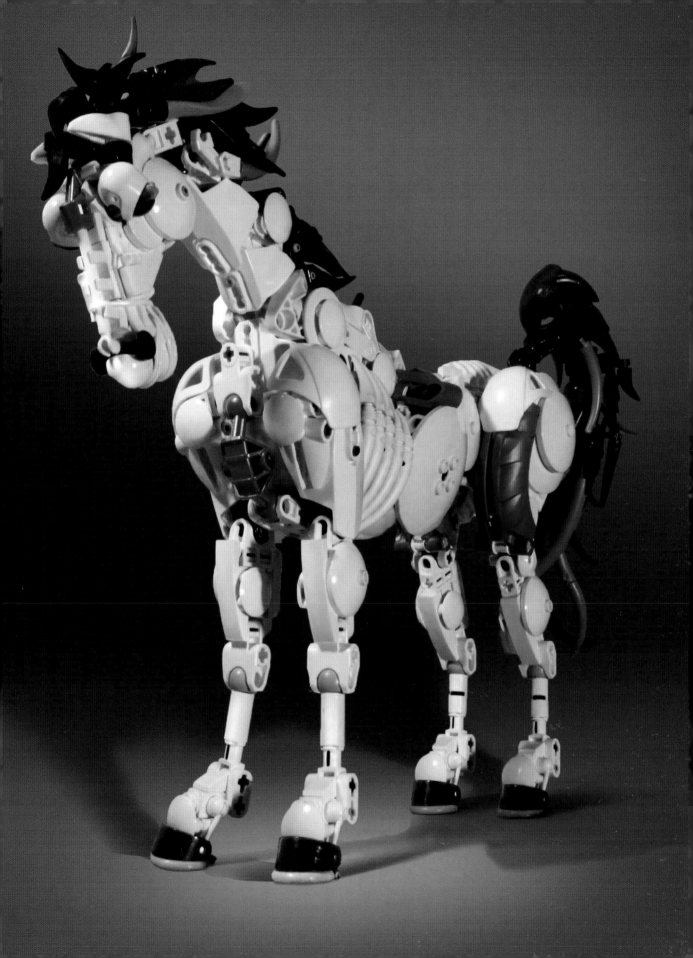

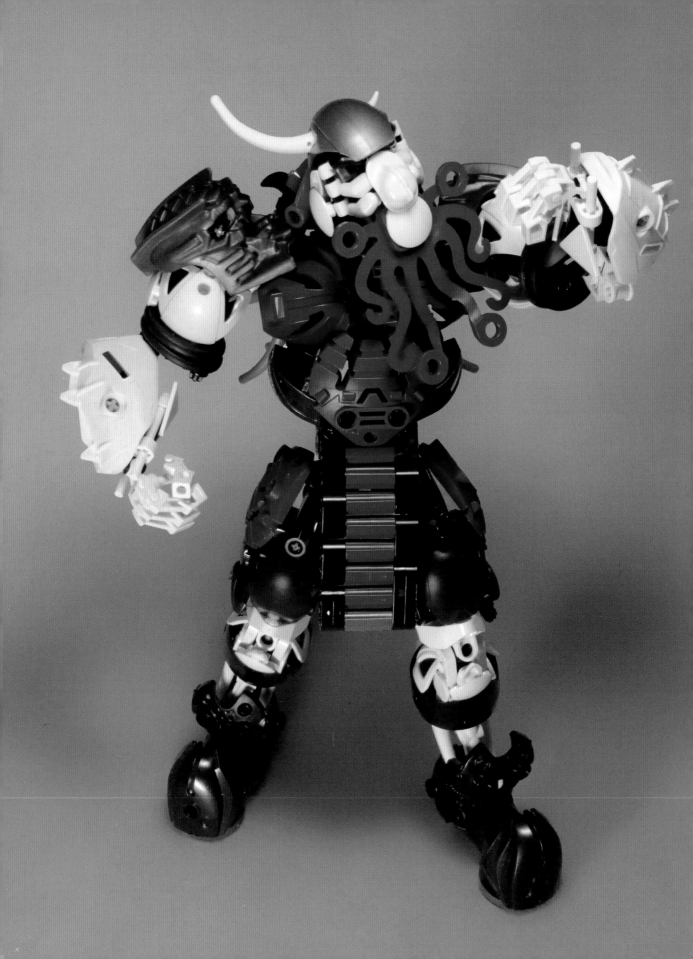

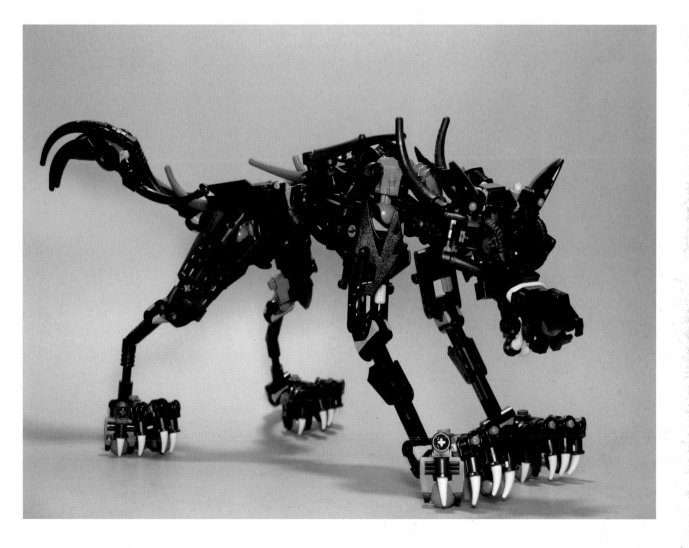

(opposite) Olaf the Bearded 2011 (above) Wolf 2010

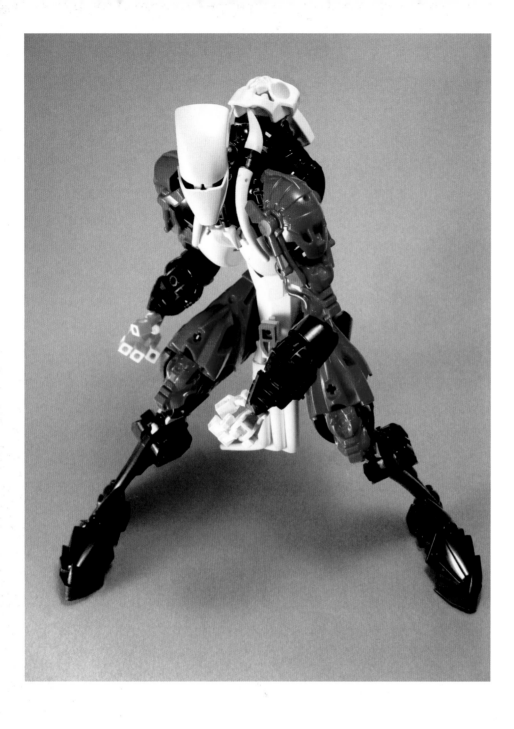

(above) Malrik 2011 (opposite) Harley Quinn 2011

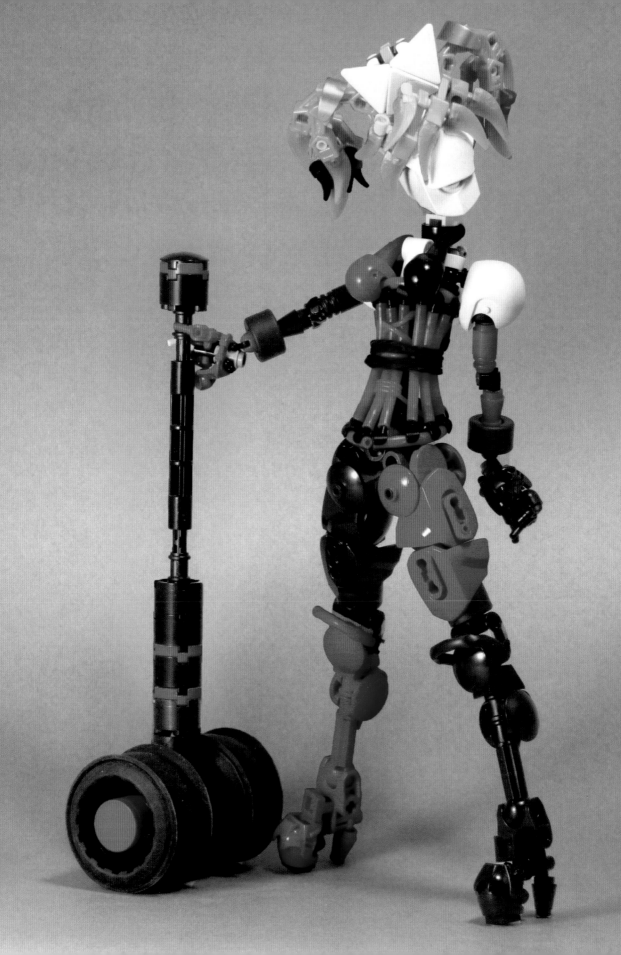

Quite the Character

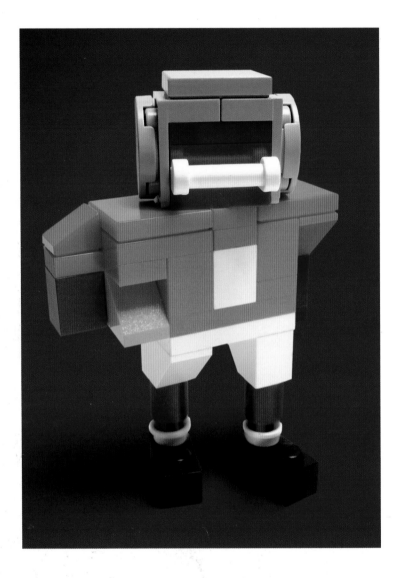

(above)
Paul Lee
Minibuild Football Player 2009

(opposite)
Nathan Proudlove
Family Portrait 2011

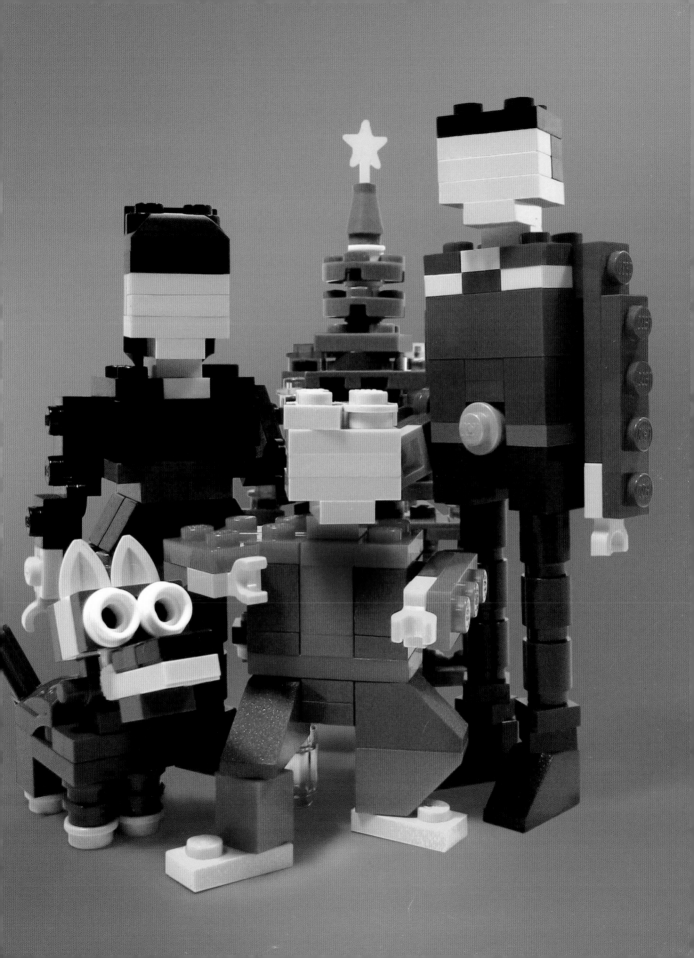

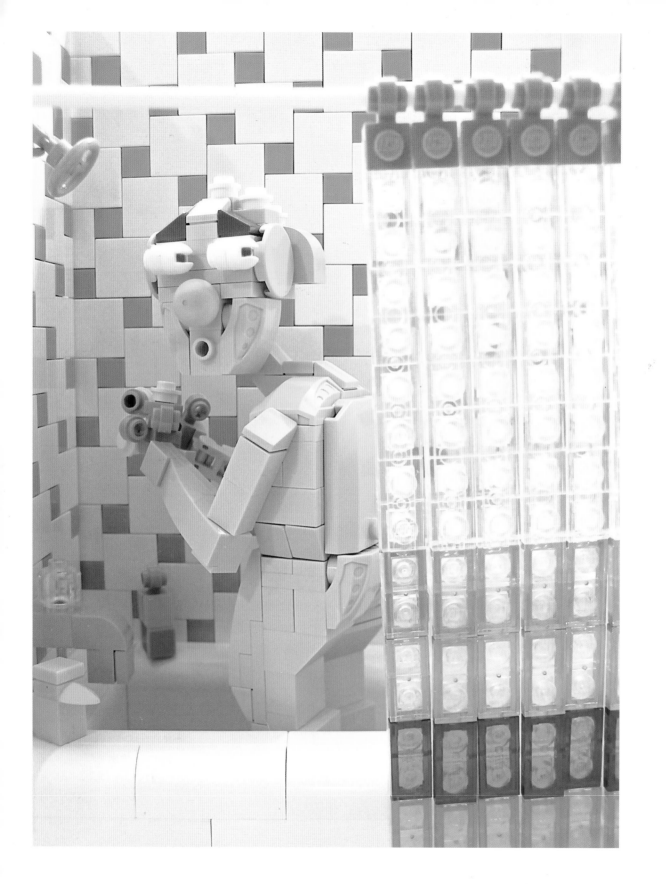

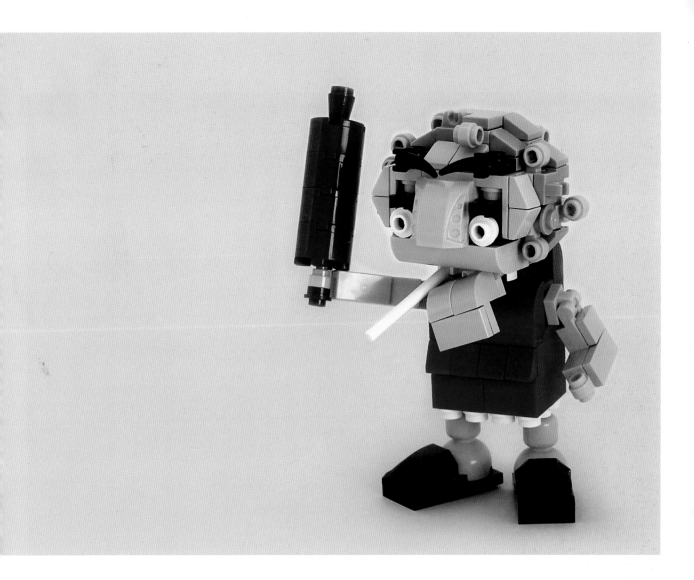

Tyler Clites

(opposite) Grandpa! You better not be using my loofah again! 2012
(above) 'mere Brucy 2012

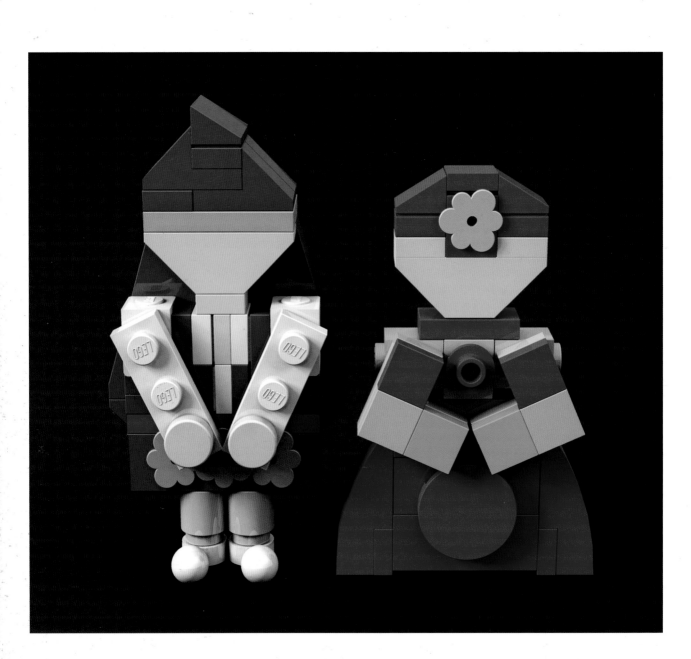

(above)
K. Amida Na
Greetings in Hanbok 2012

(opposite)
Paul Lee
CubeDude V for Vendetta 2009

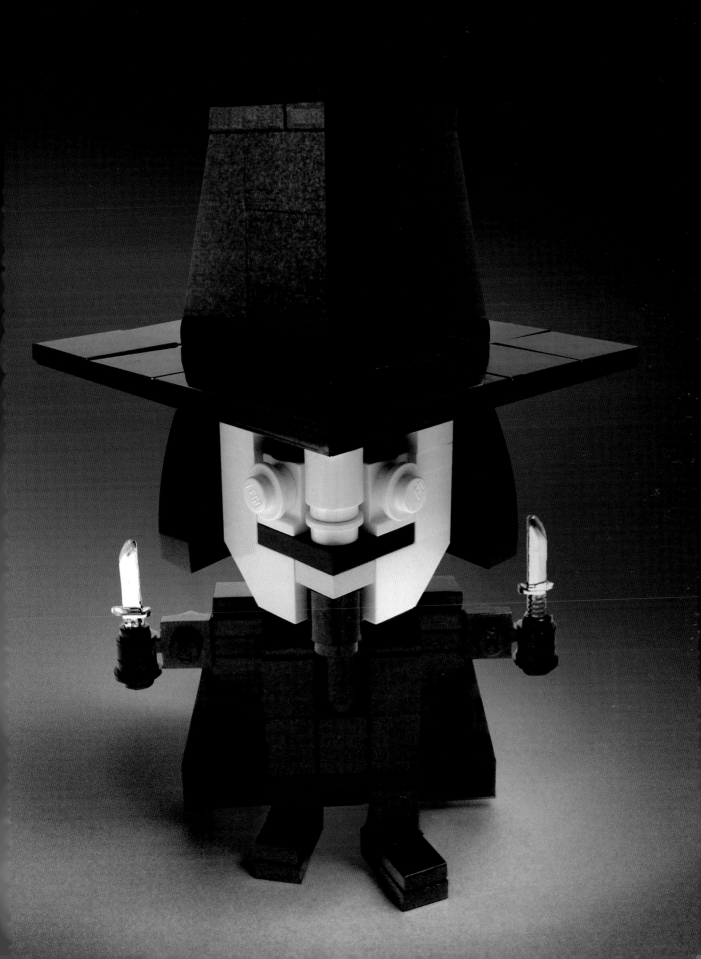

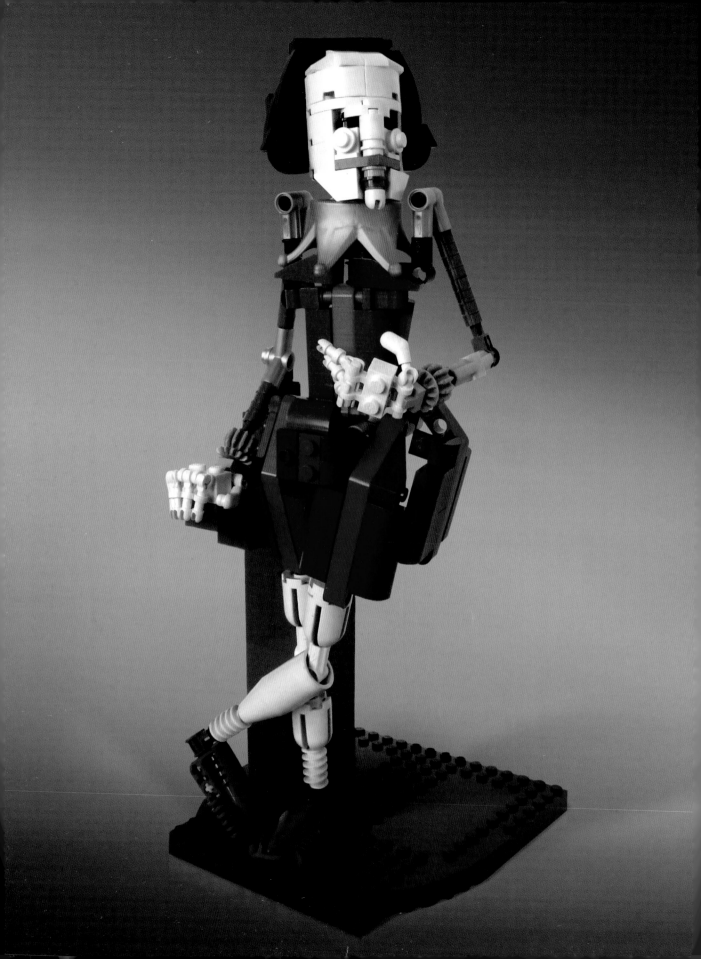

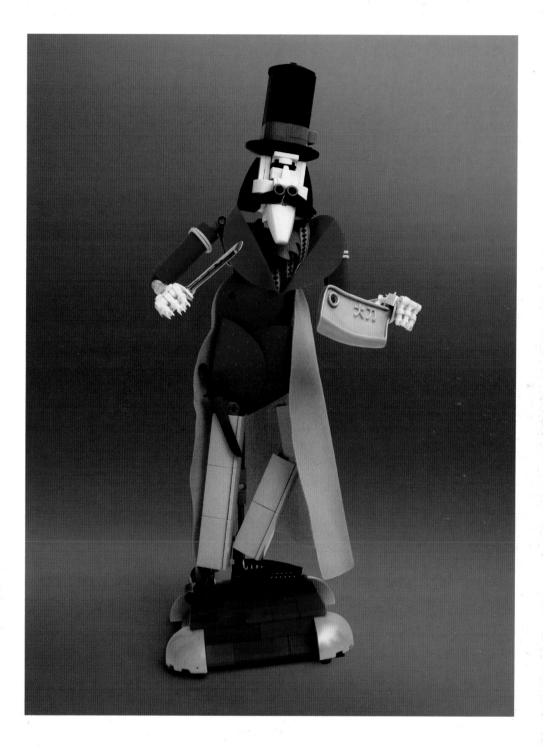

Guy Himber

(opposite) Shakespeare 2010
(above) Bill the Butcher 2011

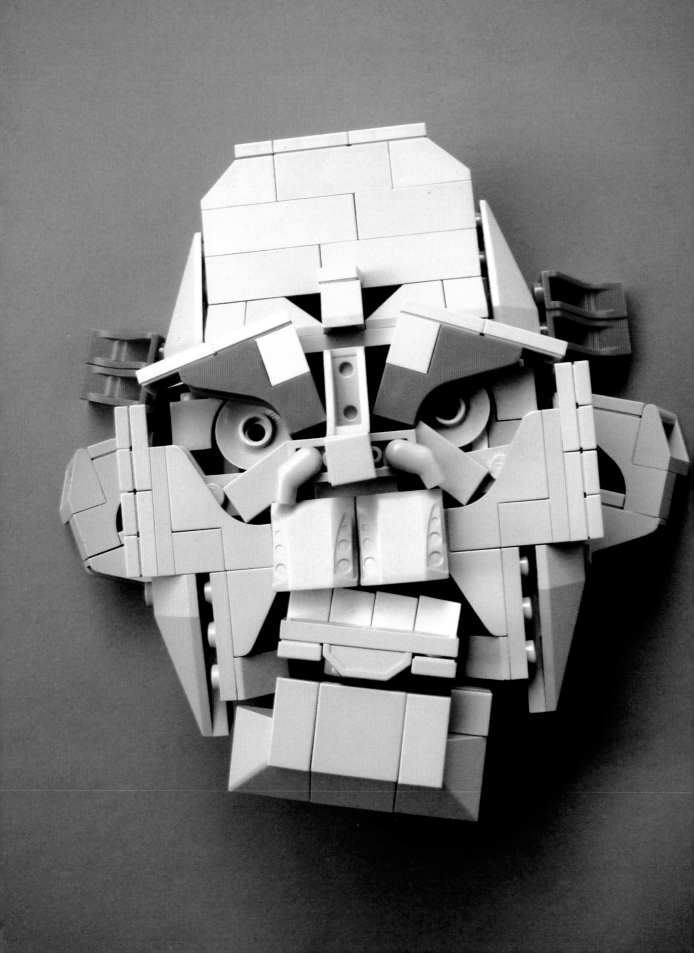

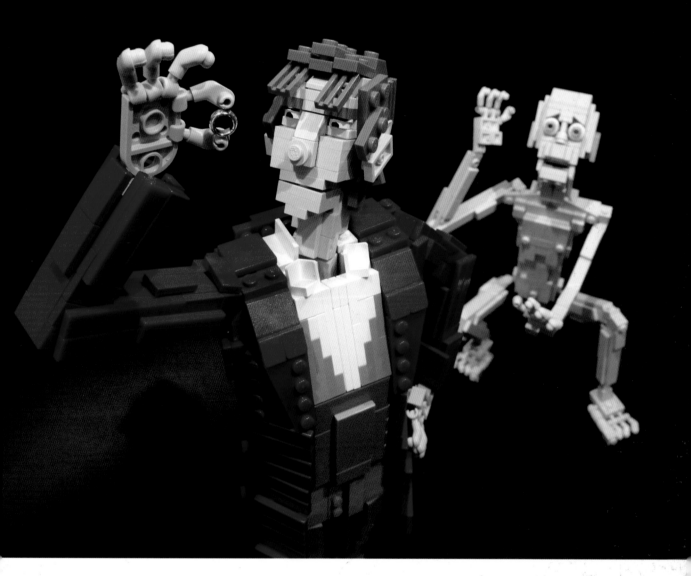

(opposite)
Guy Himber
Shaggy Caffeine 2011

(above)
Iain Heath
Finders Keepers 2012

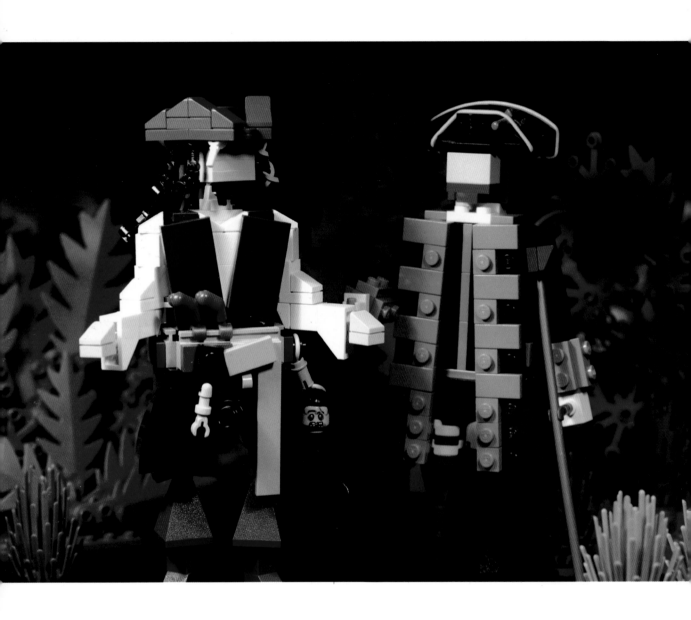

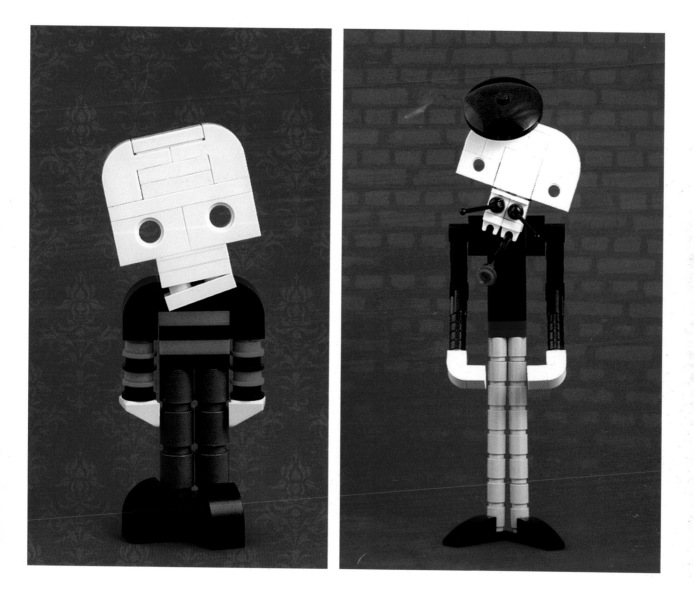

Tommy Williamson
(opposite) Jack Sparrow & Barbossa 2011

A. Anderson
(left) Mort 2010
(right) Pierre, Of Course 2010

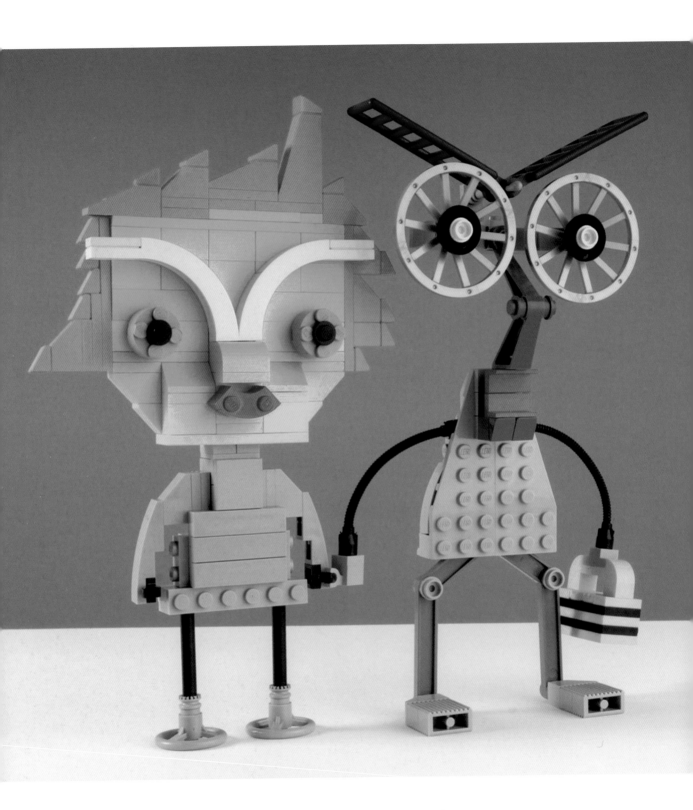

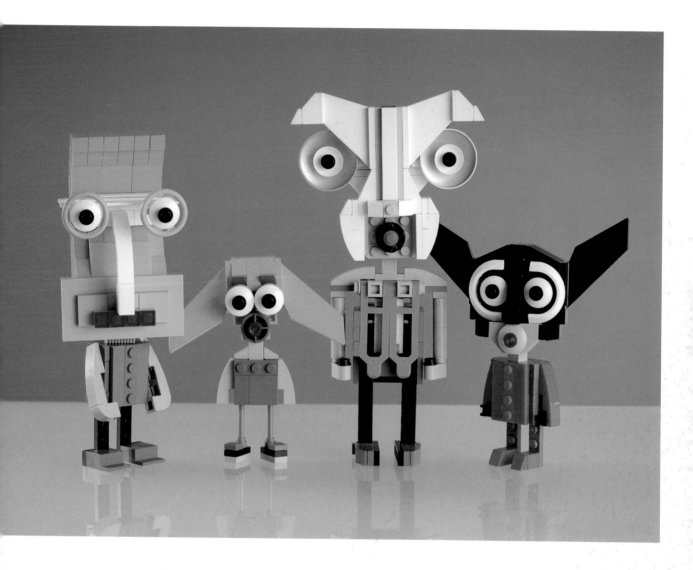

Peteris Sprogis

(opposite) Crackhead & Honey Bag Man 2010
(above) Party Animals 2011

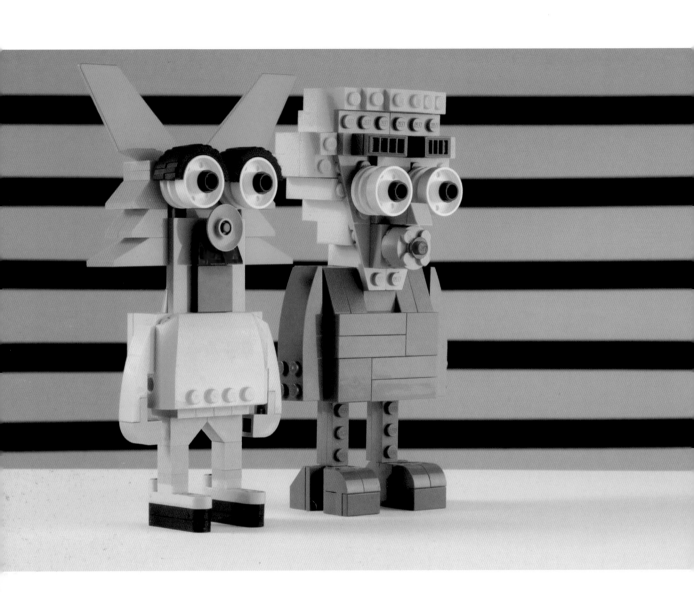

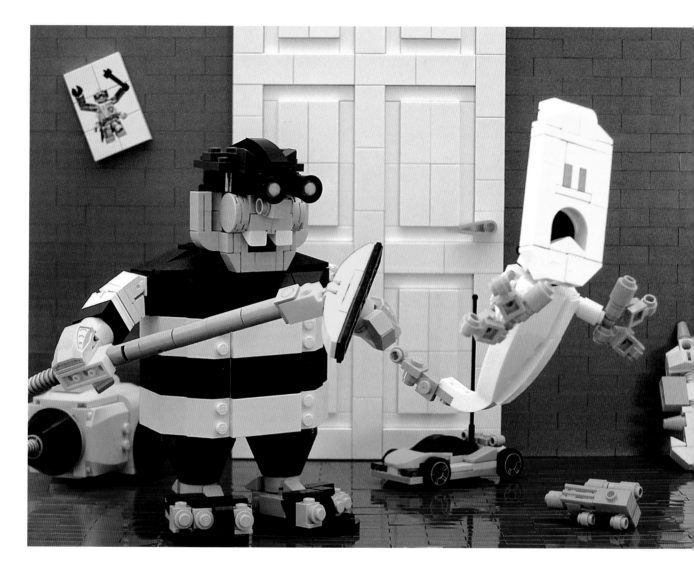

(opposite)
Peteris Sprogis
Sparkly & Barkly 2010

(above)
Tyler Clites
Sometimes It Sucks to Be a Ghost 2012

105

All Dolled Up by MisaQa

Arthur Gugick

Tell us about yourself.

Born and raised in New York City, I got my first LEGO set for my seventh birthday in 1967. I never actually quit, so that means I've been playing with bricks for 42 years. I've been a math teacher for 25.

How long have you been building landmark buildings?

The first "landmark" I built was my own home. We had just moved into a new house. I found the blueprint of the house in the attic, and one thing led to another. The first true landmark I built was the Taj Mahal, which got some amazing press (featured in the *Washington Post*, Cleveland media, and so forth). Later, I built a model of Lyndhurst Castle, which won a first prize in the very first contest I entered. With so much amazing feedback, I continued to build.

How do you go about picking which building to create?

It's the hardest part of the job. I want people to connect with my work, so I purposely select landmarks that people might know about. I have a list of the 200 or so most famous buildings, and some have been crossed off. I've built about 50 different landmarks. Sometimes, I repeat landmarks at different scales; I've got three Independence Halls and three Arcs De Triomphe. Sometimes, I see a landmark in a book and just have to build it, Angkor Wat or Mont-Saint-Michel, for example. Sometimes, I build for the challenge. Sometimes, I'm commissioned to do a piece and then the building is selected for me!

Do your pieces take a lot of planning ahead of time?

I do a lot of research in libraries and on the Internet, sketch blueprints and elevations and different scales, use CAD programs, create mock-ups of various façades, and more. I also use a lot of mathematics in my work, as in the Roman Coliseum and Petronas Towers. When I finally start to build, I usually feel that I can already see the finished model in front of me.

Are there any parts of buildings that you find particularly challenging to create?

Over the years, there have been a number of buildings that I thought to be unbuildable. Some of them I have conquered, such as the Tower of Pisa and St. Basil's Cathedral. Some I'm working out how to build, and by the time this is published, I suspect I will have built at least one of them. Another still on my list is 30 St Mary Axe in London.

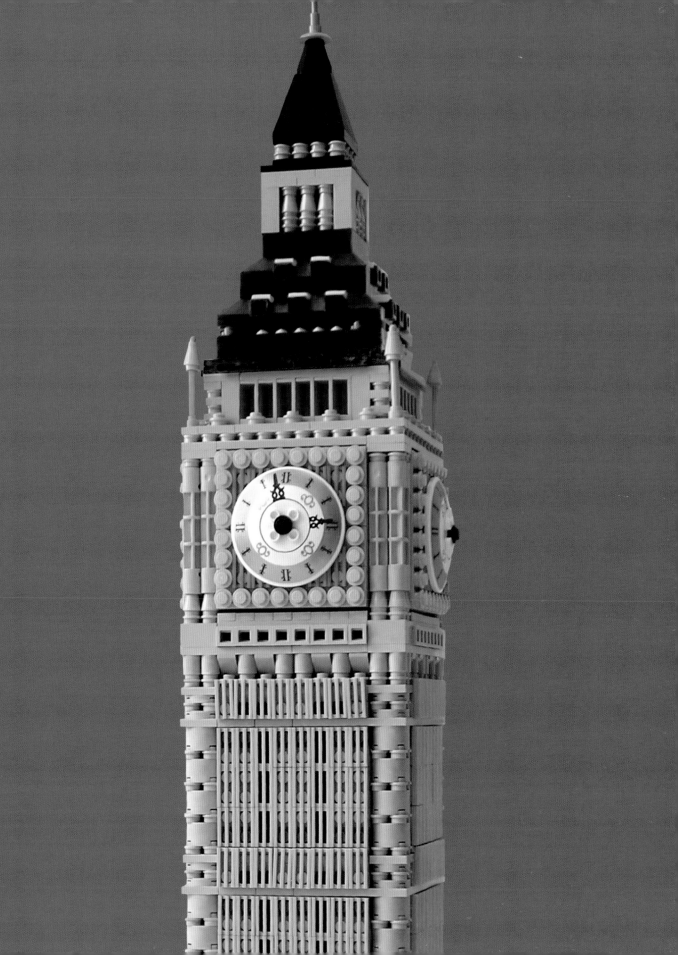

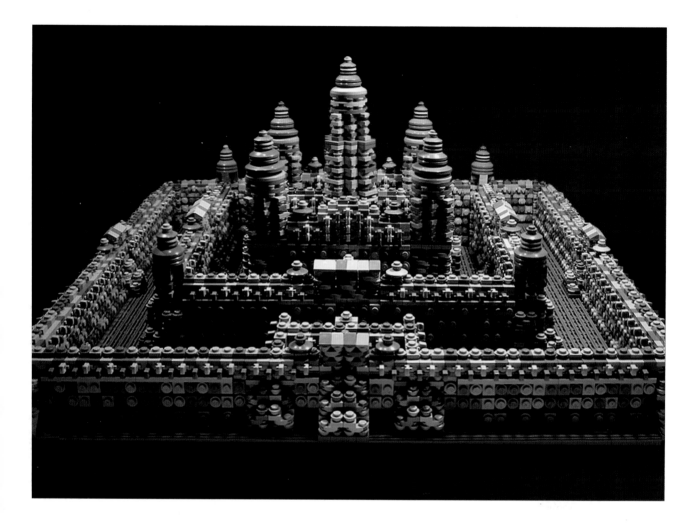

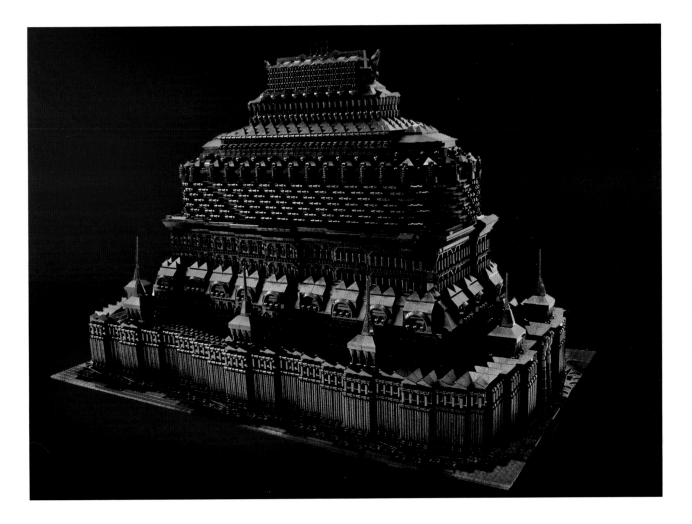

(opposite) Angkor Wat 2010 (above) The Tower of Babel 2011

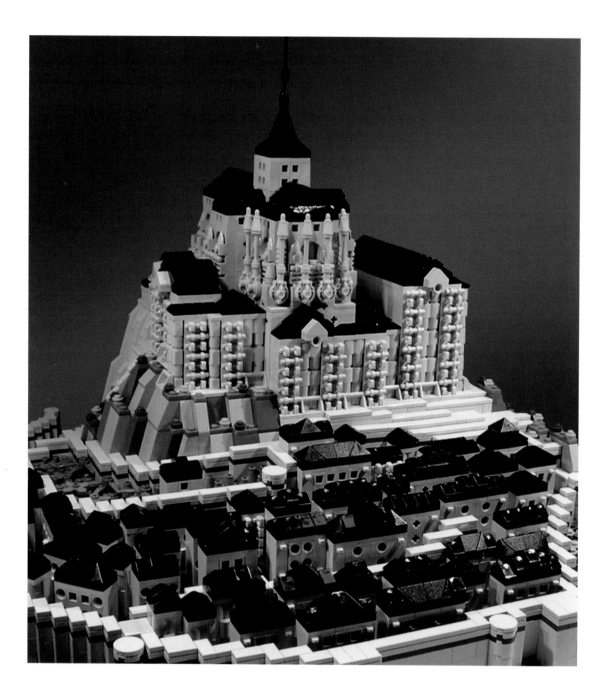

I know that you build at different scales, depending on the piece. How do you go about determining the scale you will use?

It often depends upon the scale of a particular element. The White House's scale depended on the scale of the windows. Notre Dame's scale depended on the scale of the buttresses.

I understand you put your mathematical background to good use when building. Could you give some examples?

The Roman Coliseum is an ellipse with a width-to-length ratio of 6:7. There is no formula for the circumference of an ellipse like there is for a circle. To find the circumference, I use the arc length formula from calculus. The Dome of the Rock required a bit of trigonometry. To build the dome accurately, I wrote some software that easily allowed me to build any dome shape. (If you want to use it, just ask!)

How often do you sit down to build?

I applied for a job at the new LEGO store that was opening in Cleveland. With so many applicants, they had group interviews. The first question asked to my group was "when was the last time you played with LEGO?" The first five answers were "when I was a kid," "a few years ago," "the last time I visited my nephew," and then my answer: "23 minutes ago."

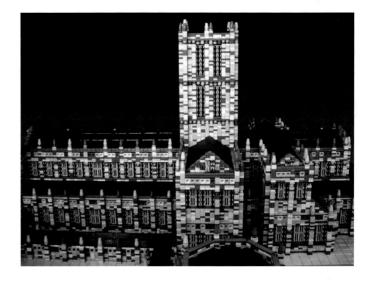

Mike Doyle

Why LEGO? It is a medium that offers instant gratification. No matter how large a project is, at the end of the day, I can look at the section I've built in its finished state. LEGO is a one-step process; there's no gluey mess, sanding, or painting to worry about. I just build. This gives me the opportunity, after each session, to assess visually how the piece is working as a whole.

LEGO offers a vast palette to work with. There are thousands of different LEGO elements, each available in an array of colors. With all the variety, I can create innumerable types of textures, which give each of my pieces a unique look. I can use elements to mimic bark, rotting wood, grass, weeds, roots, snow, mud, building ornamentation, endless varieties of rocks and boulders, and on and on. All this can be done using only black, white, and two greys.

While the bank of elements to choose from is vast, LEGO is still a finite system with its own set of rules engineered into each piece. Additionally, the rigid plastic generally does not bend. This stiff, prefab, one-step system comes at the cost of the precise detailing that an artist expects from wood, metal, or clay. However, what I enjoy about that constraint is the puzzlelike thinking that is needed to work out new solutions for detailing. It is enjoyable to coax and manipulate pieces together by using clever combinations. Other people are shocked to see well-combined elements come together in ways that do not seem possible, given the system's boundaries.

For me, this means transforming hard, plastic, mechanical forms into objects that seem impossibly organic and natural. I seek out the relatively few pieces that bend and use them to round out and give a flow to the elements with hard forms. In this way, my works tend to reach new realms of expression. For example, in *Victorian on Mud Heap*, I connected long, bendable hoses to the base and let them curve up toward the house, connecting at the porch. These hoses then served as the skeleton that I built "mud" on top of. While the mud looked like it was made with a large pile of LEGO elements haphazardly spilled on each other, in reality, it was a thin layer of connecting LEGO elements propped up on hose scaffolding.

I enjoy turning this simple, familiar toy into expressive works of art. There is a shock of seeing this toy, so familiar to most, executed on such a serious level. The puzzlelike challenge of overcoming a strict, rule-based system to create works of beauty and meaning is especially attractive to me and always keeps me coming back for more.

Three Story Victorian with Tree 2011

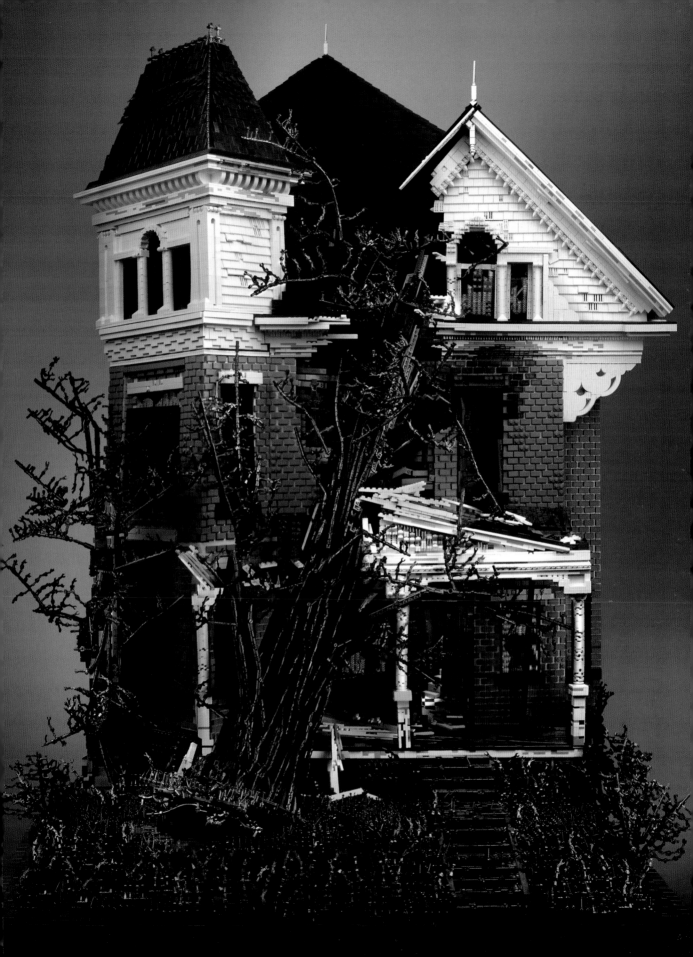

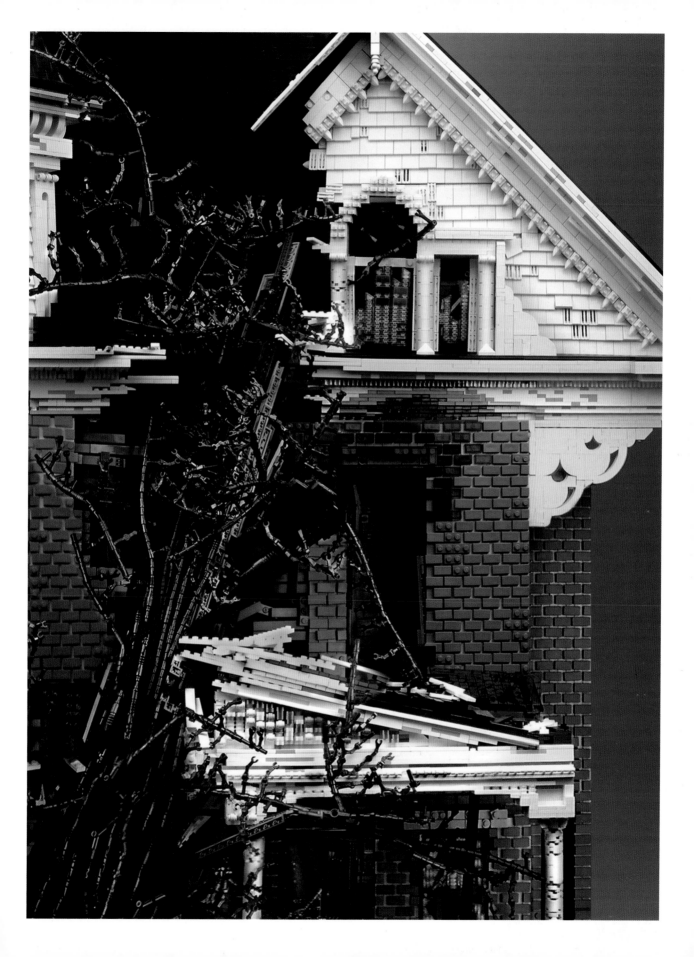

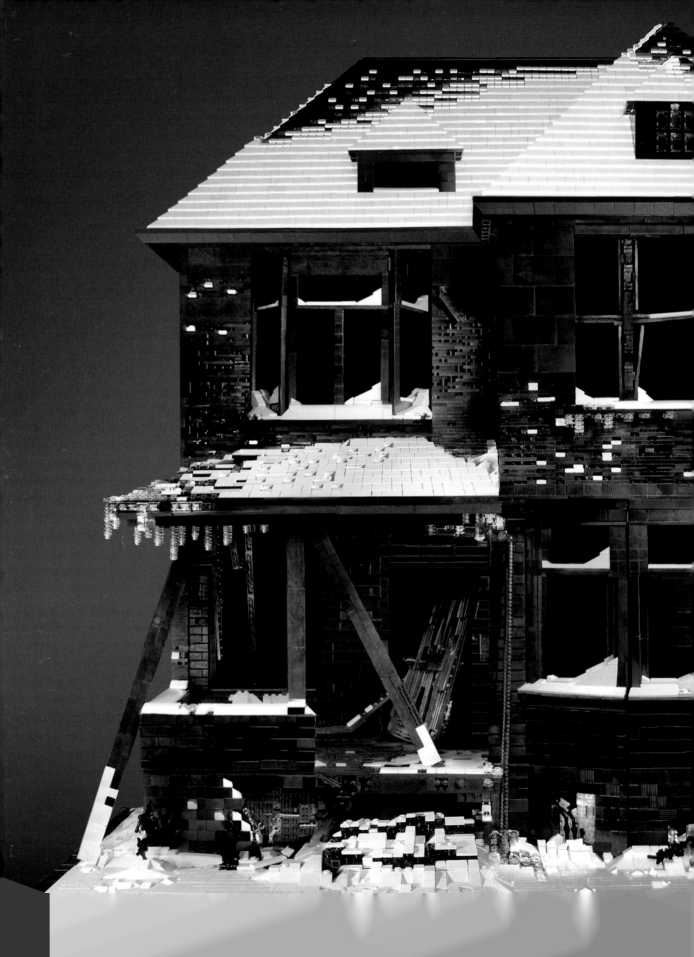

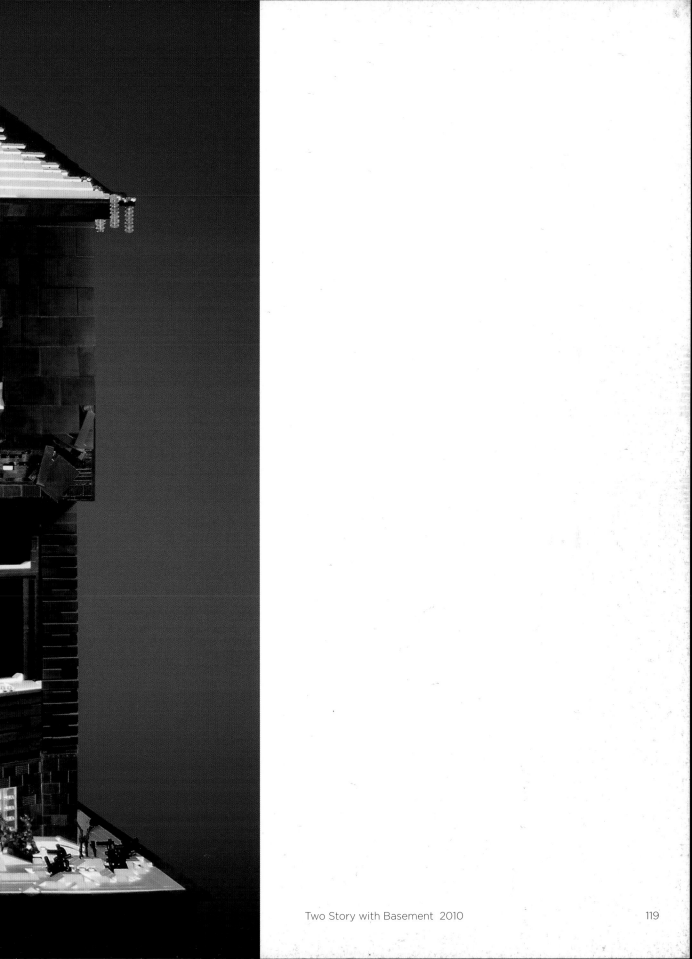

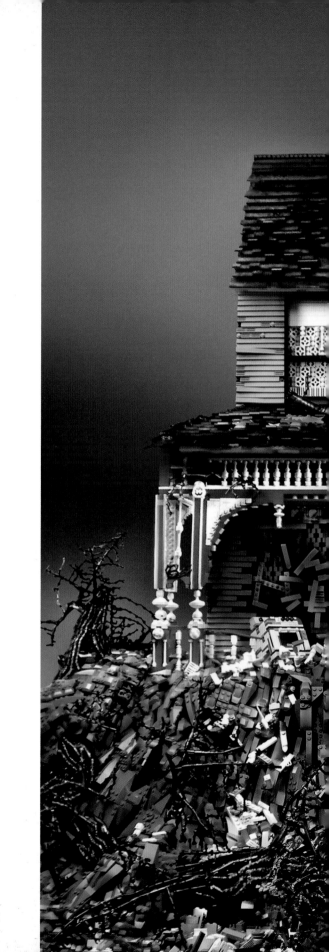

Victorian on Mud Heap 2011

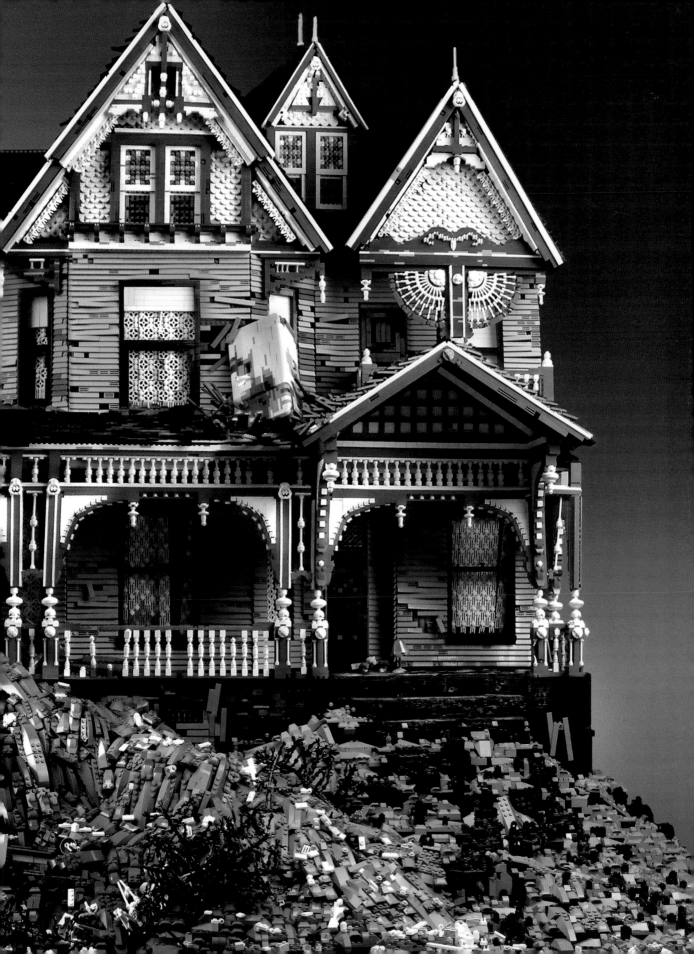

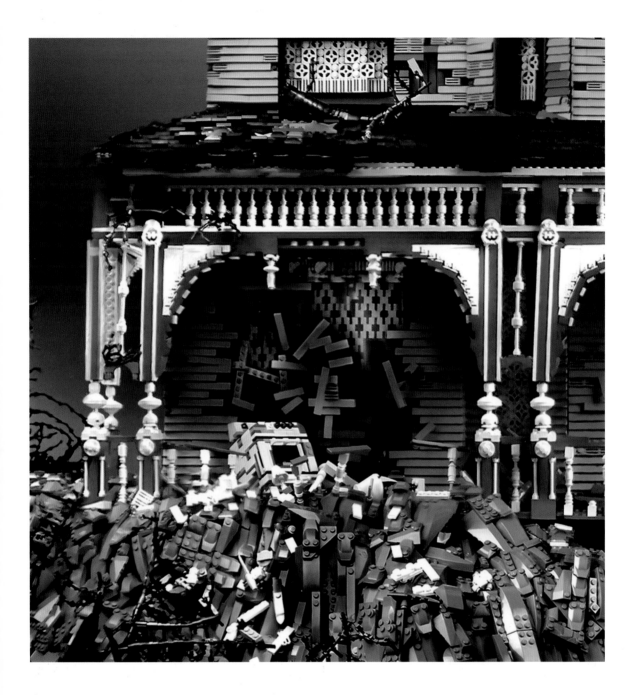

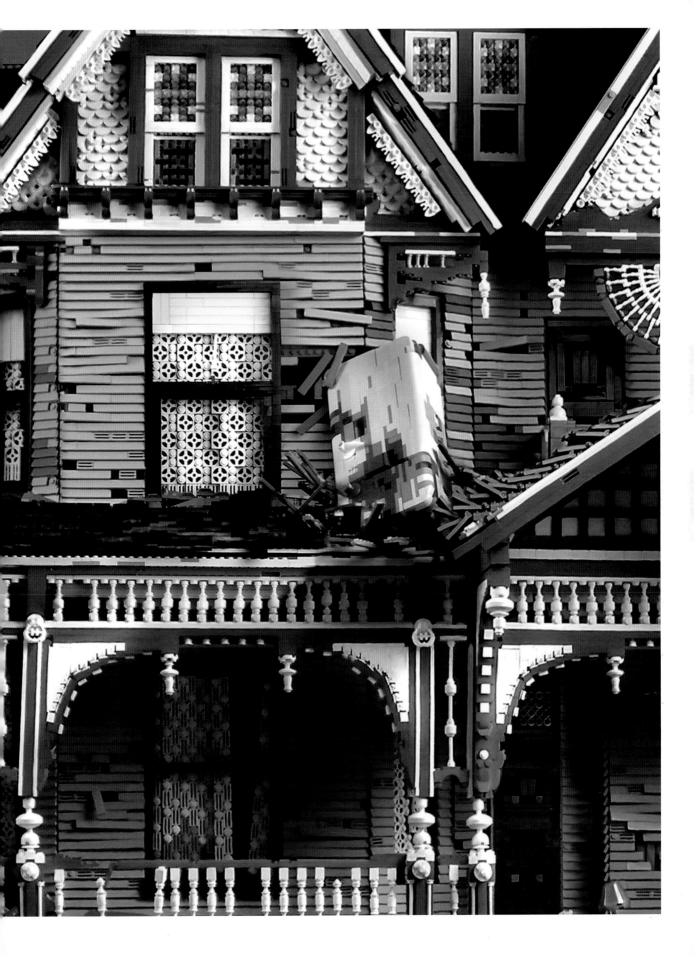

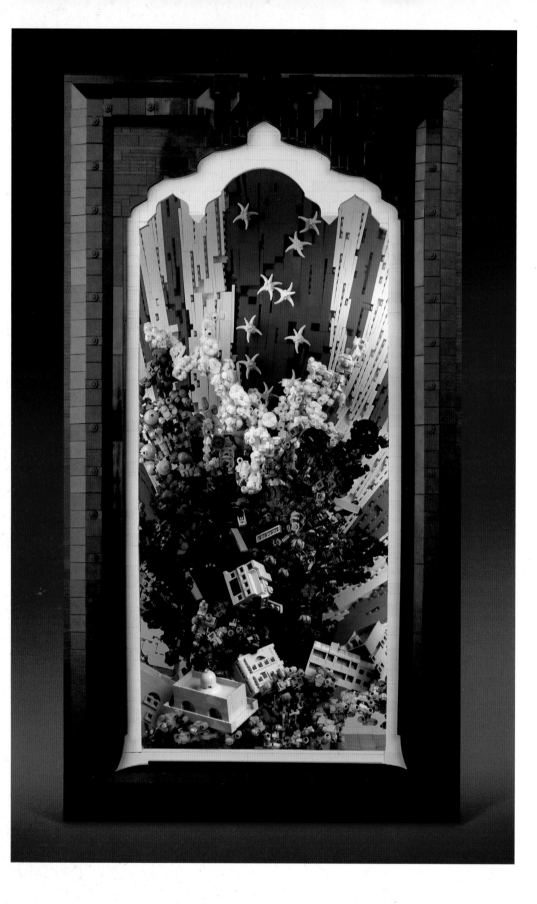

The Power of Freedom: Iraq 2012

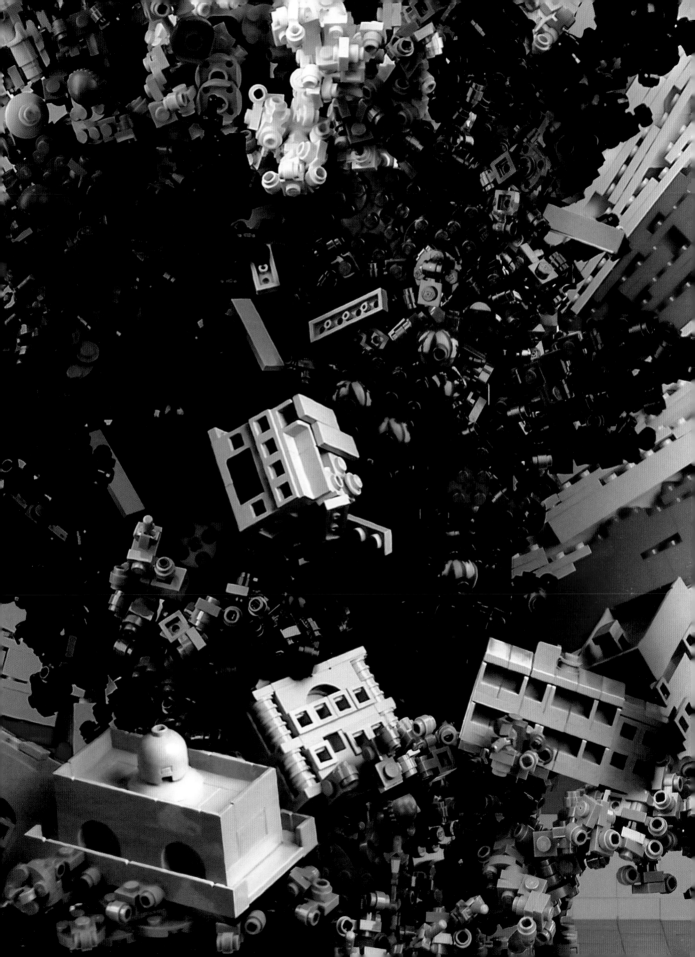

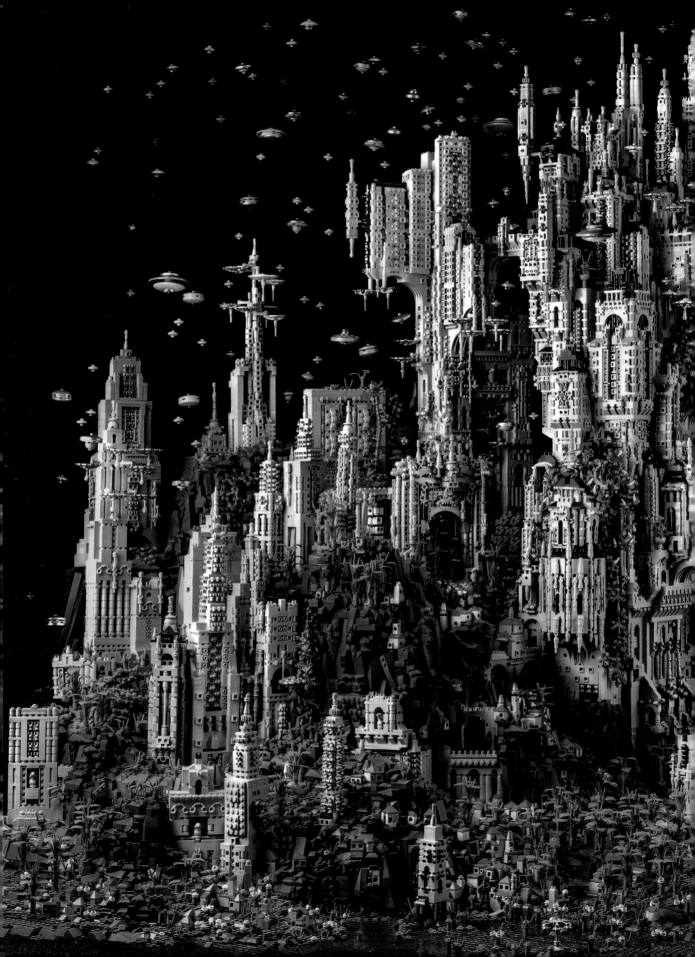

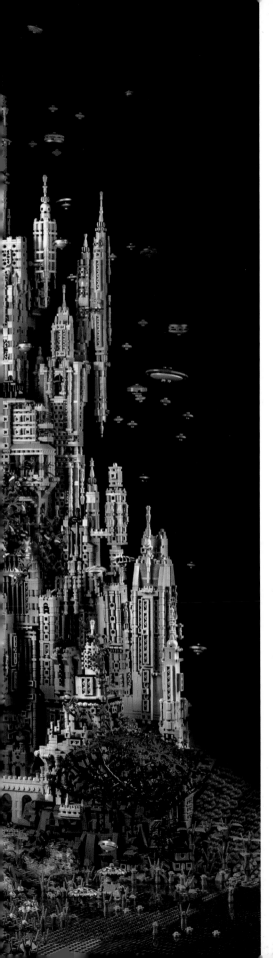

Contact 1: The Millennial Celebration
of the Eternal Choir at K'al Yne, Odan 2013

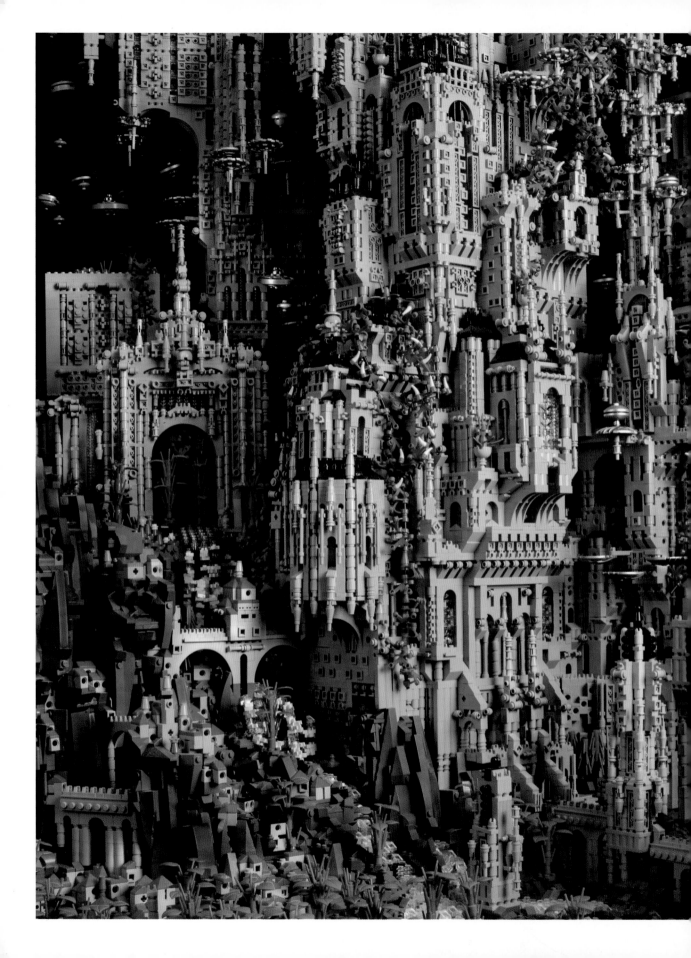

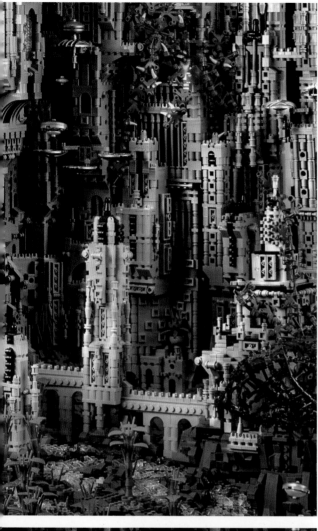

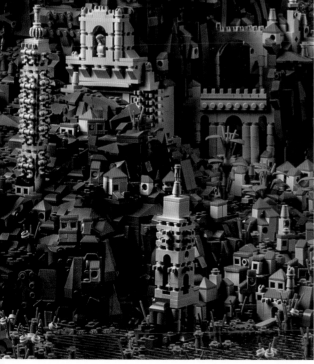

Urban Planning

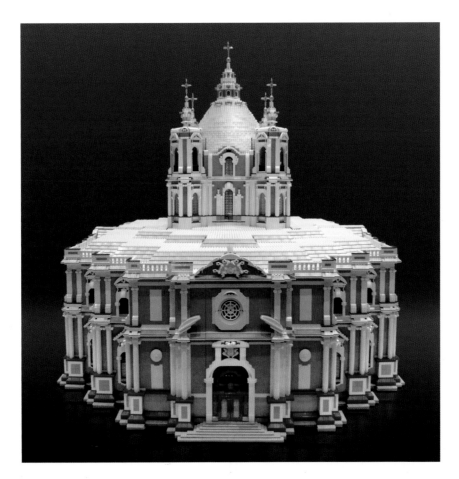

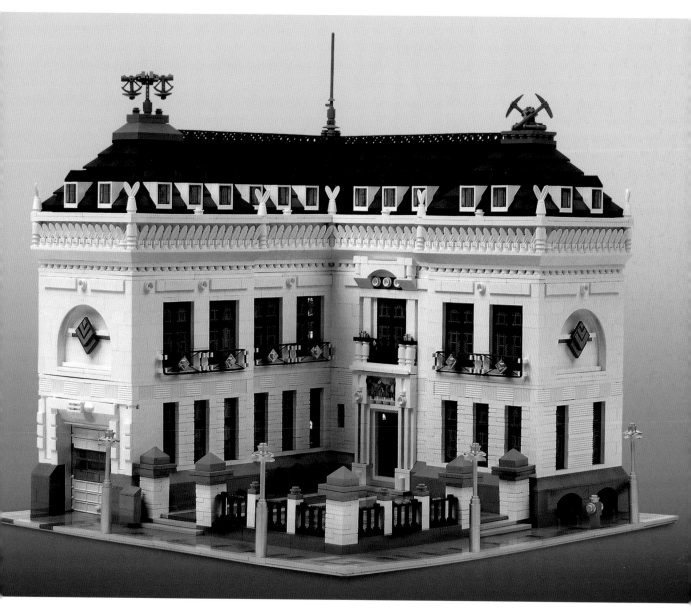

(opposite)
Heath Flor
Smolny Cathedral 2012

(above)
Jasper Joppe Geers
Muntstraat Police HQ 2011

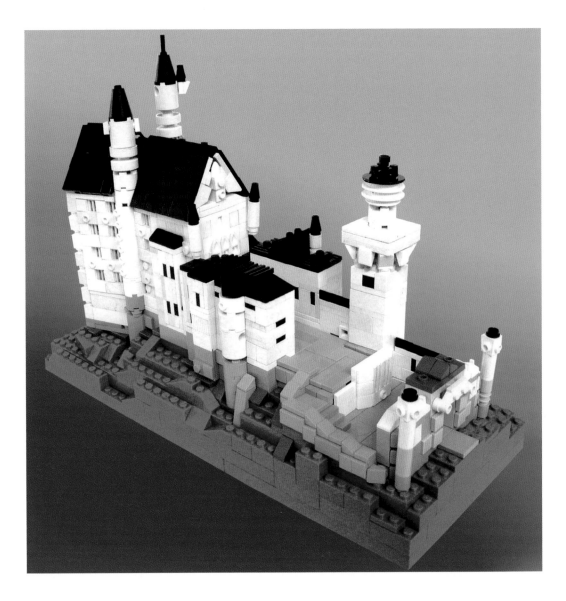

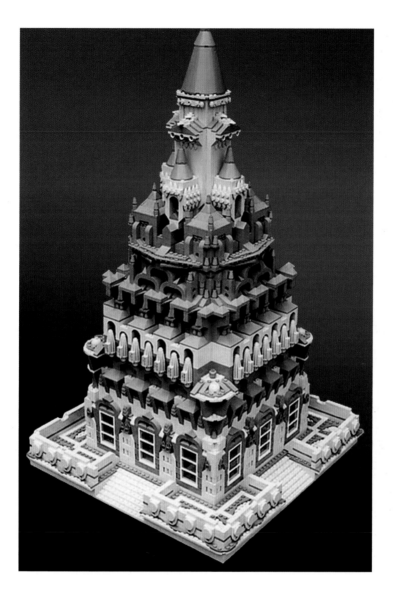

(opposite)
Sven Junga
Schloss Neuschwanstein 2010

(above)
Pete White
Sandcastle 2010

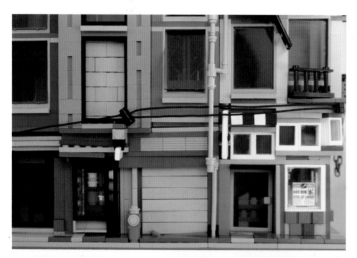

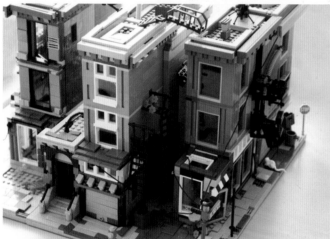

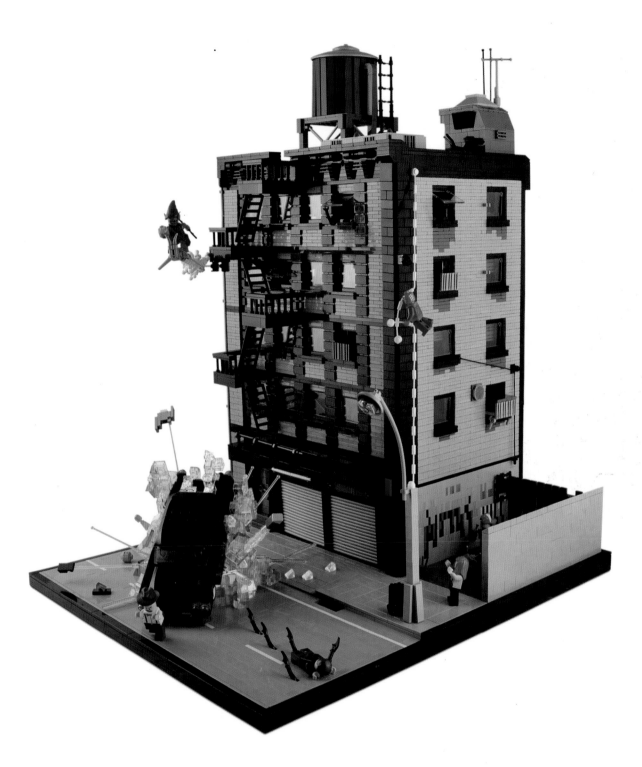

Alvin Tseng
(opposite top) Downtown 3 2009
(opposite bottom) Downtown 1 2008

Thorsten Bonsch
(above) Spider-Man vs. Green Goblin - A Tribute to Frank Dillane 2012

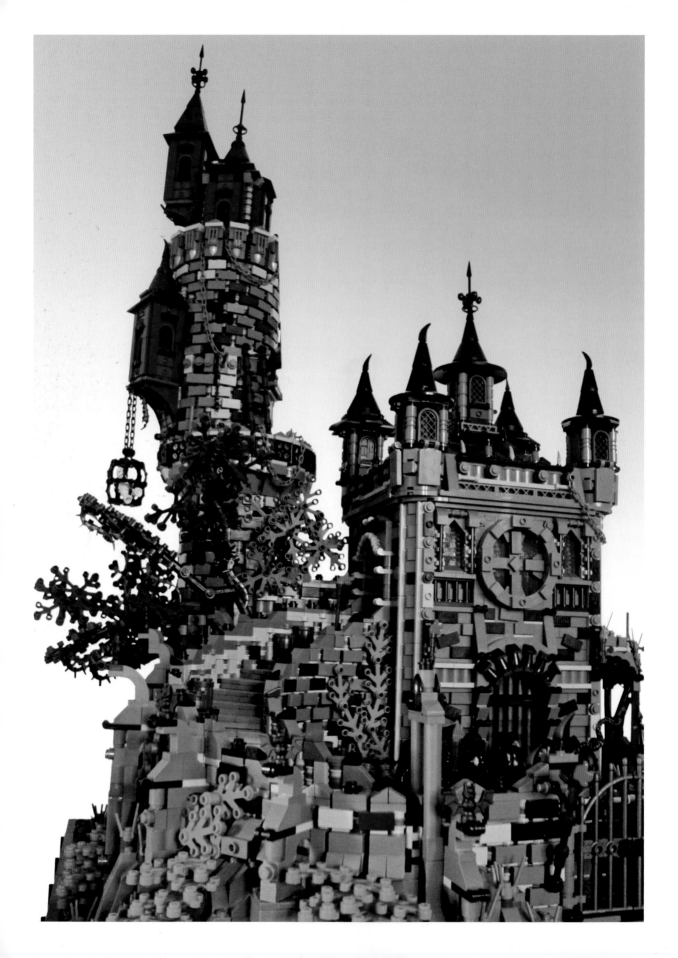

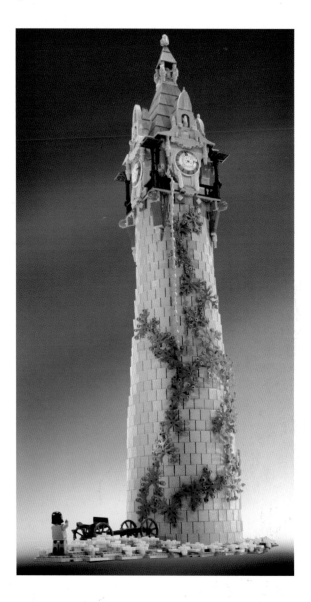

(opposite)
Luke Hutchinson
Sanctuary of the Damned 2012

(above)
Jordan Schwartz
Rapunzel's Tower 2010

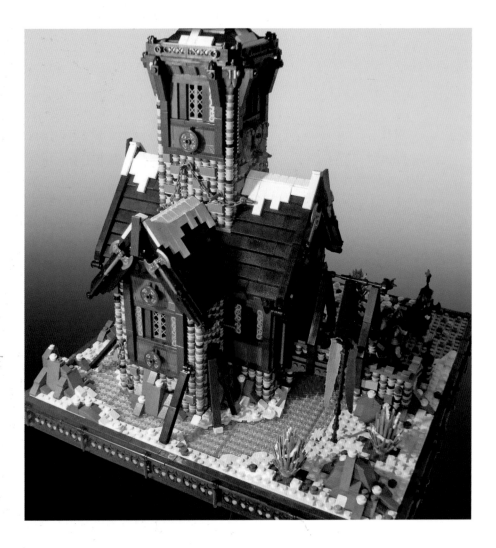

Luke Hutchinson

(above) Lindinis Uarro 2012
(opposite) Leodasham Manor 2012

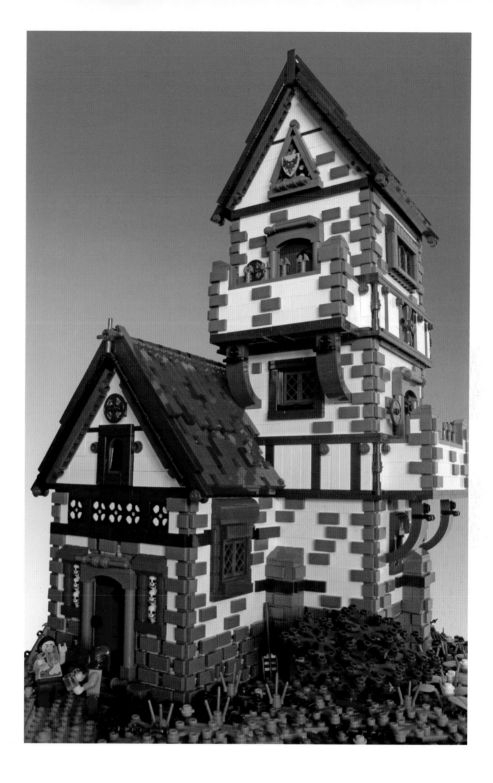

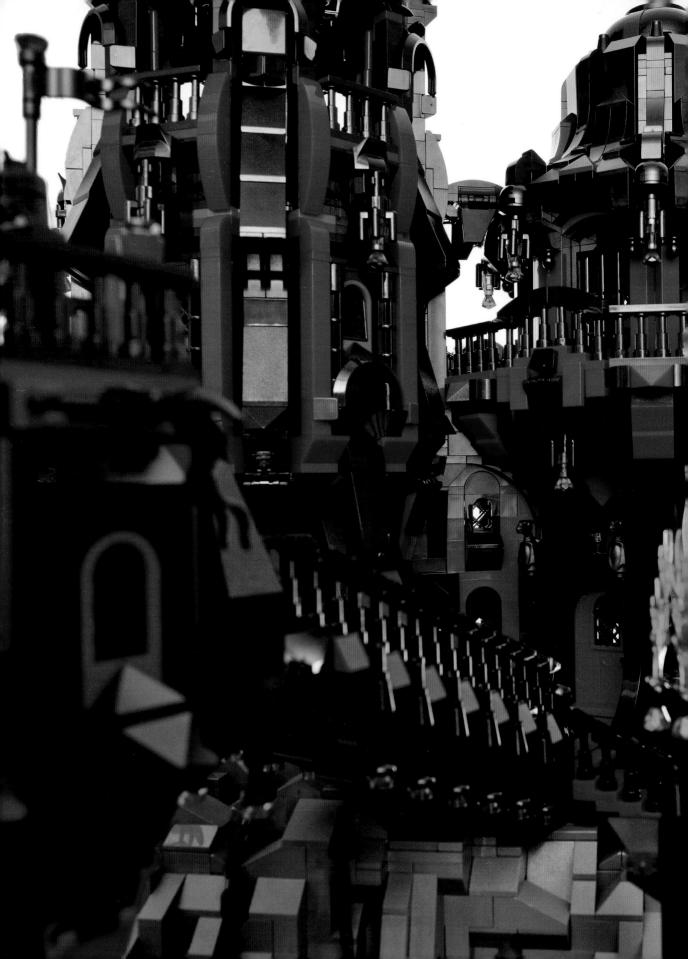

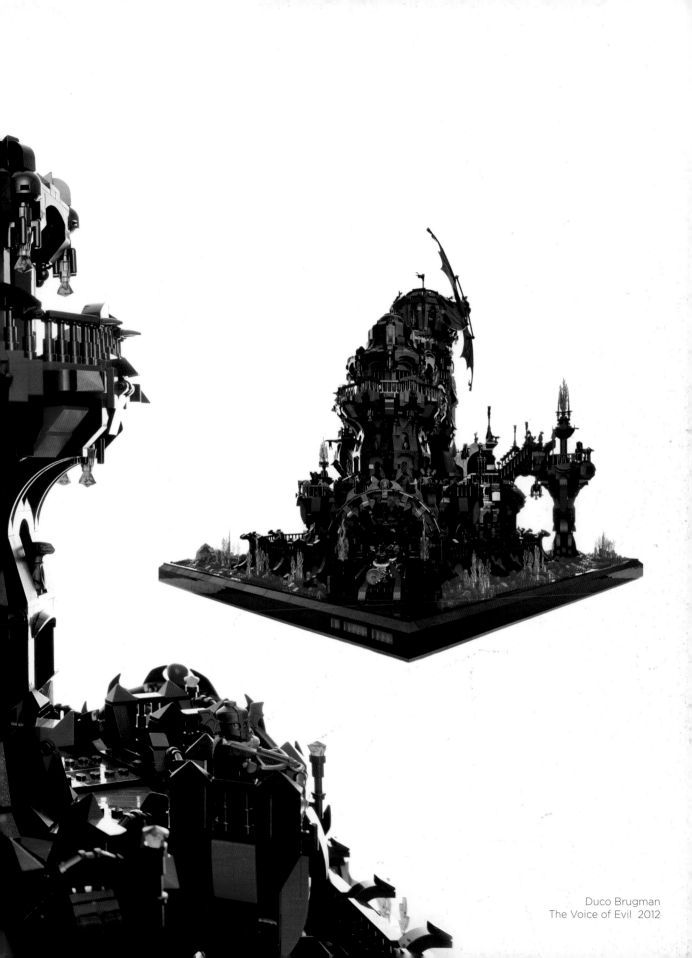

Duco Brugman
The Voice of Evil 2012

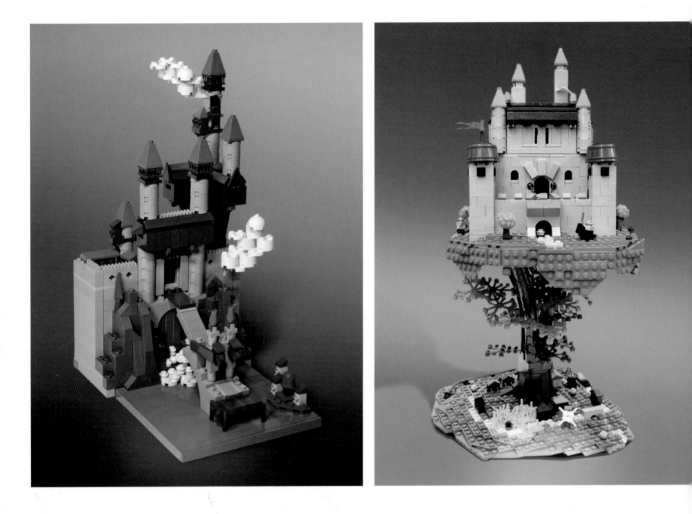

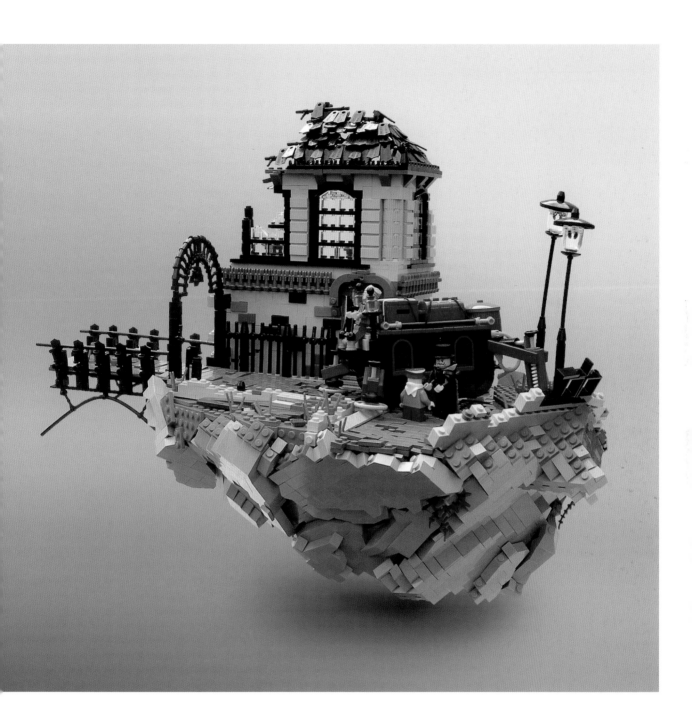

Sean and Steph Mayo
(opposite left) Micro Falls Fortress 2011

Barney Main
(oppposite right) The Castle in the Canopy 2009
(above) The Last Evacuee 2012

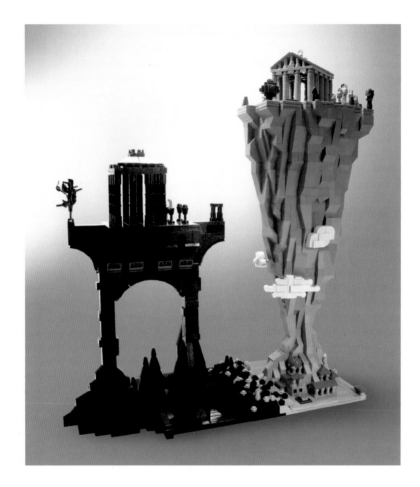

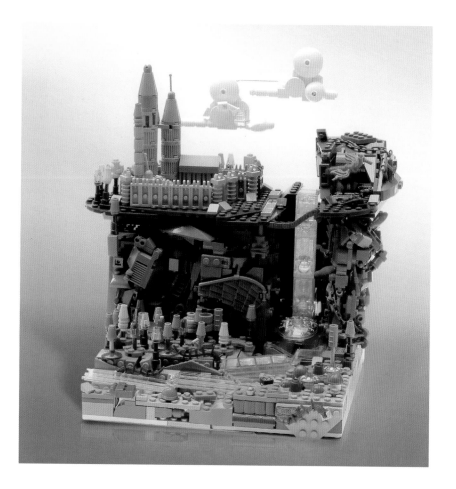

(opposite)
Lukasz Wiktorowicz
Tartarus 2011

(above)
Carson Hart
Welcome to Aedificus 2012

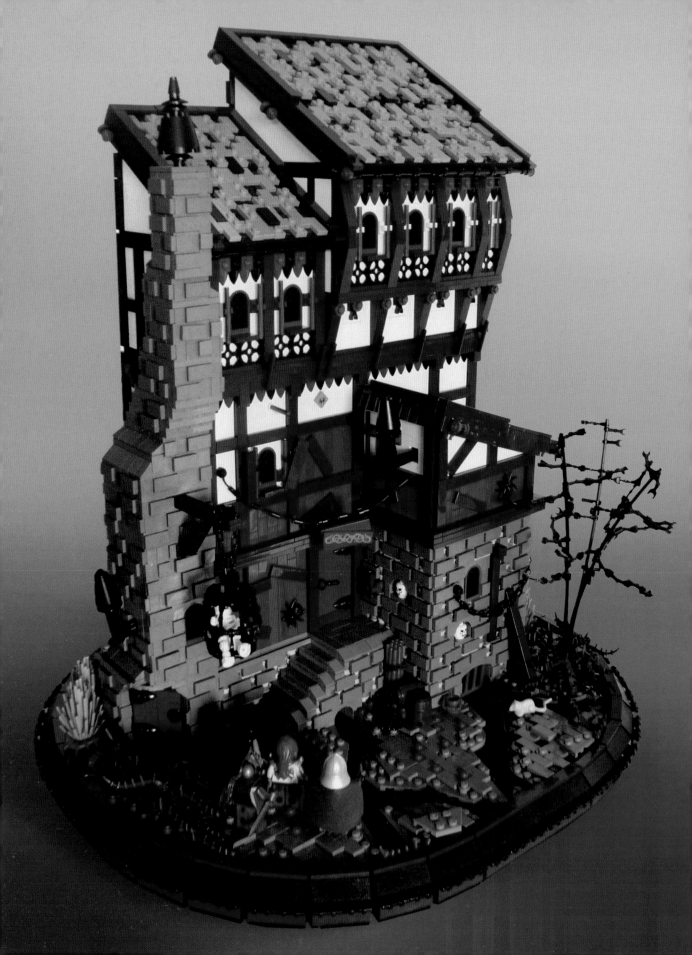

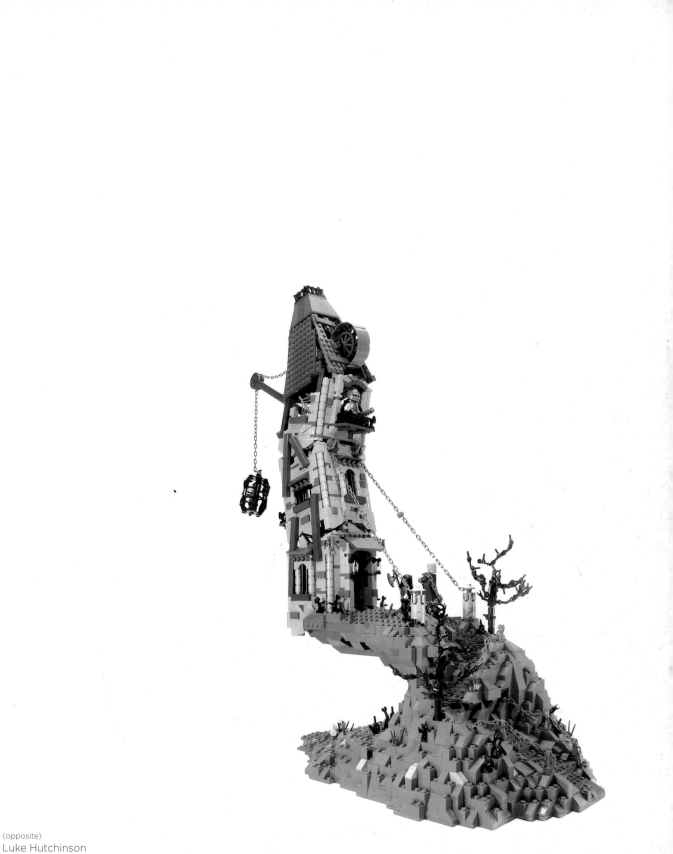

(opposite)
Luke Hutchinson
Grimm Hollow 2012

(above)
Tyler Clites
Tower of Torment 2008

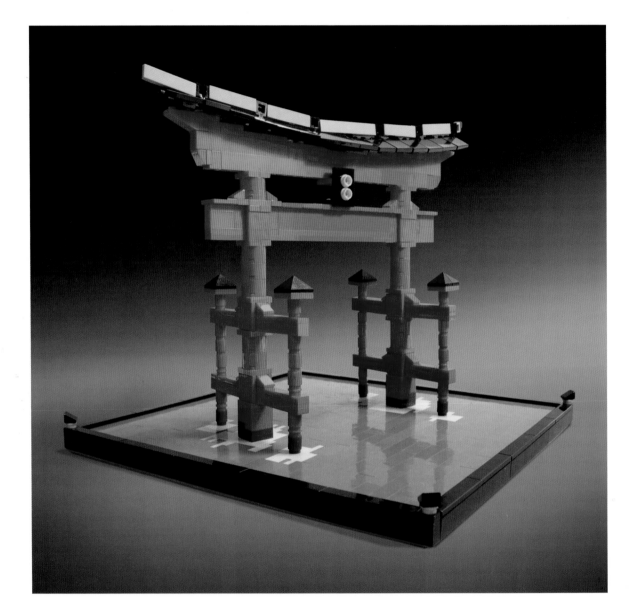

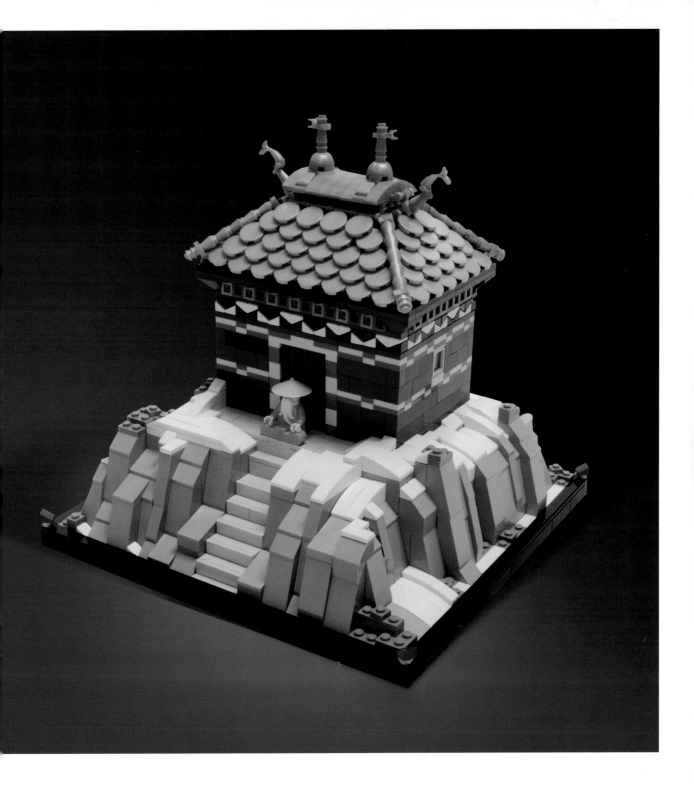

Matija Grguric

(opposite) Miyajima Torii 2011
(above) Tibet 2011

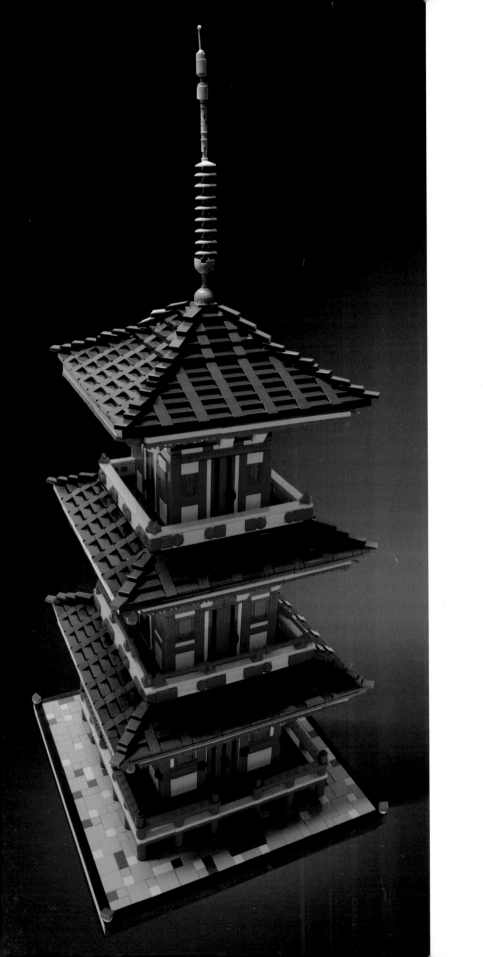

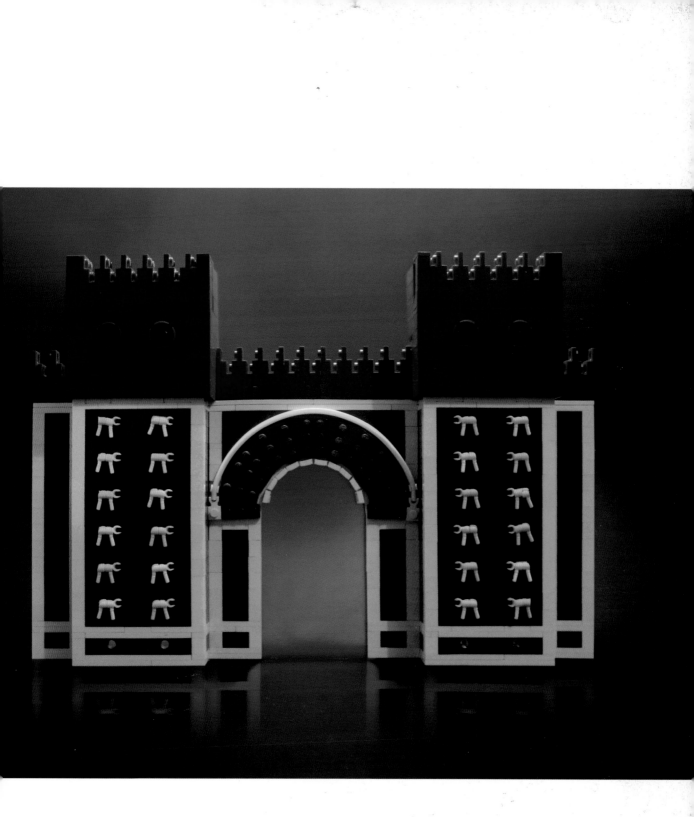

(opposite)
Matija Grguric
Japanese Pagoda 2011

(above)
Lukasz Wiktorowicz
Ishtar Gate 2012

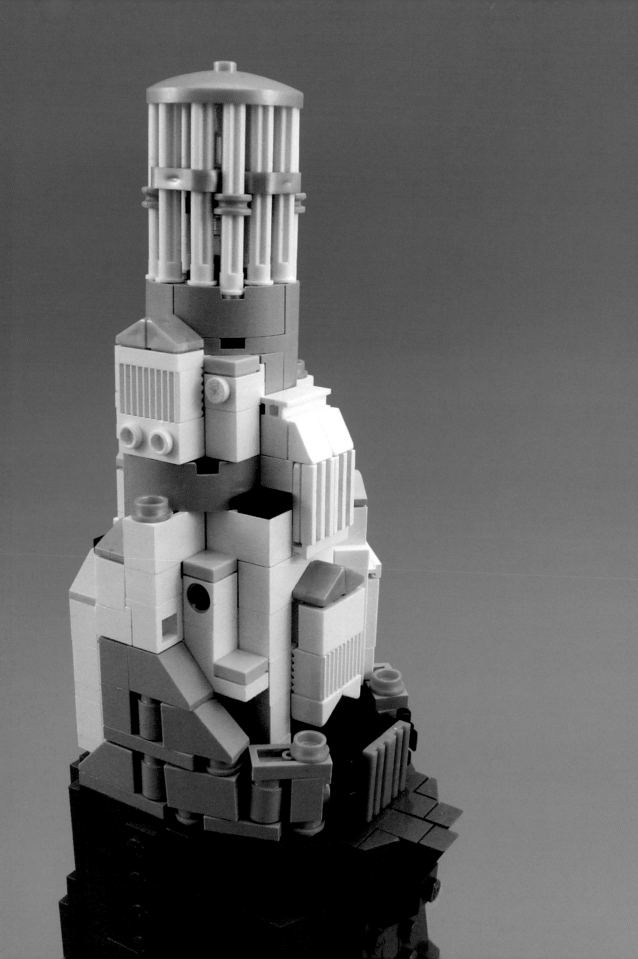

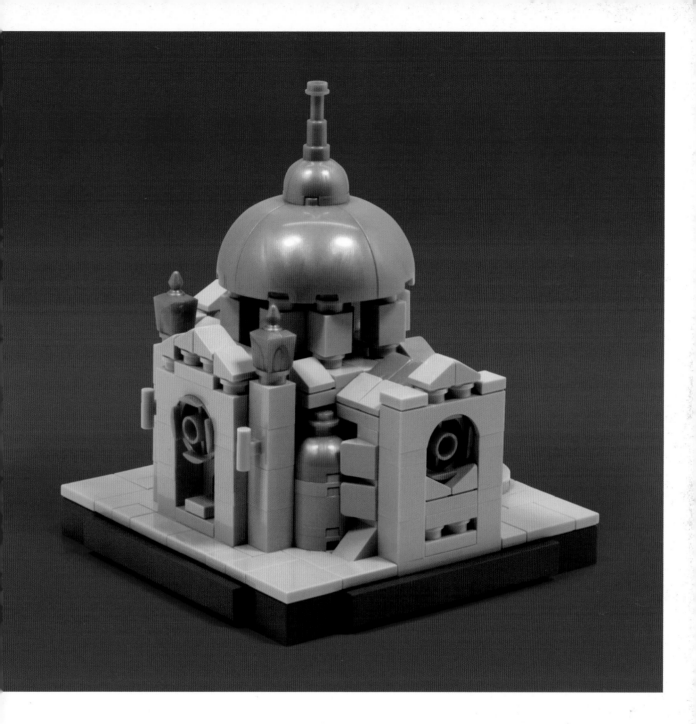

(opposite)
Peter Anderson
Olympus 2010

(above)
Stacy Sterling
St. Paul Cathedral 2011

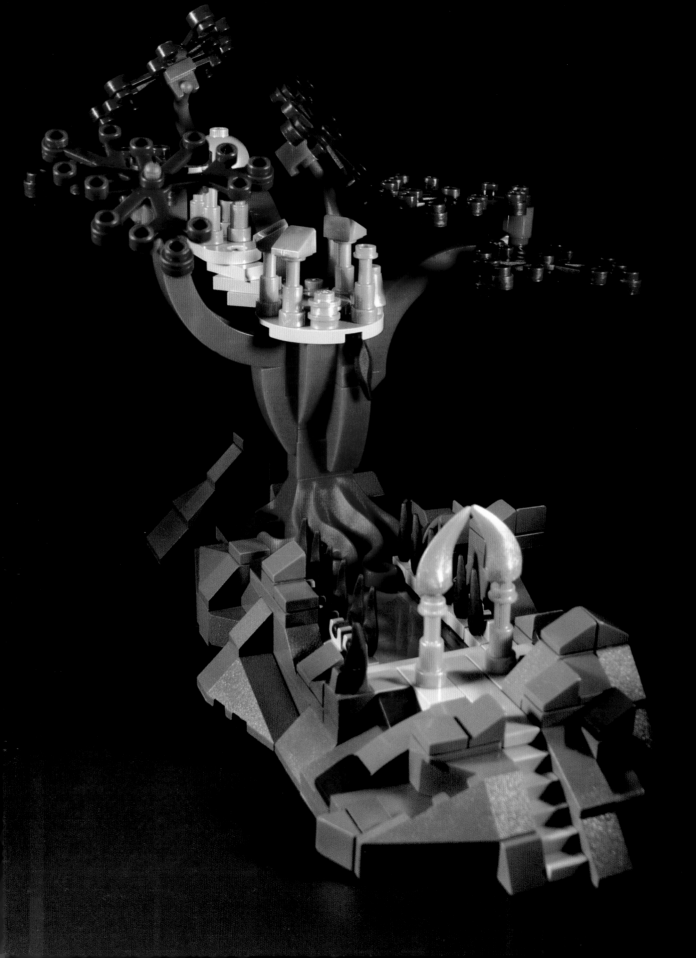

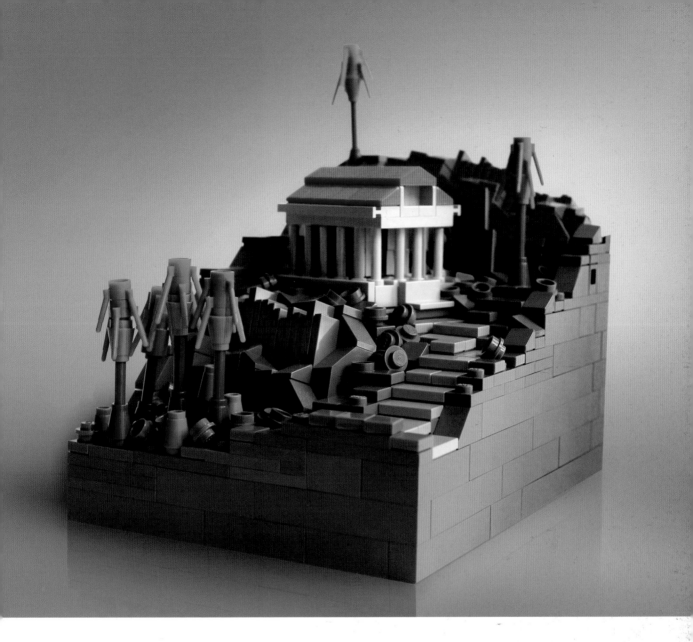

(opposite)
Chris Malloy
The Temple of Ehlonna 2012

(above)
James Pegrum
Temple of Jugatinus 2012

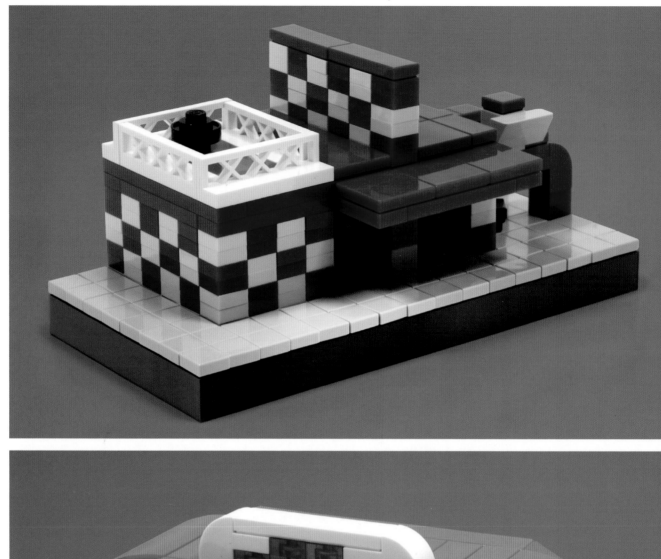

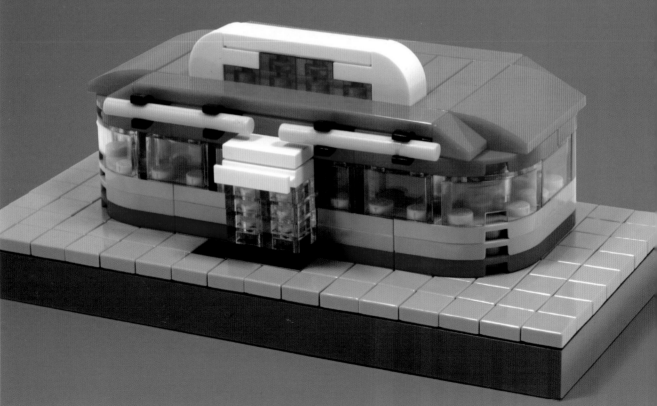

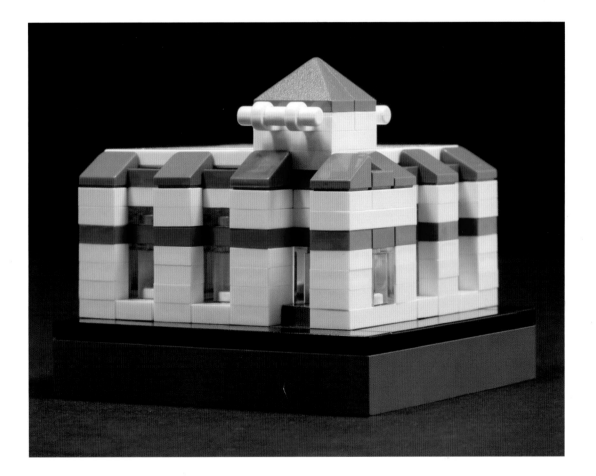

Stacy Sterling

(opposite top) Porky's Diner 2011
(opposite bottom) Mickey's Dining Car 2011
(above) White Castle Restaurant 2011

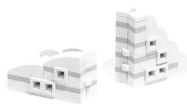

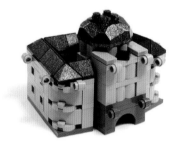
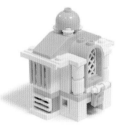
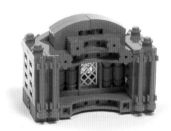

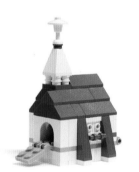
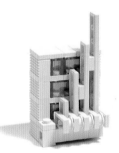
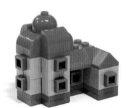

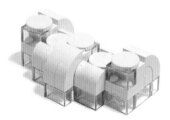
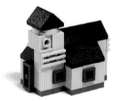
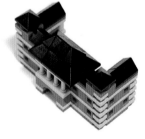

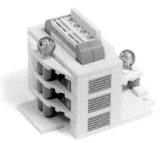
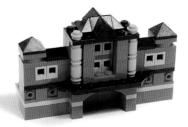
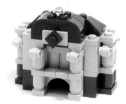

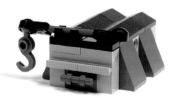
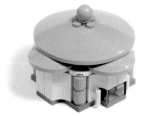

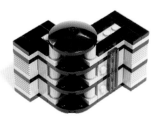
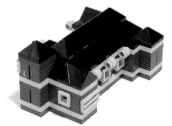
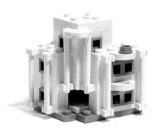

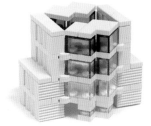

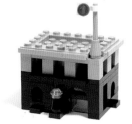

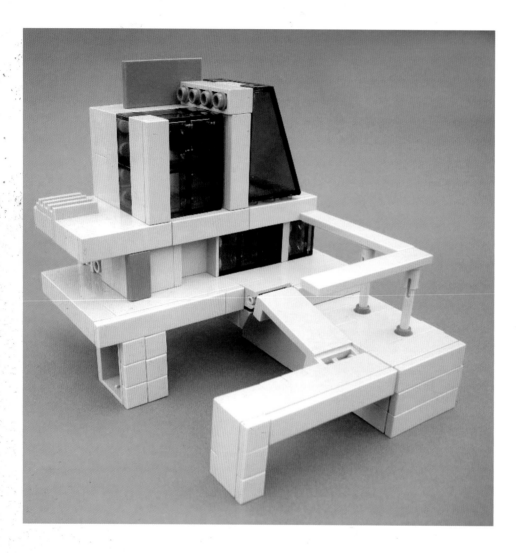

(above)
Shannon Sproule
"Kestrel" Seaside Living 2010

(opposite)
J. Spencer Rezkalla
World Trade Center & 9/11 Memorial, New York 2012

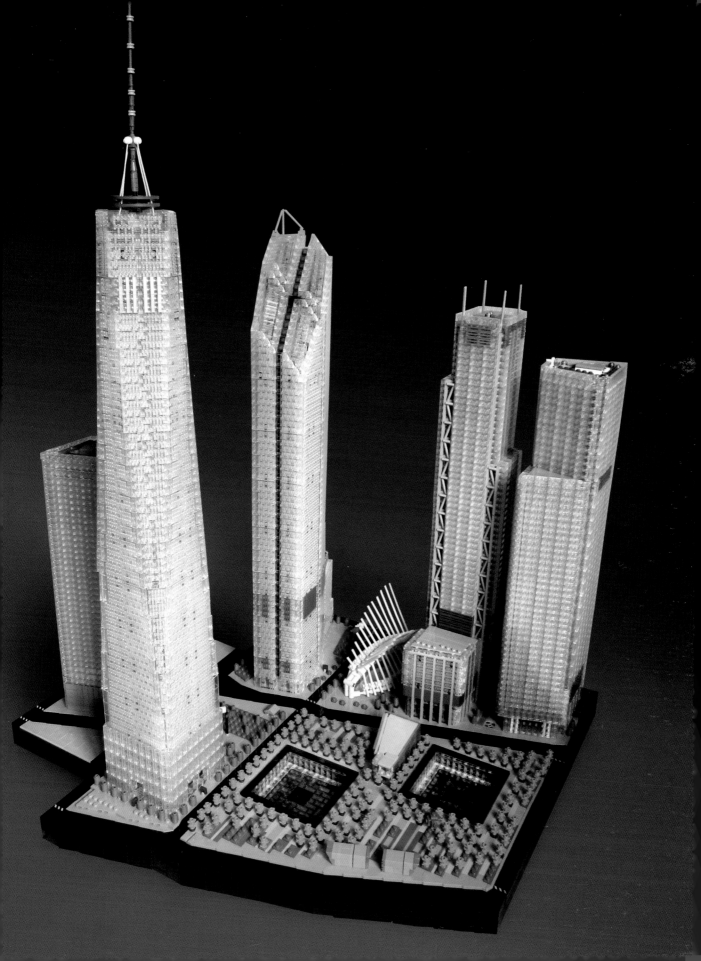

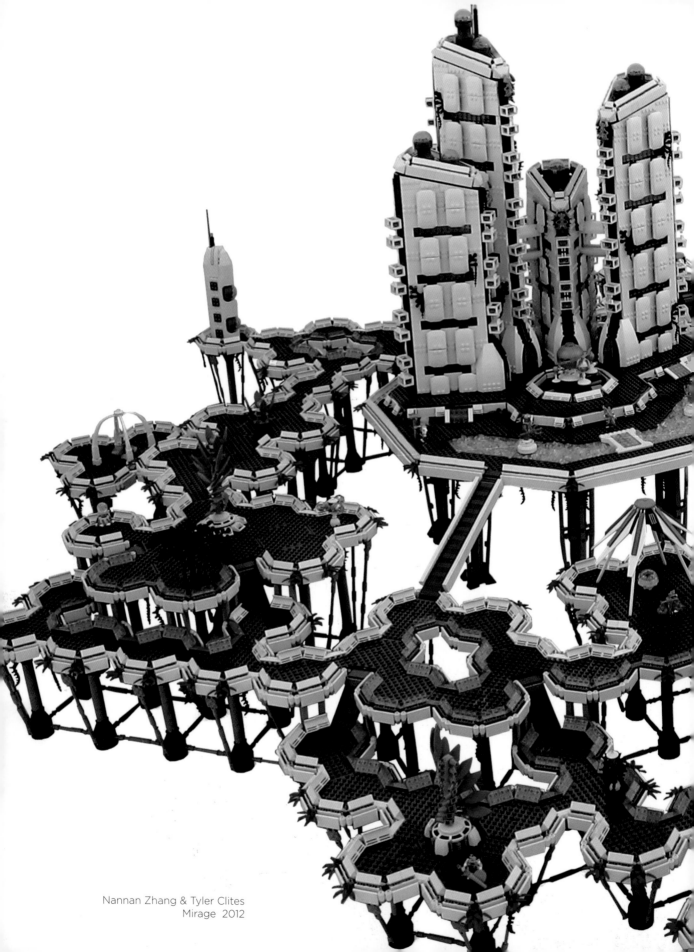

Nannan Zhang & Tyler Clites
Mirage 2012

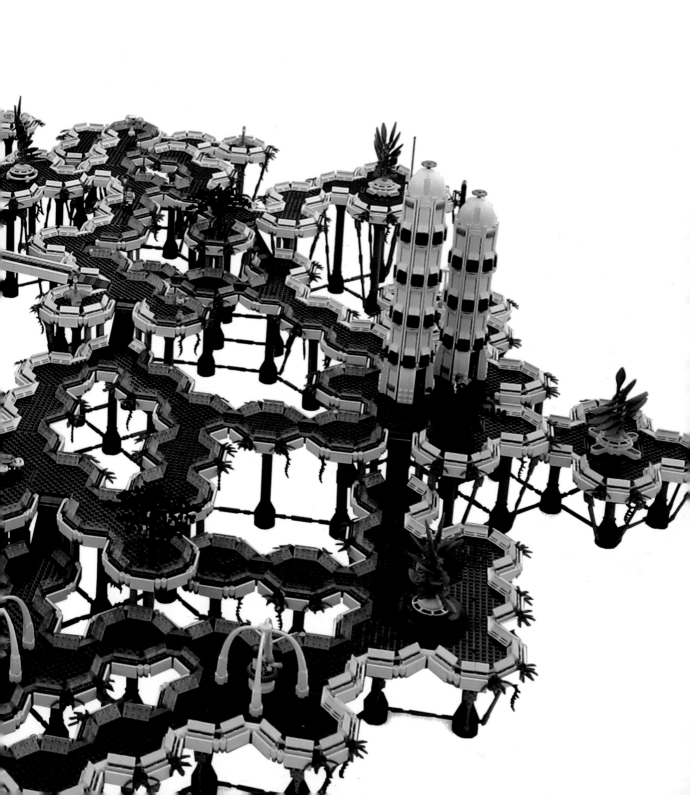

Nannan Zhang

Why LEGO? Like many people, I enjoyed LEGO when I was young, but at the age when others began to grow out of it, I discovered the online LEGO community—and, for the first time, I saw the works of adult fans. I was blown away by their complex and large models. I couldn't believe what I saw. I knew for sure that I wanted to build creations that would one day inspire others.

Part of LEGO's appeal is its dual aspect as an expressive and a technical medium. You can create anything with your imagination, but it also takes skill to work with the varied yet very specific selection of parts. The process of building is like making art while simultaneously solving a puzzle, with the satisfaction of doing both.

Cry of Dreams 2007

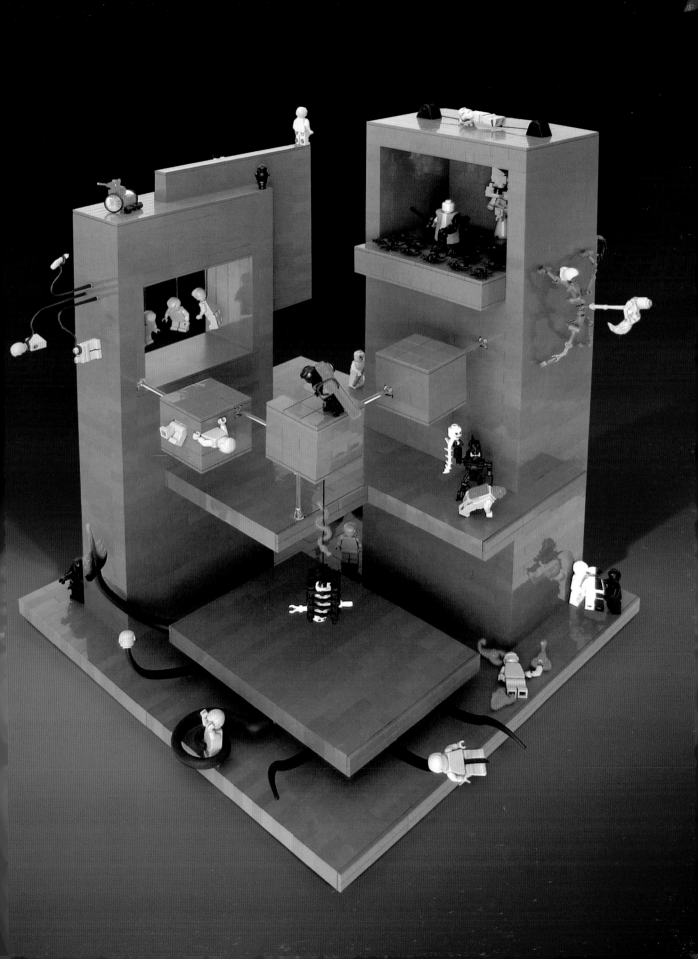

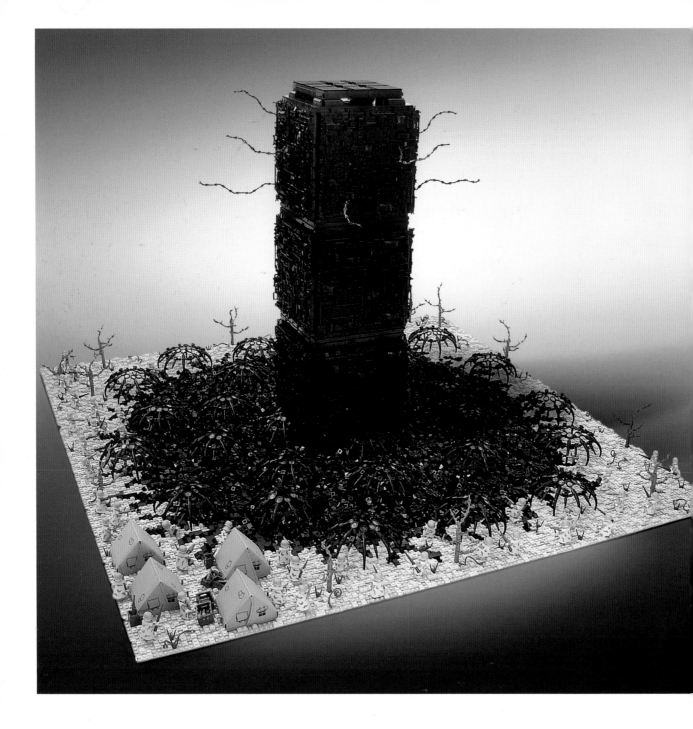

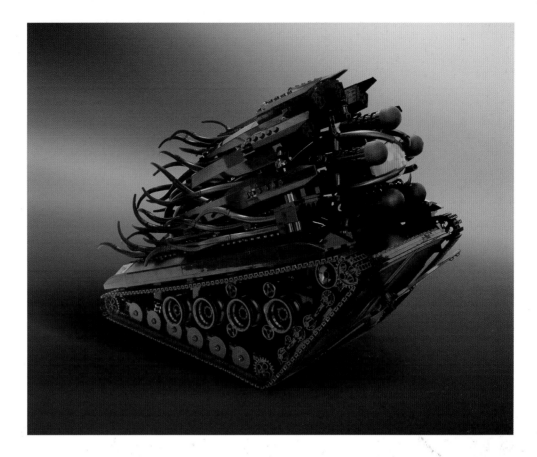

(opposite) End of Days 2008 (above) Armageddon 2007

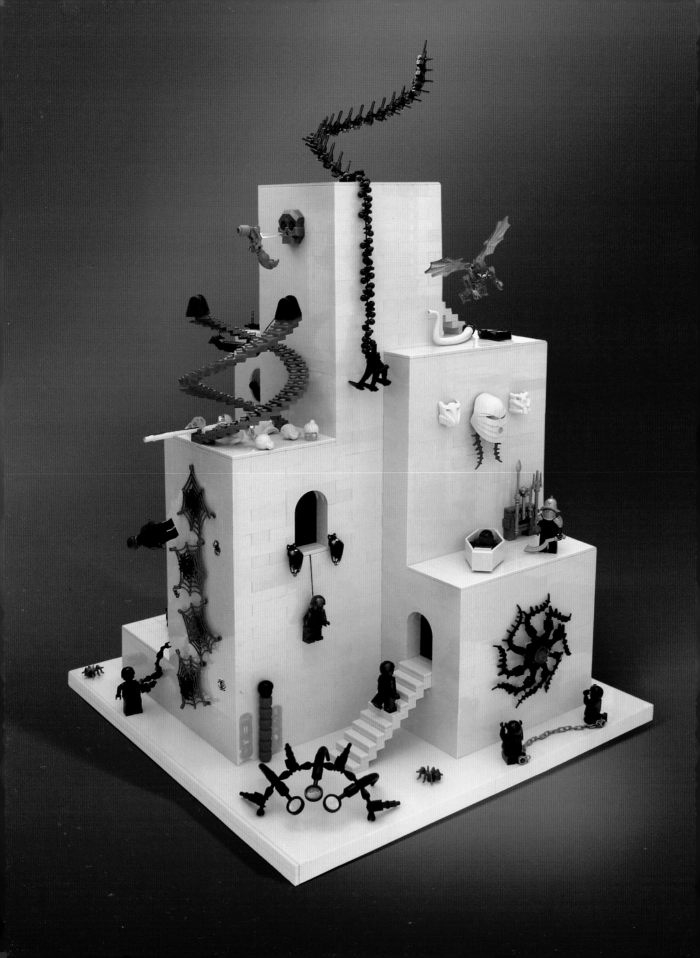

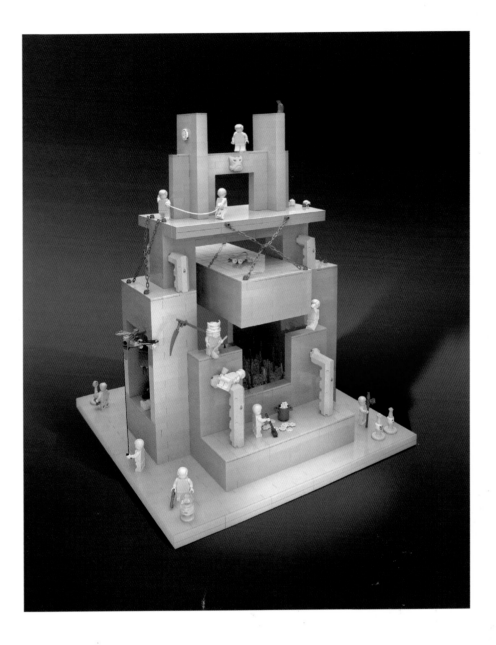

(opposite) Legacy of Vision 2008 (above) Echo of Silence 2009

Mosaics
by Katie Walker

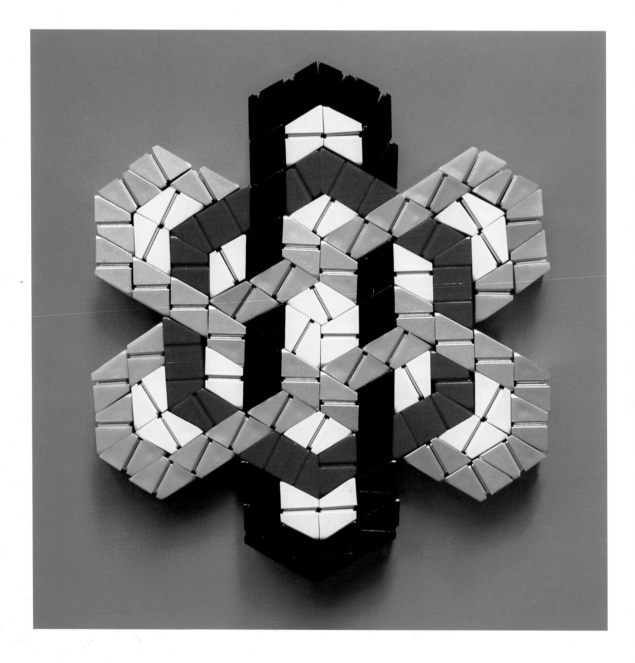

(above) Knotty Doodle 3 2011 (opposite) Flower Petal Study 2012

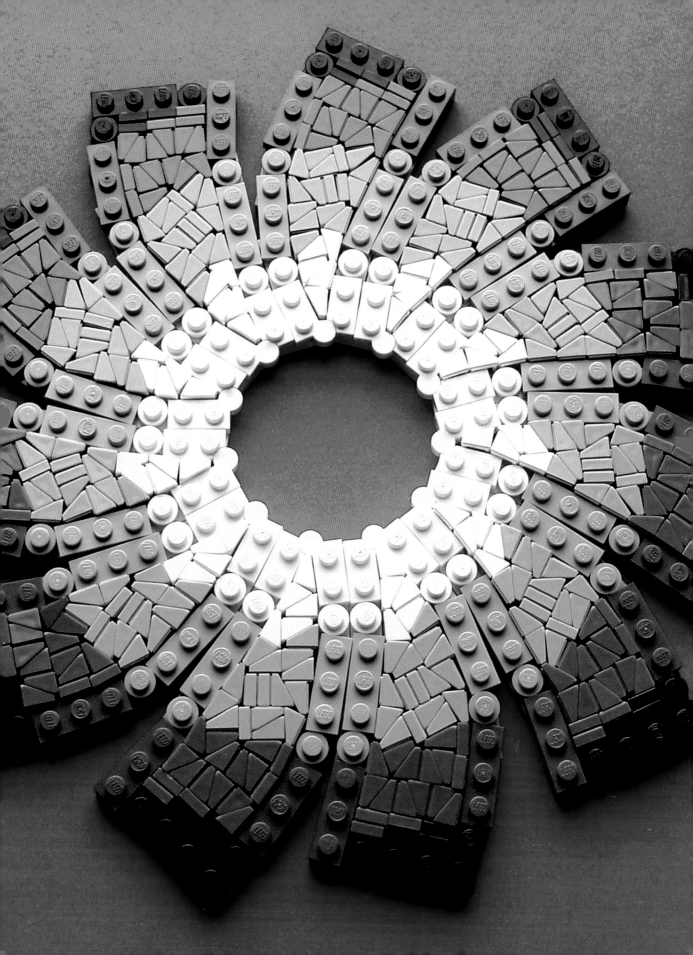

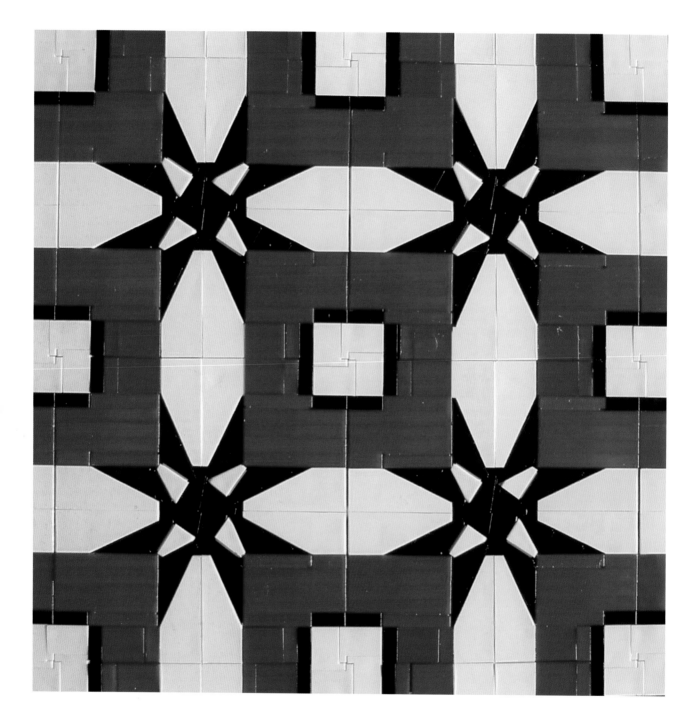

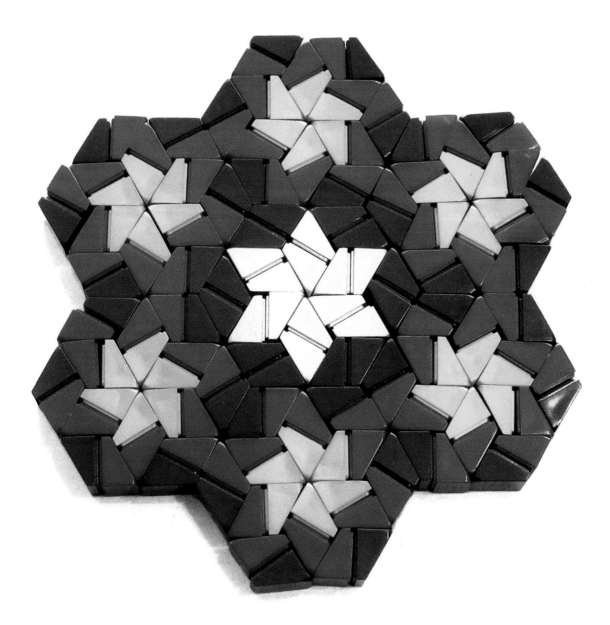

(opposite) Color Variation 1 2010 (above) Practicing Some More 2011

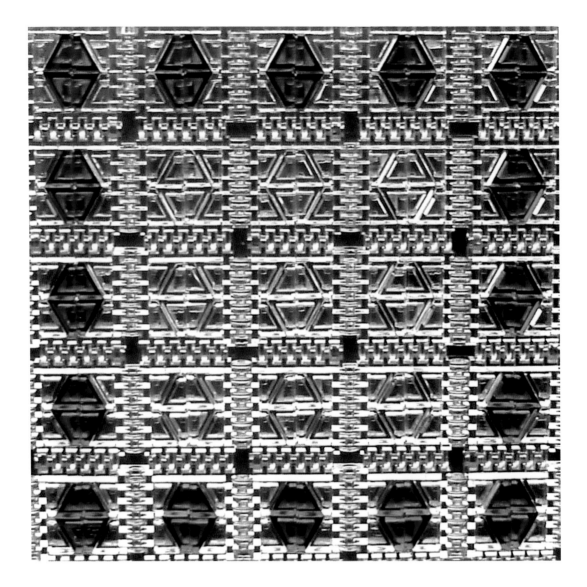

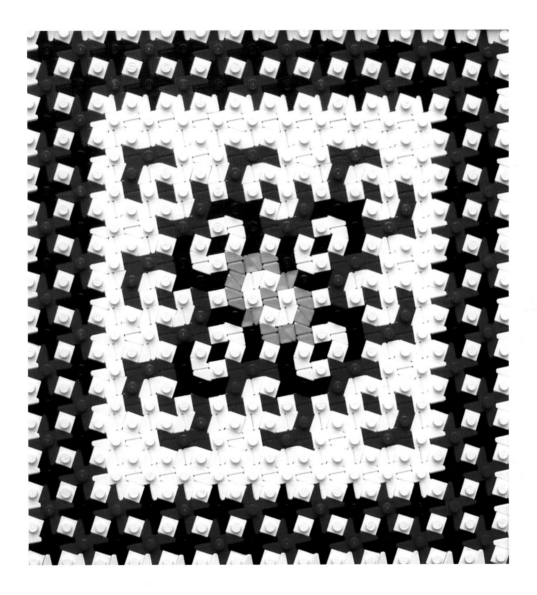

(opposite) 12.13.10 004 (Window) 2010 (above) The Prettiest Picture 2011

On the Road

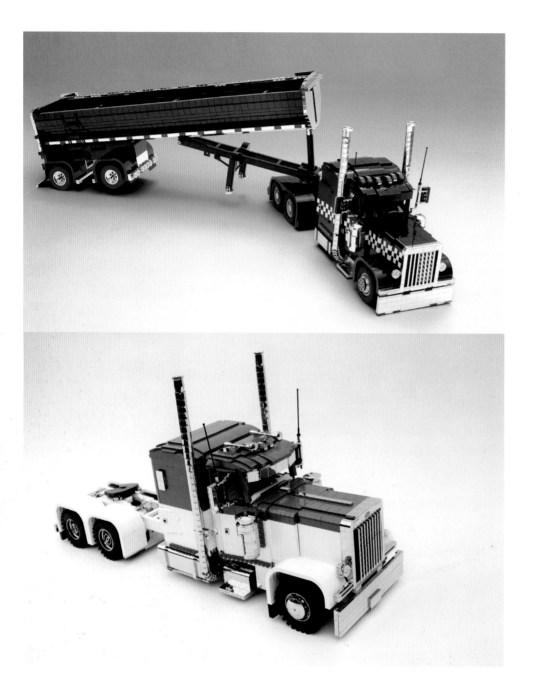

Dennis Glaasker

(top) Peterbilt 379 Dump Combo 2012
(bottom) Peterbilt 379 2012
(opposite top) Harley Davidsons 2011
(opposite bottom) Harley Davidson (detail) 2011

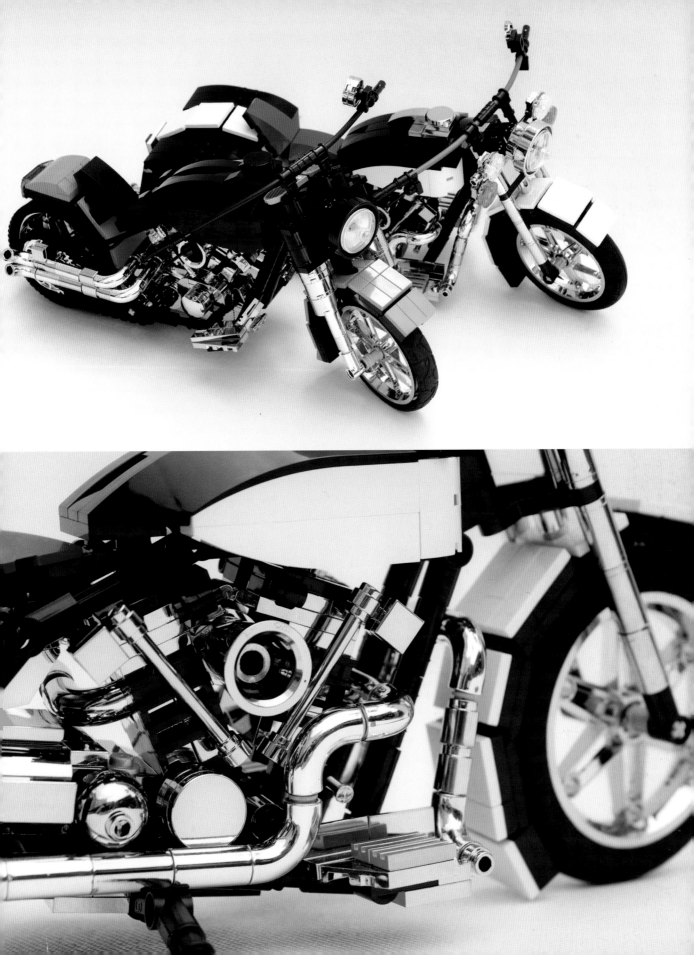

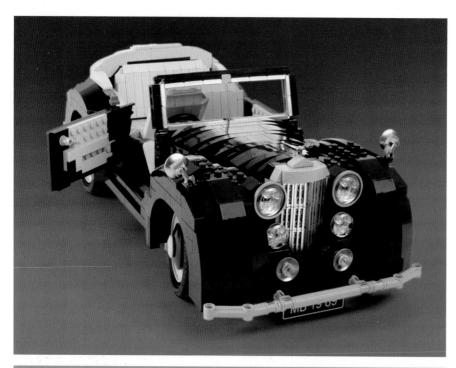

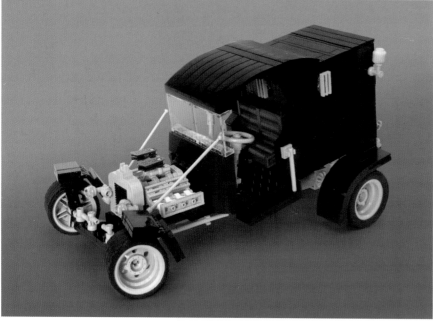

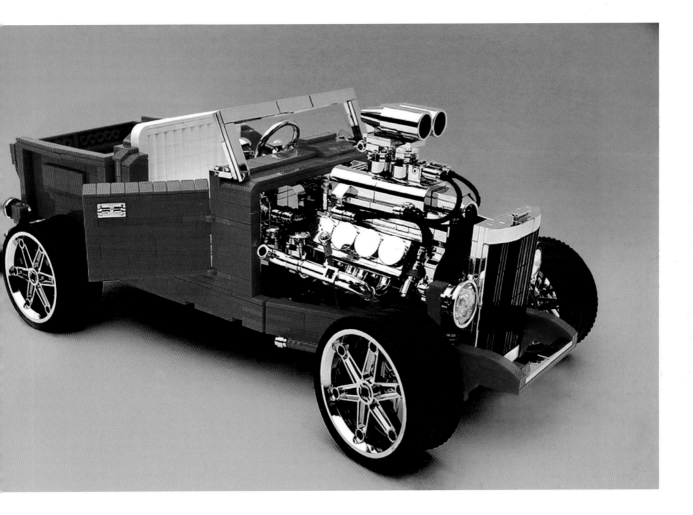

(opposite top)
Marcos Bessa
Alvis TA28 2011

(opposite bottom)
Nathan Proudlove
Paddy Wagon 2009

(above)
Dennis Glaasker
Ford Hot Rod 2012

Lino Martins

Why LEGO? If you ask a mountain climber why he summited Everest, you may get something along the lines of "because it was there" or "it's just what I do." While I could give a similarly circular answer, for me, the impulse to build goes deeper. My desire to work with LEGO started with traditional plastic model kit building. What attracted me to model building in the first place was the level of detail you can obtain with a little paint and glue and a lot of patience. After painstakingly following the directions on a couple model kits, I learned that you can "kit-bash" your own creations: By veering from the directions, you can create something entirely new. For example, you might combine a model car kit with the stickers for a model plane to create your own military-inspired hot rod. But model building was time-consuming and limiting. While you could in theory turn an aircraft carrier into an amazing sci-fi starship, this took time, skill, and resources beyond the means of most kids, including me.

I was drawn to model building because I was drawn to all things creative. I was a quiet and smaller-than-average child and therefore not so good at sports and playing the social game. But I figured out quite early on that I could draw better than most. Sure, I had toys as a kid, LEGO included, but my father always brought home reams of computer paper from work. In those days, it was the perforated, dot-matrix sheets that you could either separate from each other or keep intact for larger panoramic projects. I could spend hours creating anything from my imagination and even visit other worlds or travel forward or back in time. With a vivid imagination and a little skill, there was no limit to the worlds I could create, where dragons fought with superheroes in giant underwater castles or where airplanes had 10 engines and tiny ants took down horrific monsters.

Or perhaps my connection with LEGO is just childhood nostalgia. I recall my first sets my dad got me at a very young age, maybe four or five or so. While I had a world of ambition and imagination, I didn't yet have the skill to build a set based on the instructions, so my dad had to help me. Few things have stuck with me most of my life the way LEGO has.

Nearly all people who consider themselves adult fans of LEGO have gone through what is called the Dark Age, the time where fitting in trumps the desire to build. In my case, it meant reluctantly putting away the toys at about 13 while I awkwardly grew into my body and tried to discover what the world was about. As a young man fresh out of high school, I joined the Navy and, while it was strict and regimented, my free time was spent drawing quietly with other like-minded friends. During this time, I developed my own tastes in music and fashion and discovered that I could be funny, smart, and likable.

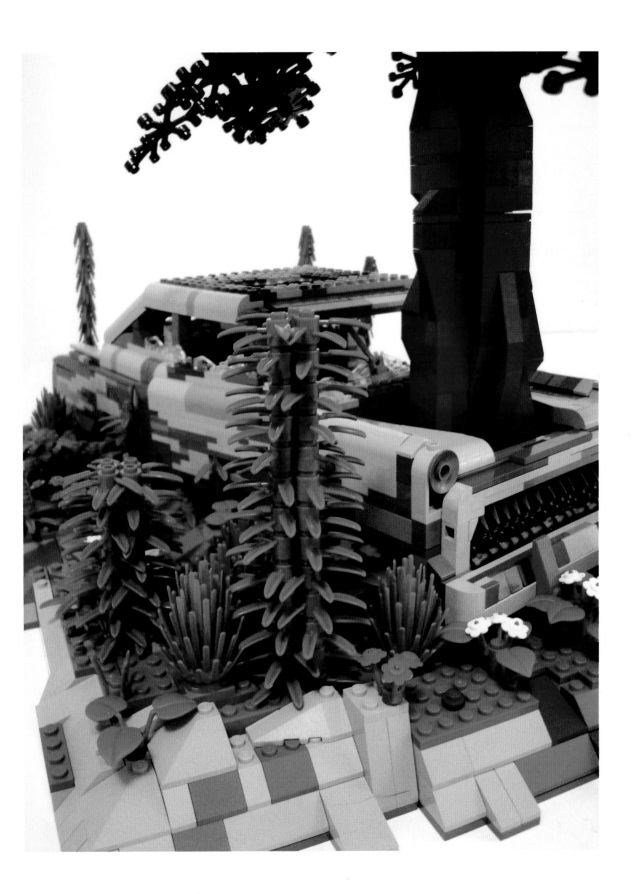

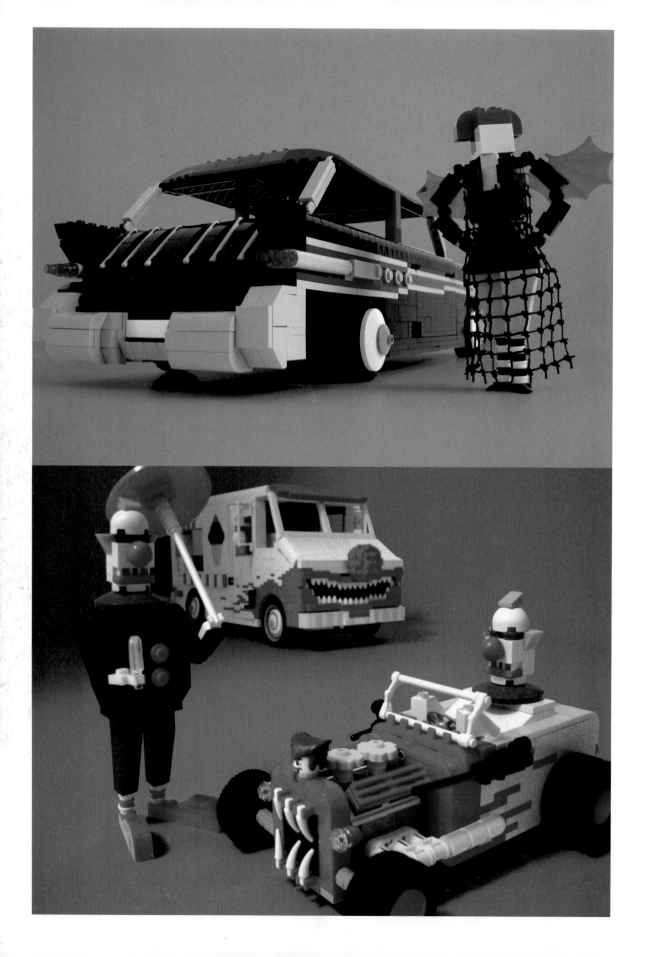

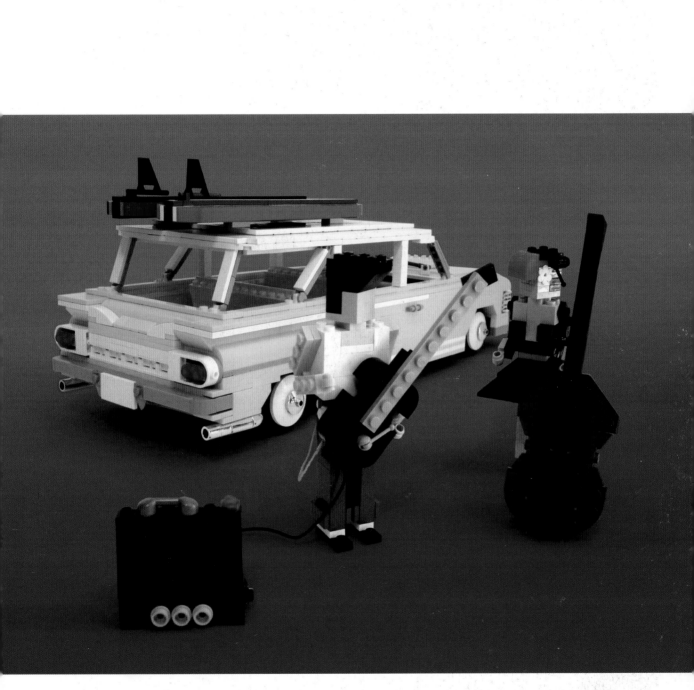

(opposite top) 1957 Pontiac Safari Wagon 2008
(opposite bottom) I Scream Truck 2008

(above) Solar Flare - 1960 Impala Wagon 2008

Shortly after my four-year stint in the Navy, I realized art was the only constant throughout my life. And so, for better or worse, I learned to paint by watching Bob Ross with his "happy little trees" and created a portfolio to get me into art college. There, I honed my skills as a painter and illustrator and further developed my tastes in music, friends, and more. Through my courses, I developed an interest in exotic cultures and faraway places, devouring tikis, book covers—particularly pulp covers—and retro designs, especially those based on art of the 1950s. Along with this interest came my unique artistic feel, my own persona. I knew that, in a world of strange and unique artists, I could still stand out. Even during this period of artistic growth, I didn't work with LEGO, but I would occasionally visit the toy stores to look at the Wild West and other cool themes I was missing out on and secretly formulate unique LEGO projects in my head.

I was in my late 20s when I moved cross country from New England to Seattle and discovered the huge network of very talented adult LEGO artists online. I wanted to be just like them, and I knew on some level I could do it. They showed me that it was not only okay for an adult to have toys and build with LEGO but also cool. The "Ages 7-14" recommendation on the box be damned! I had the time and resources now to buy my own LEGO pieces, and with a head for art and design, I found I was pretty good at it. With LEGO, all the things I ever strive for in my imagination can be achieved. With the very same artistic medium, a model car can conceivably later become a spaceship, a house, or a dragon fighting a superhero in a giant underwater castle.

I would show my friends what I was doing. They didn't think it was nerdy or weird at all; in fact, they were fascinated. They saw clear skill but also loved that I disregarded the conventional thinking that LEGO is only a toy for kids. I felt grateful for their support, and I attended my first LEGO conventions around this time. I made more friends because of LEGO.

Why LEGO? For me, maybe it's the fame or, rather, a kind of micro-fame. Place me in a convention setting, and people look at me and my friends in wide-eyed amazement. I look back at them in wide-eyed amazement, too, when I think about the fact that well over 11,000 people have paid to see what we do. They tell me how much they enjoyed seeing me in some magazine or documentary. It's just a part of life now. I take it all in stride and smile politely. By now, I've been featured in countless blogs, several magazines, newsletters, and books, and even a few TV spots, radio interviews, and at least one documentary that I can think of.

Why LEGO? Because it makes me different. I like being that intriguing guy people like to read about. I'm an artist and a LEGO builder. People like that. I have tikis and skulls in my apartment because that is what's expected of me; it's what I want. With my LEGO and art projects, I am always learning, always researching, always evolving. It never gets dull. All my friends are LEGO and artist friends now. Lots of my friendships exist online with people all over the world. Our only correspondence is commenting on each other's photos and emails. Sometimes, I send them stuff. Sometimes, they send me stuff. Occasionally, we meet in person. I get interviewed. I get published.

(top) Blue Voodoo - 1971 Caddy Eldorado 2008
(bottom) Aztec Gold - 1961 Dodge Polara 2011

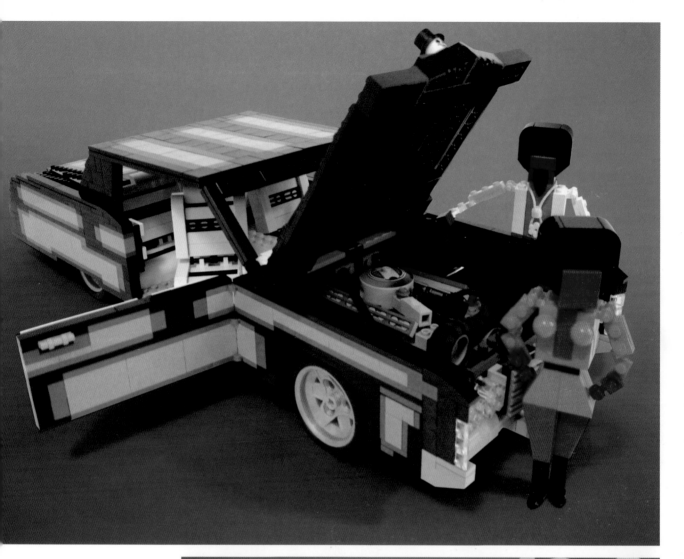
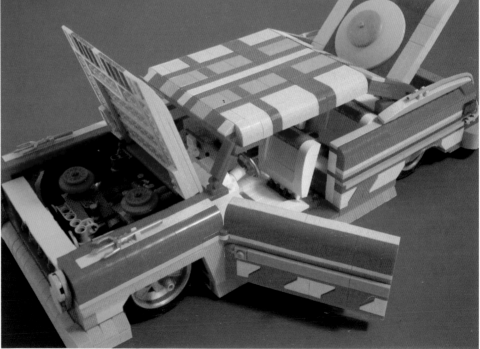

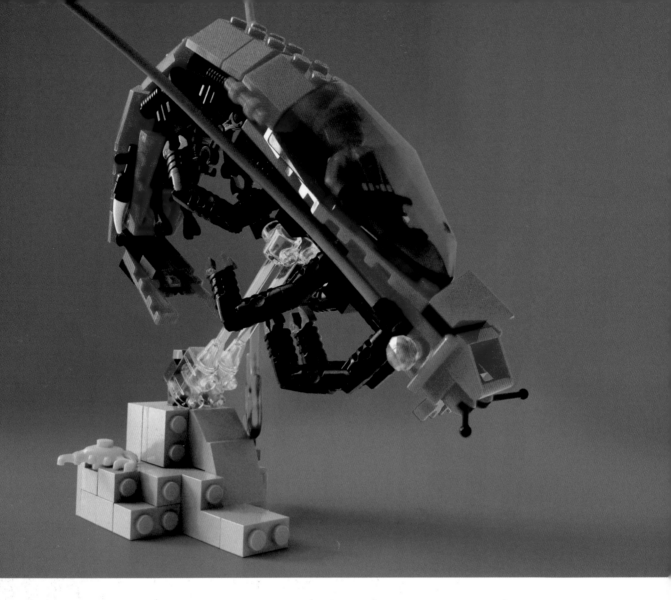

It's just how it is. With each interview, it becomes more natural. Yet, you still get a boost of confidence in knowing that you can stroll into any bookstore and find a number of books you have been featured in.

Even without the friends, the interviews, and the recognition, LEGO itself is what drives me at my very core. One LEGO piece, while an engineering marvel, is not very exciting on its own, but bins of thousands of pieces—that's stored kinetic potential. That is a million works of art waiting to be made. That is life. And in the hands of another LEGO artist, the very same pieces can become a million things I have never fathomed myself. It's like being in art school all over again. Even without a signature, our styles are diverse enough that we can tell one artist's work from another.

So why LEGO, you may ask again? Because it's just what I do.

(above) Nemo 2007 (opposite) Protector of the Great Queen 2010

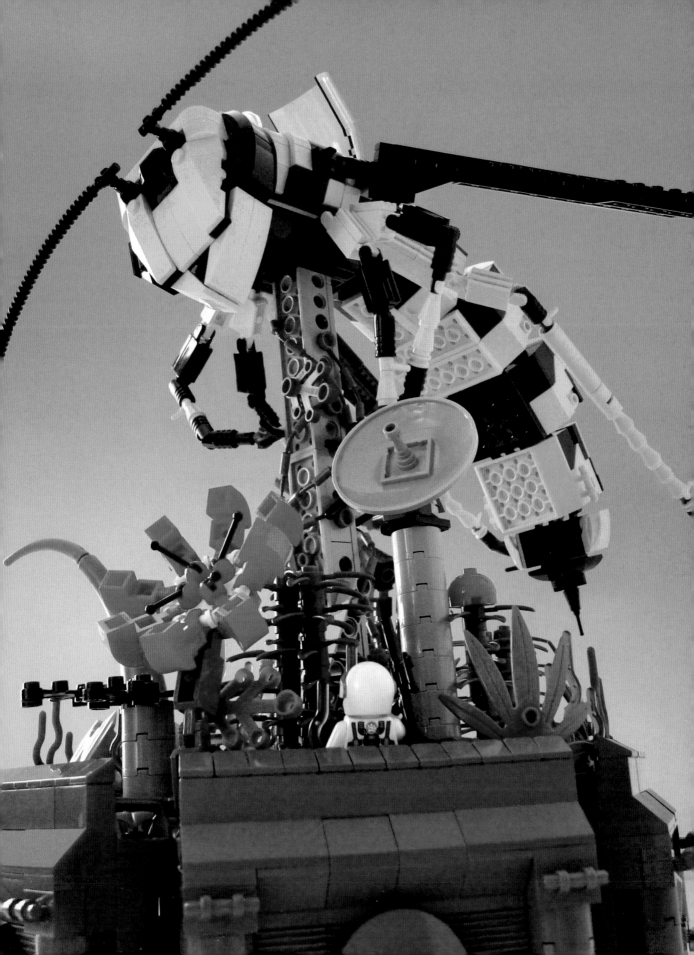

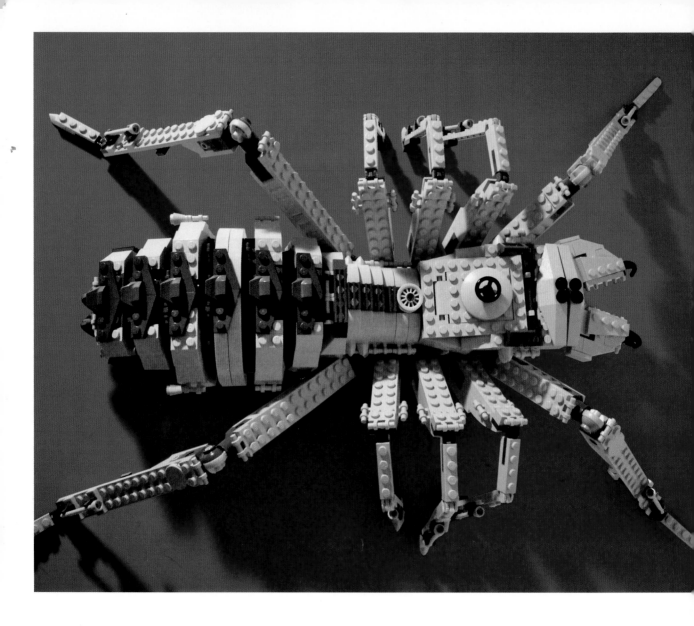

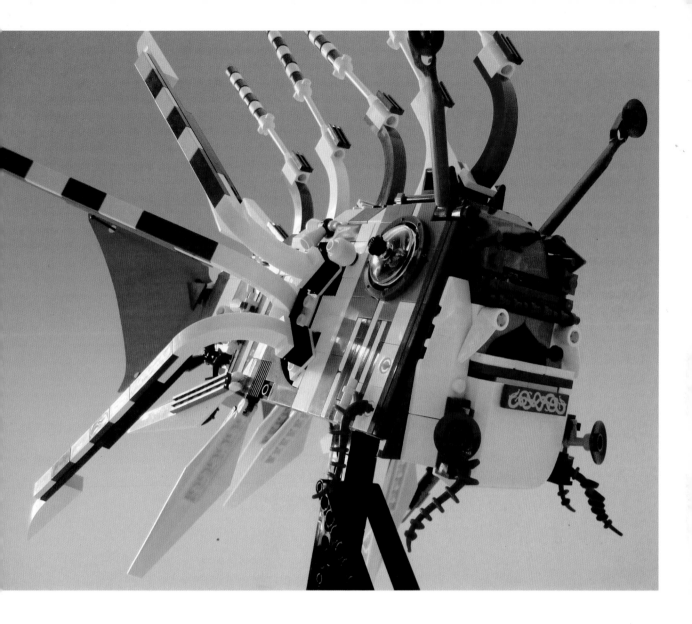

(opposite) Baal - Camel Spider 2010
(above) Lionfish 2010

(next spread)
(left) Neptune 2007
(right) Leviathan 2007

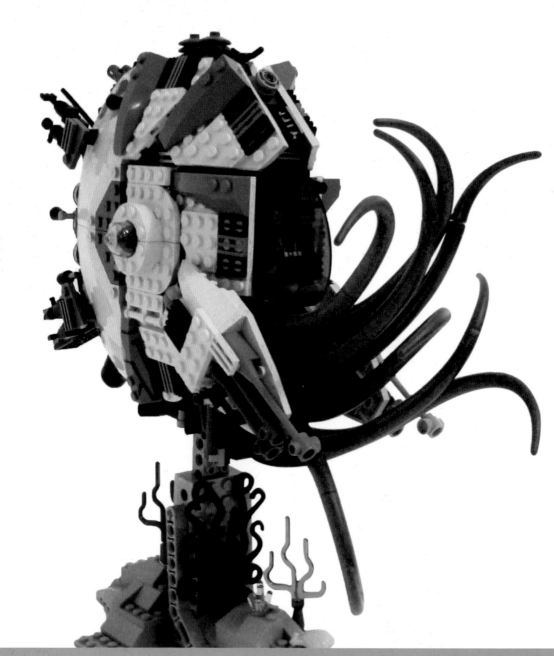

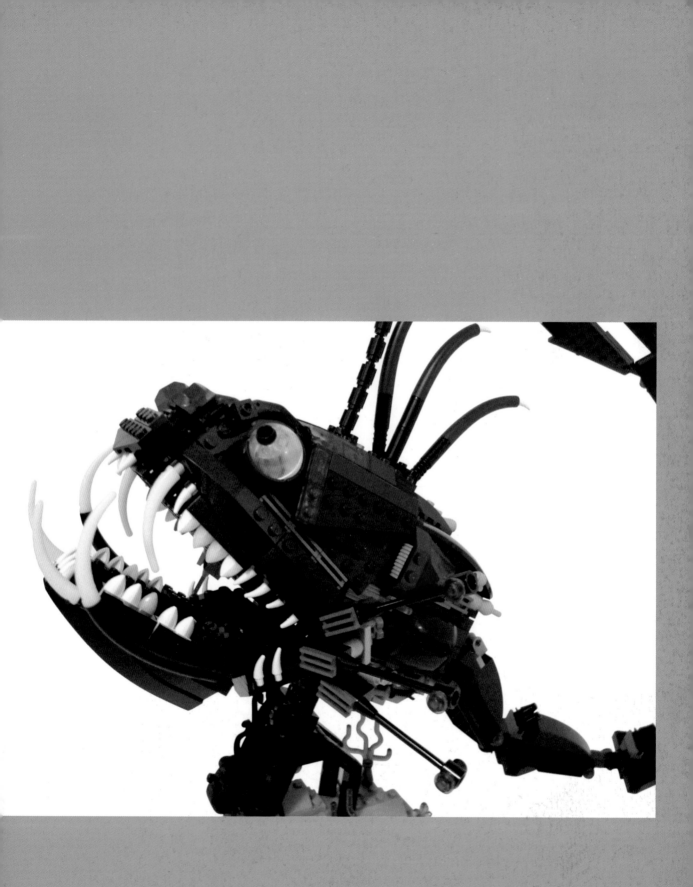

Mecha

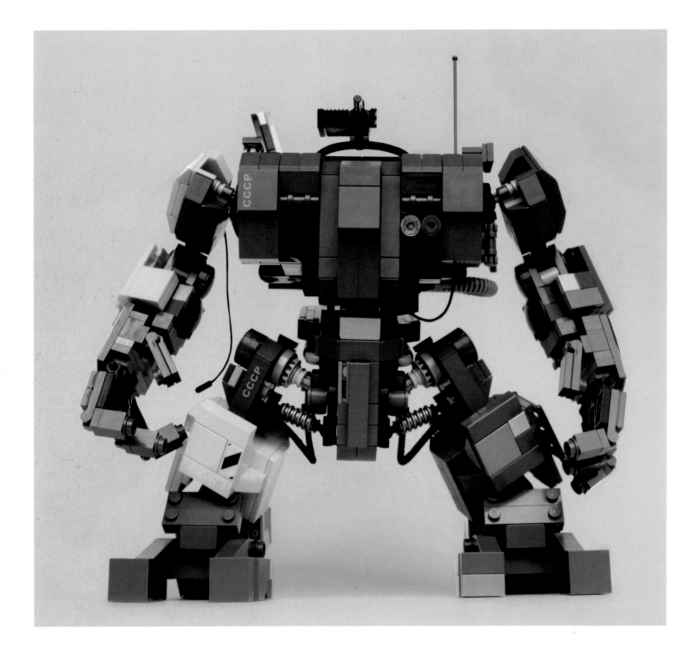

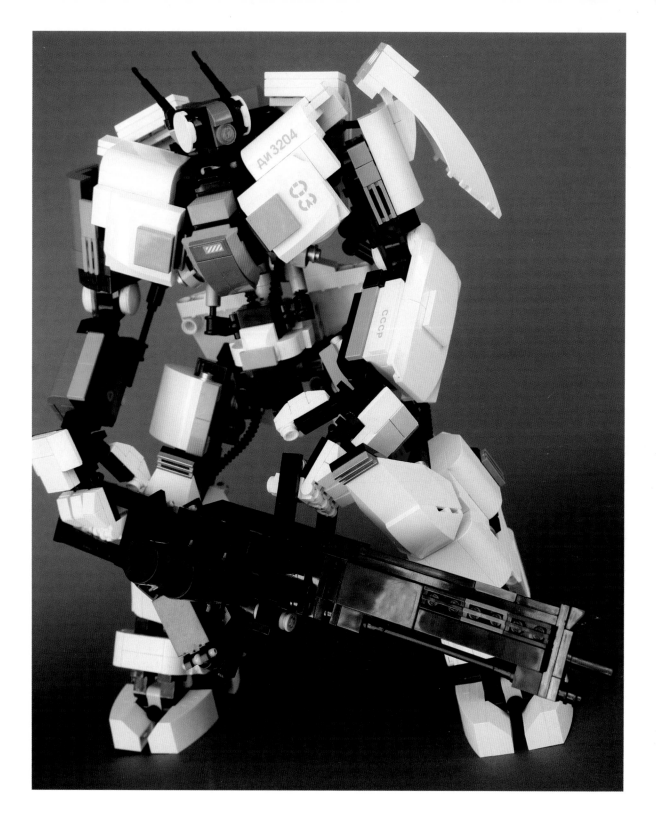

Aaron Williams

(opposite) MD105 Mongrel 2012
(above) Guardian Heavy 2011

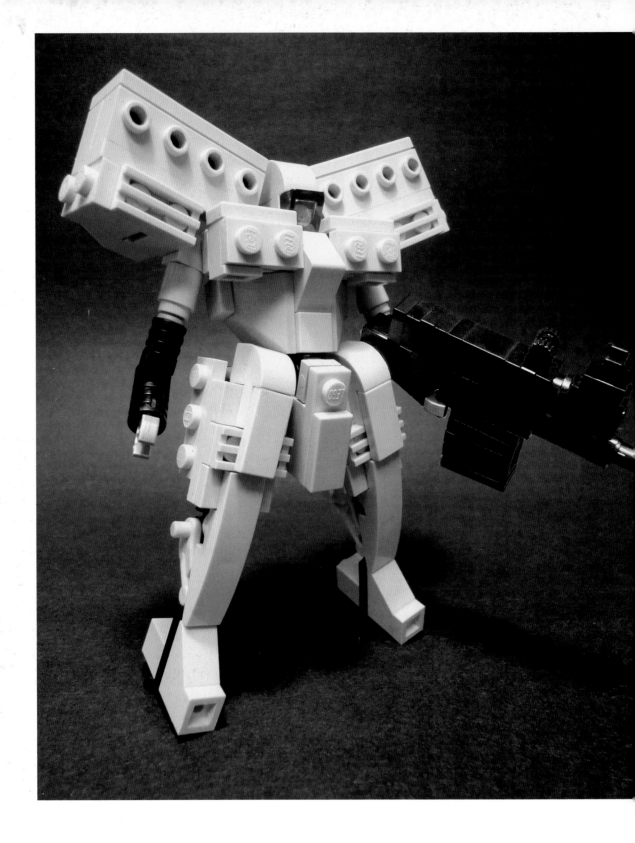

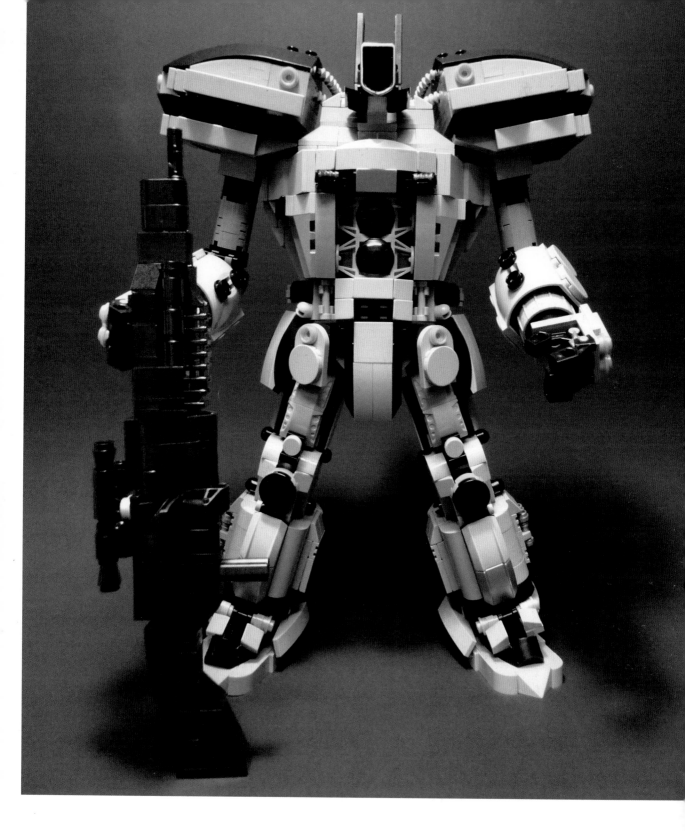

Nathan DeCastro

(opposite) CAMM-119 DESERT FOX 2012
(above) FCM-112 THYLACINE 2012

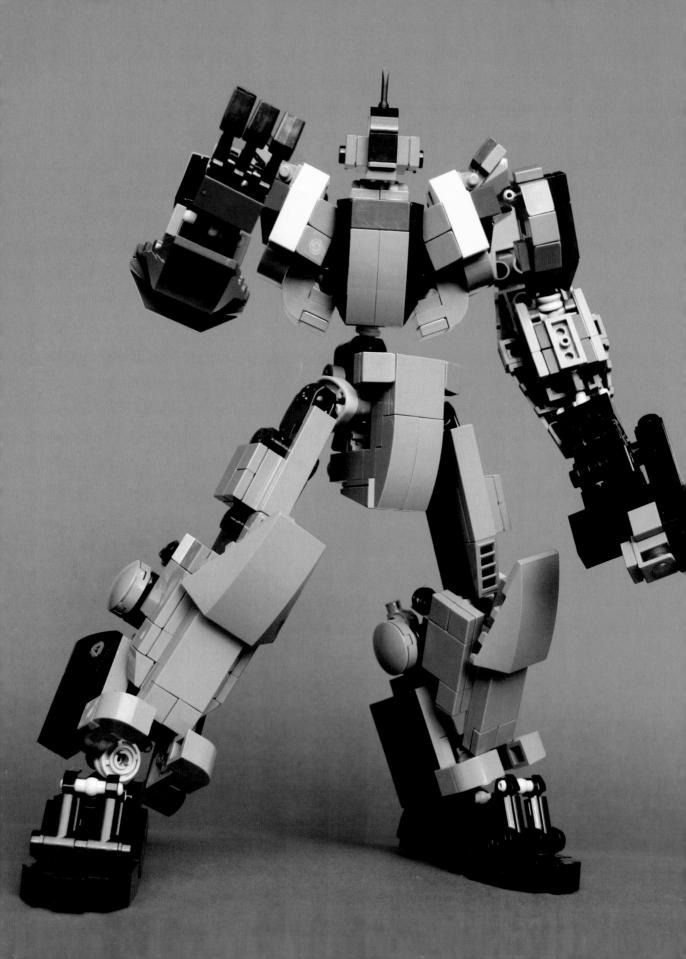

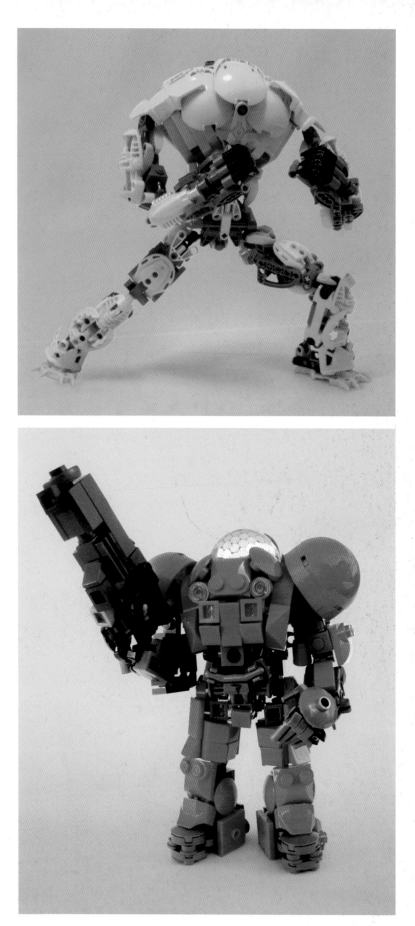

(opposite)
Aaron Williams
Expeditionary Strike Unit 2011

(top)
Eero Okkonen
Keetongu 2010

(bottom)
Sven Junga
Starcraft II Space Marine 2011

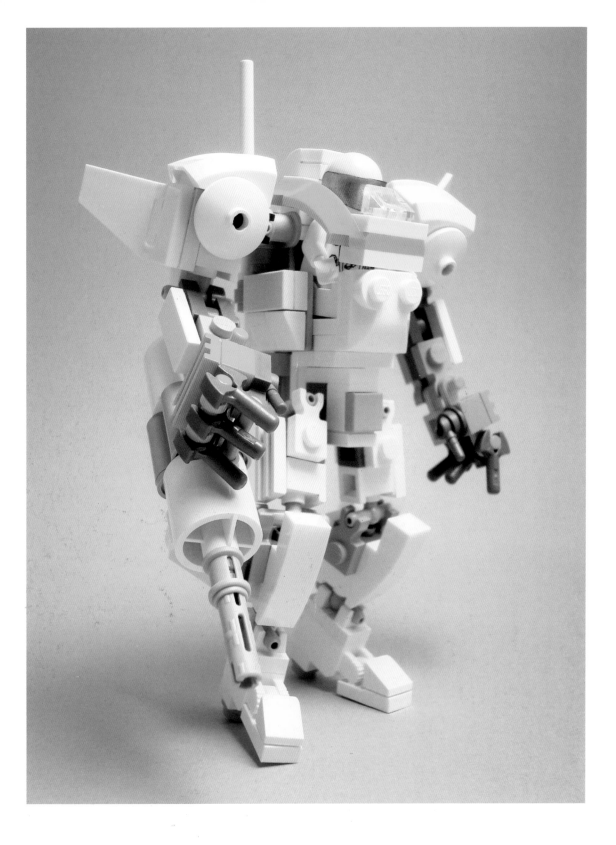

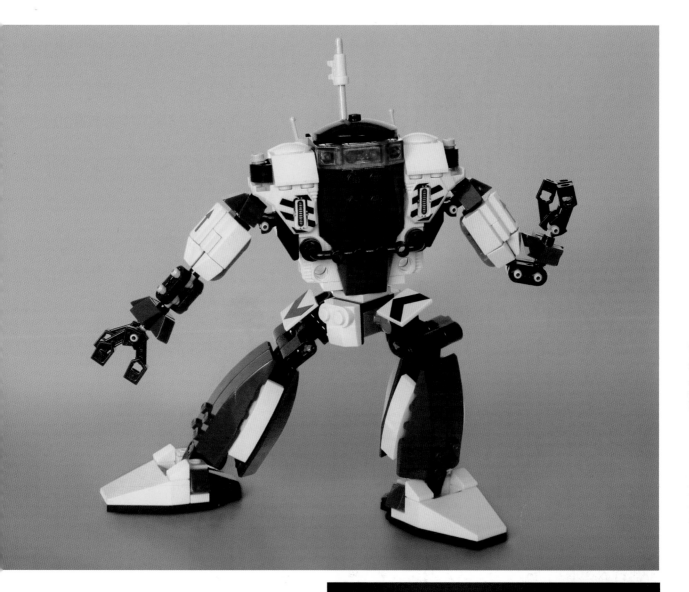

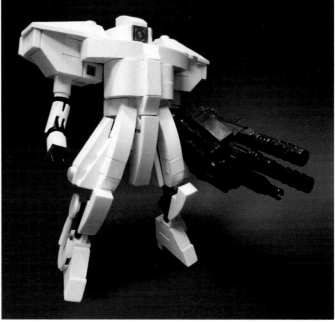

(opposite)
Paul Lee
Mars Mission Variant / Gorilla Hard Suit 2008

(top)
Nathan Proudlove
Brawler 2009

(bottom)
Nathan DeCastro
CAMM-103 YMIR 2012

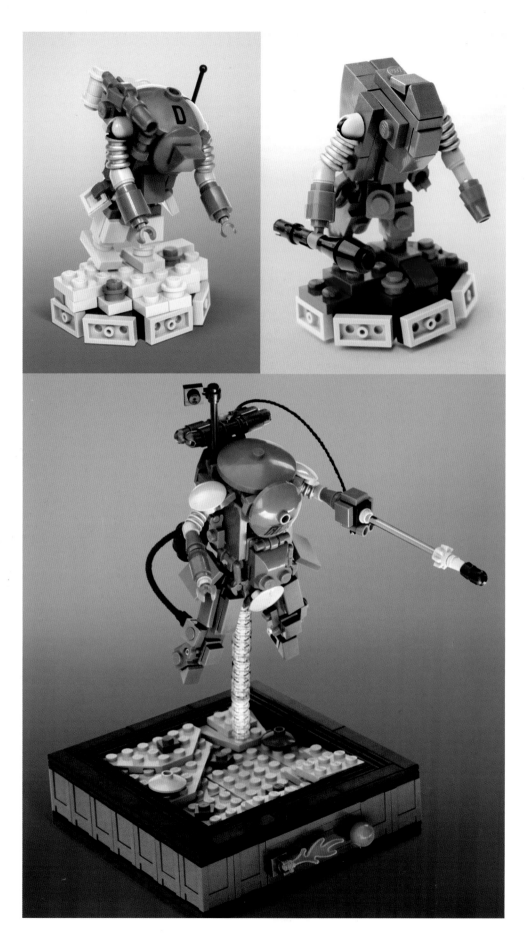

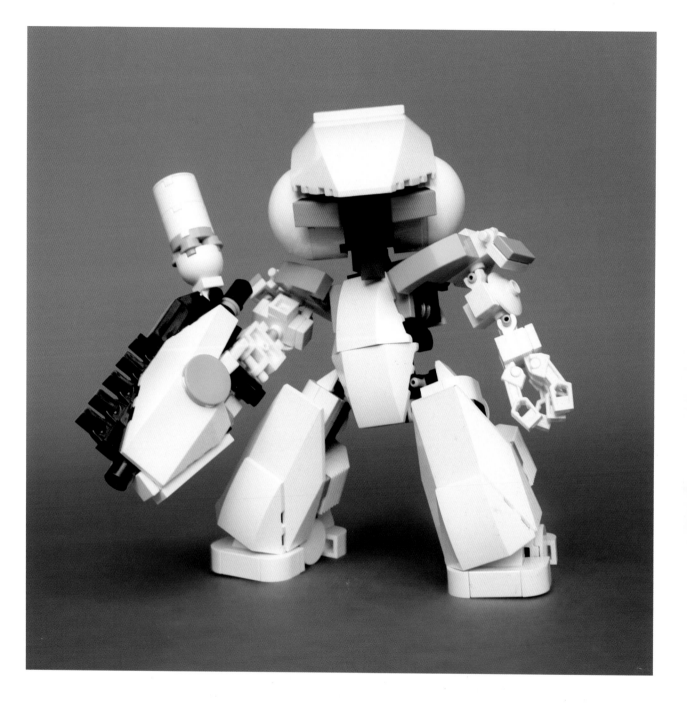

Logan F.
(opposite left) Ma.K Raccoon 2012
(opposite right) Ma.K Melusine 2012
(opposite bottom) Ma.K Fireball with Diorama 2012

Aaron Williams
(above) Neville the little bot 2011

201

The Final Frontier

Garry King
Cetanclass Baseship 2012

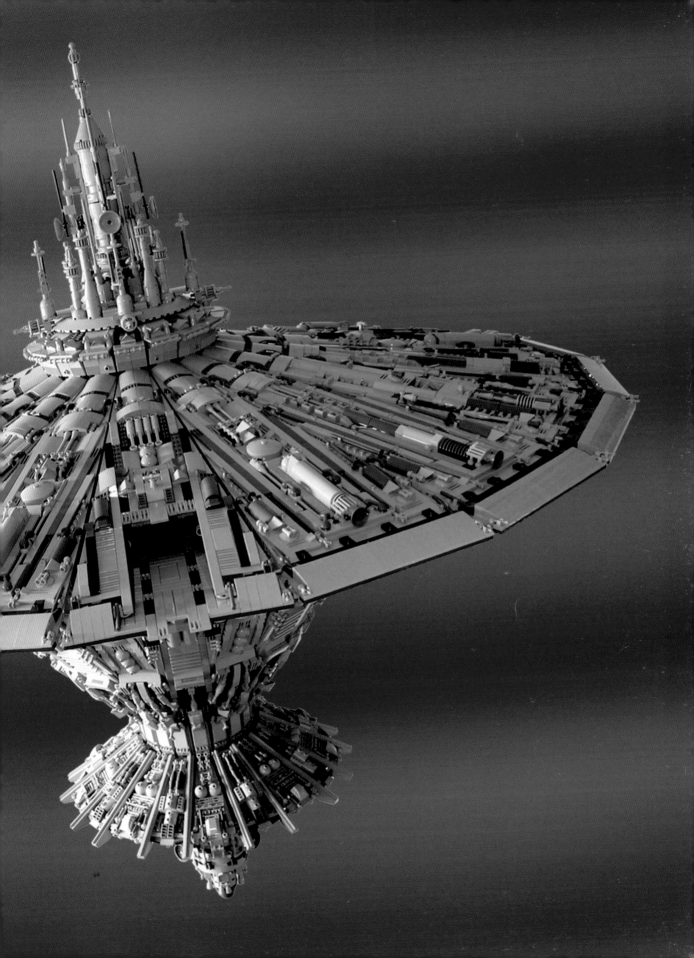

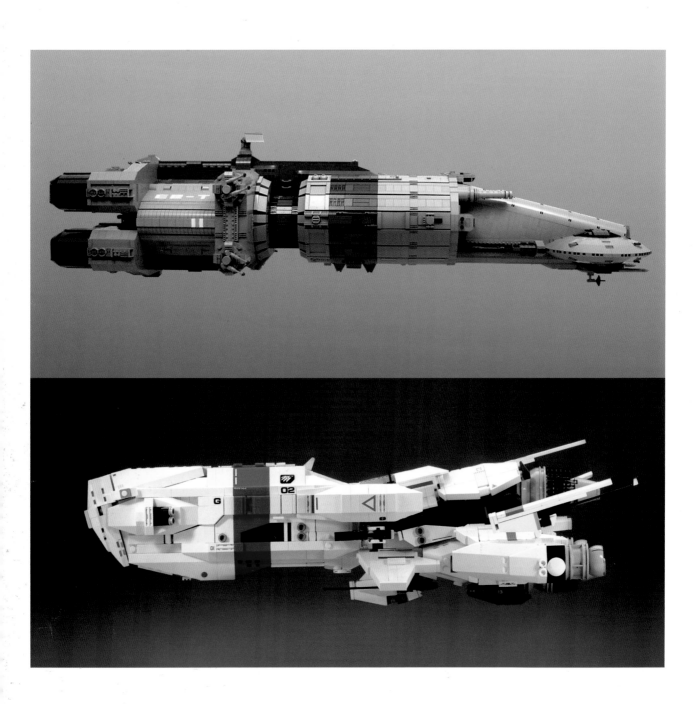

Jonathan Walker
(top) Solaris 2006
(opposite) Arcturus 2009

Rob Morrisseau
(bottom) Picket Frigate Prometheus 2012

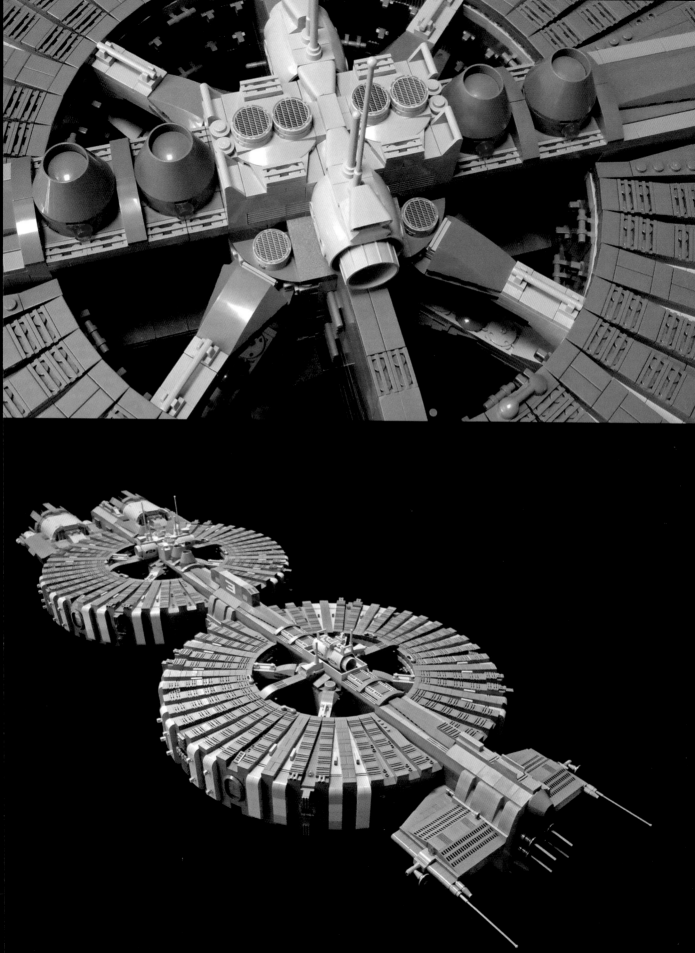

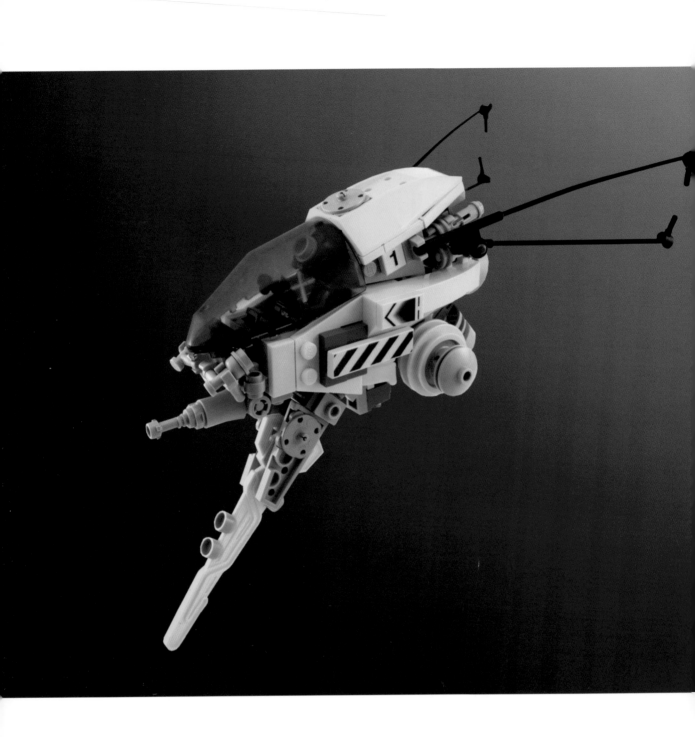

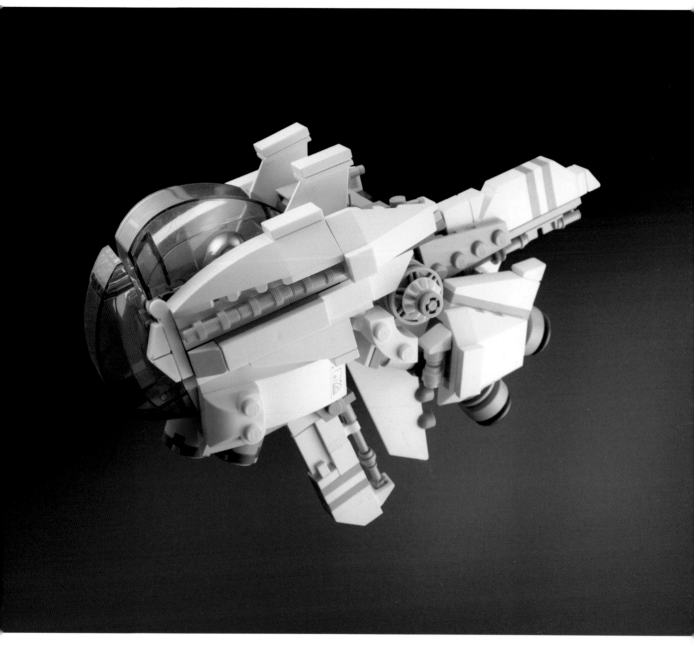

Theo Bonner

(opposite) La Guêpe 2011
(above) "Mola" Recon Probe 2011

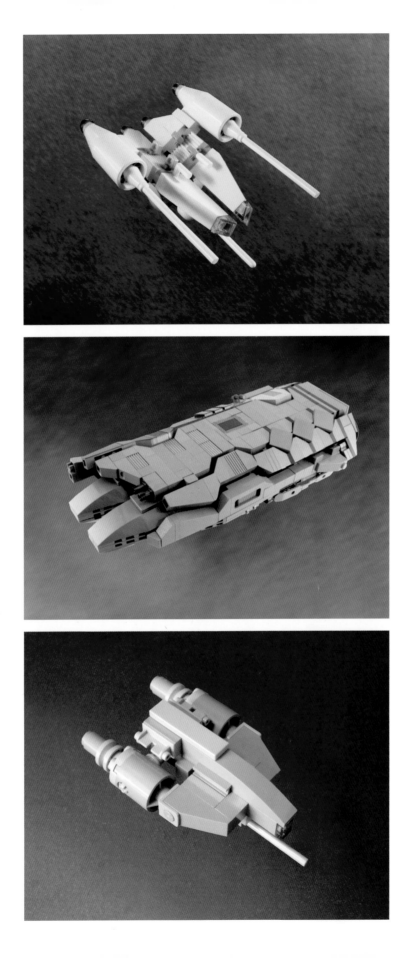

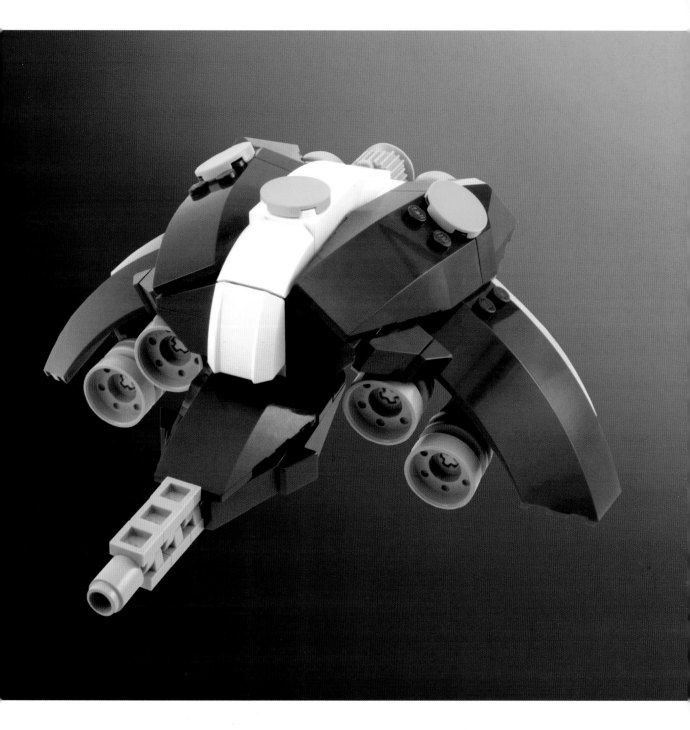

Jonathan Walker
(opposite top) Dalu Support Craft 2011
(opposite bottom) Arcturus Support Craft 2009

Theo Bonner
(opposite middle) Orthrus 2011
(above) Invidia 2011

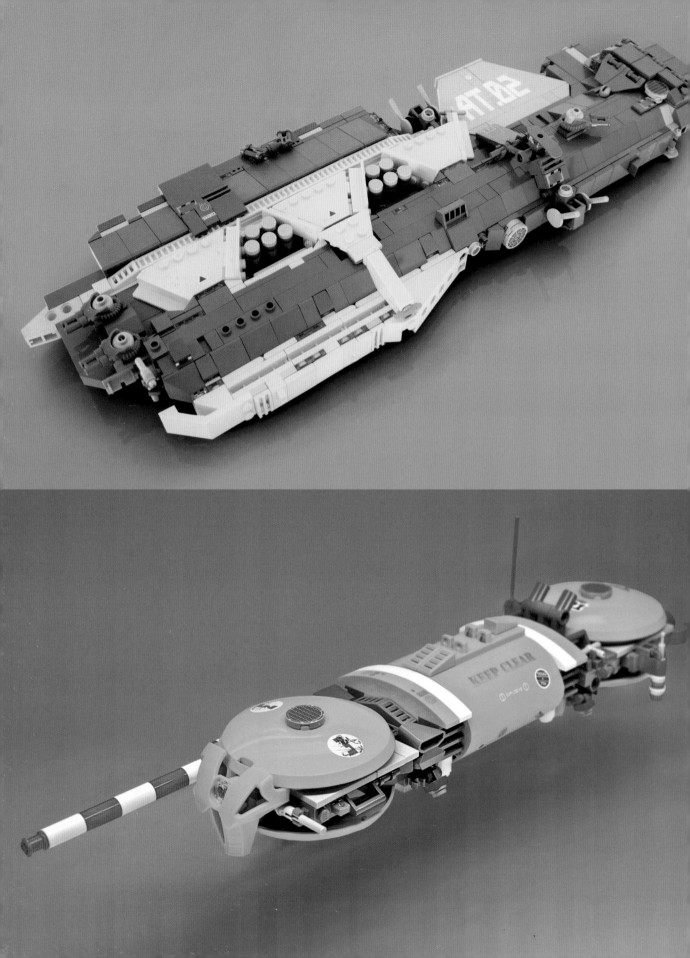

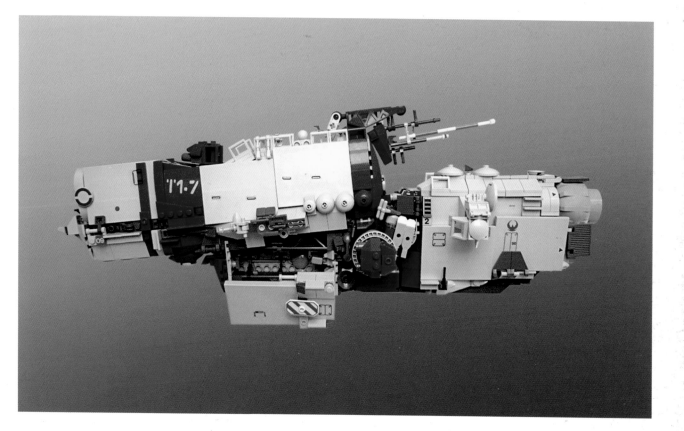

Pierre-E. Fieschi
(opposite top) "Tempest" Bombardment Platform 2012
(above) Sobani Field Command Ship 2010

Andrew Becraft
(opposite bottom) Pit Viper-Class Fuel Tanker 2012

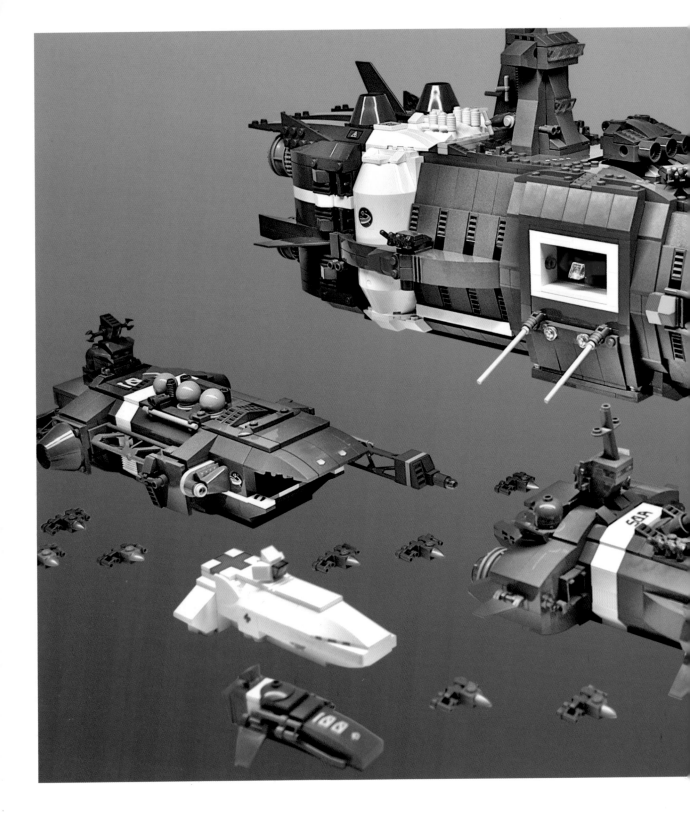

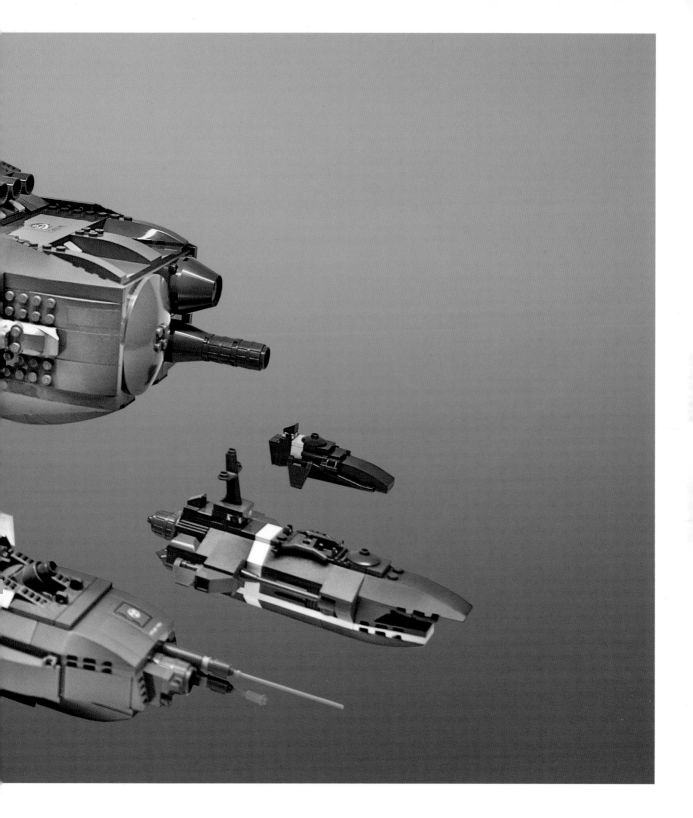

Andrew Becraft
U.E.F. Battle Fleet 2011

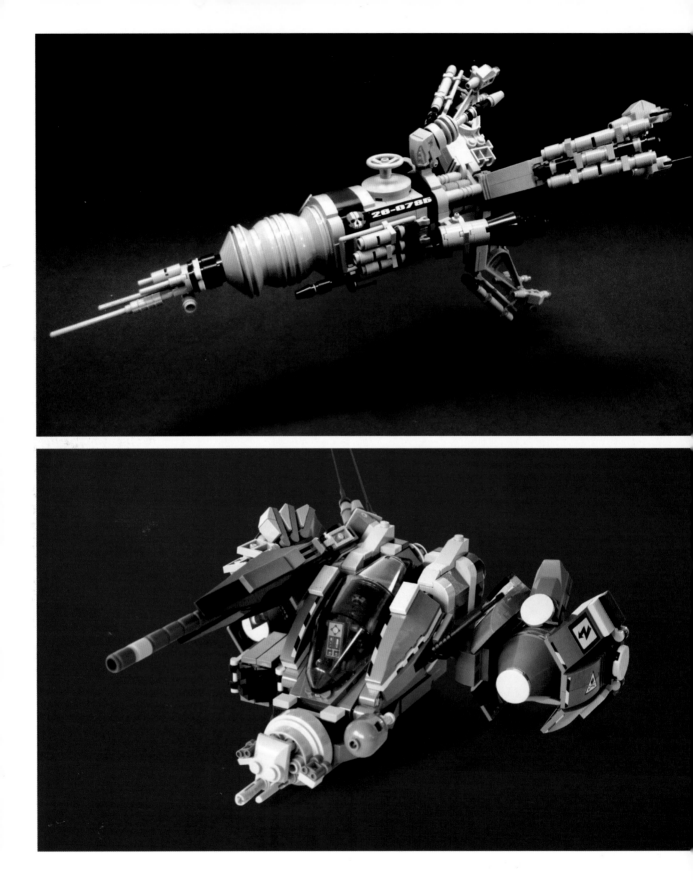

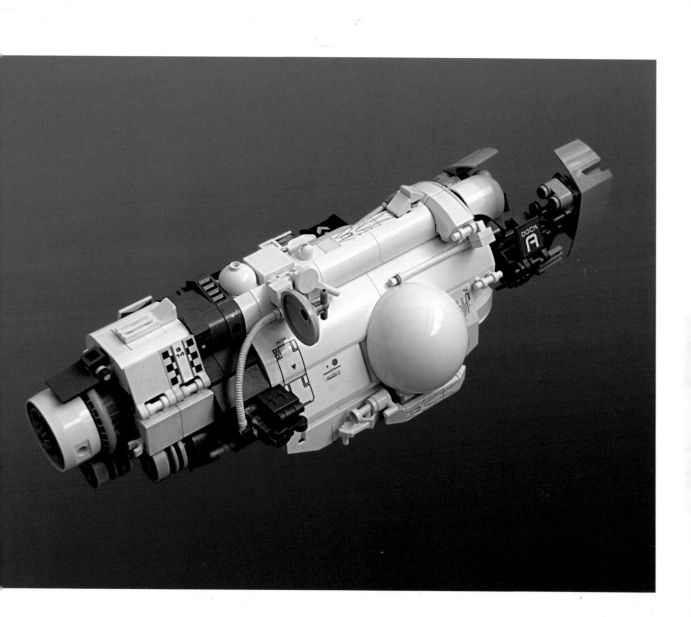

(opposite top)
Nathan DeCastro
Strahl J-60 "Bluthund" 2011

(opposite bottom)
Jack McKeen
Ma.K Yellow Jacket Starfighter 2011

(above)
Pierre-E. Fieschi
"Spark-Class" Carrier 2010

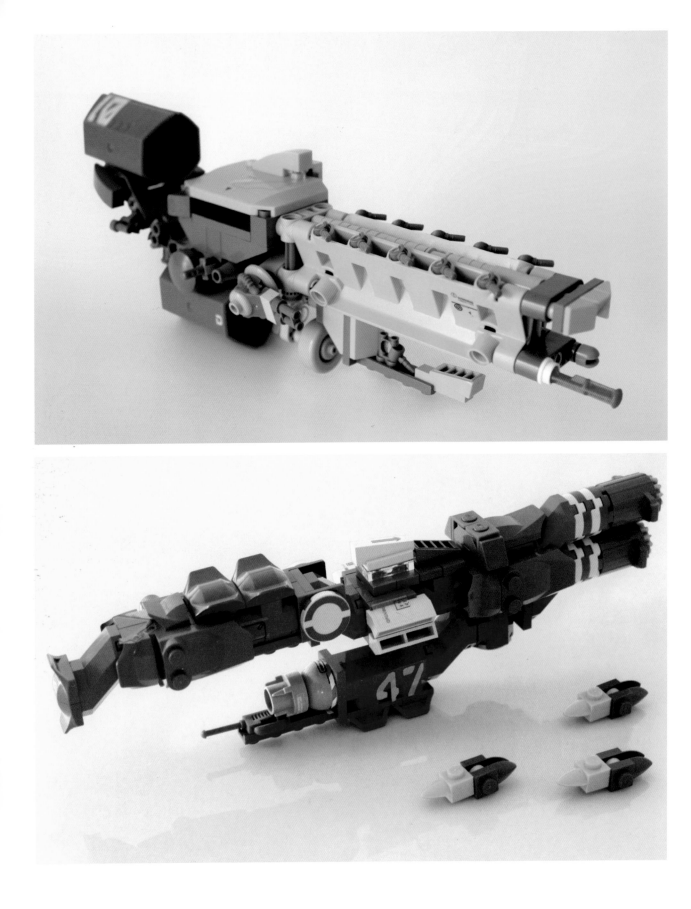

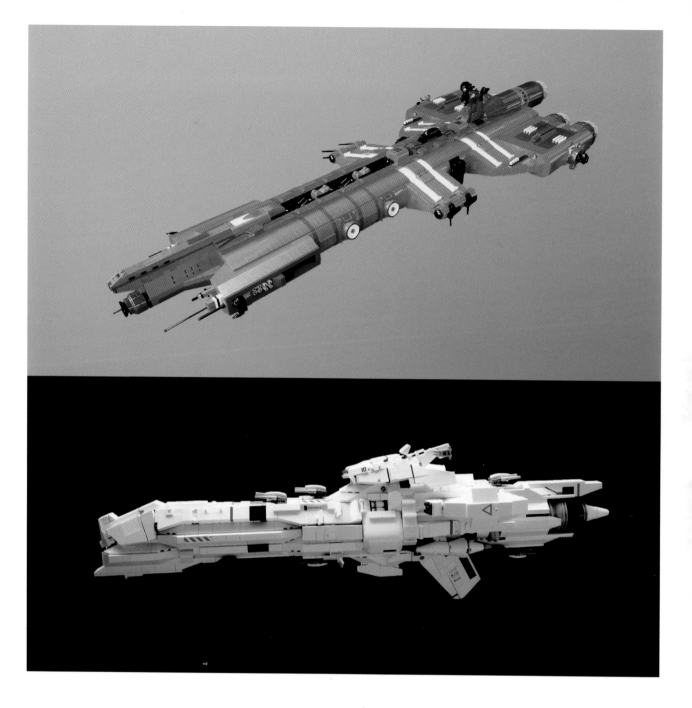

Pierre-E. Fieschi
(opposite top) "Breacher" Light Assault Cruiser 2011
(opposite bottom) Laser Artillery Frigate 2012

Jonathan Walker
(top) Phobos 3 2008

Rob Morrisseau
(bottom) Heavy Corvette Thakrar 2010

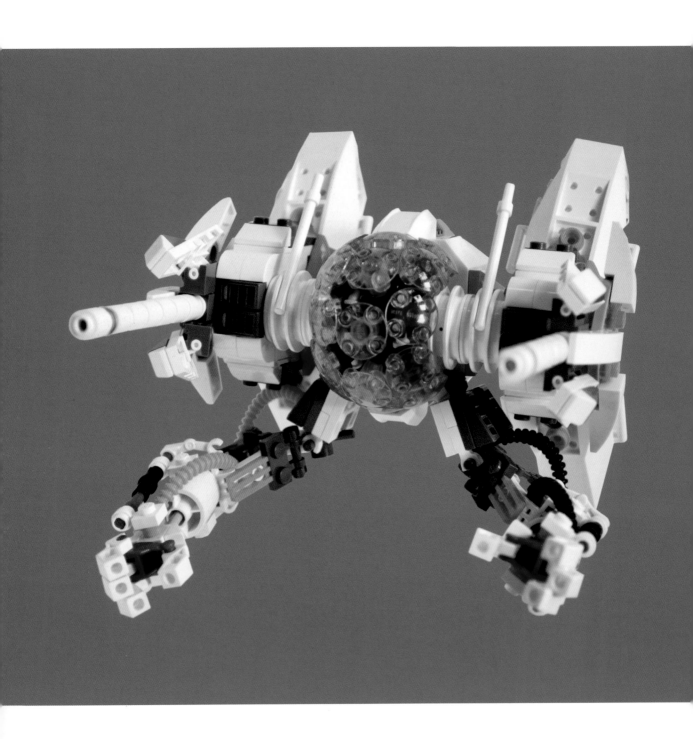

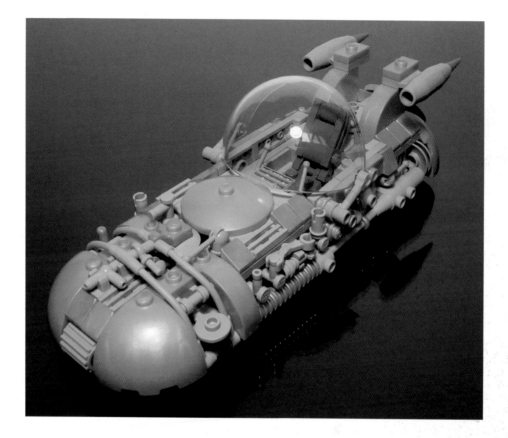

(opposite)
Jack McKeen
PShip 2011

(above)
Luka Kapeter
Protocol Droid's Landspeeder 2011

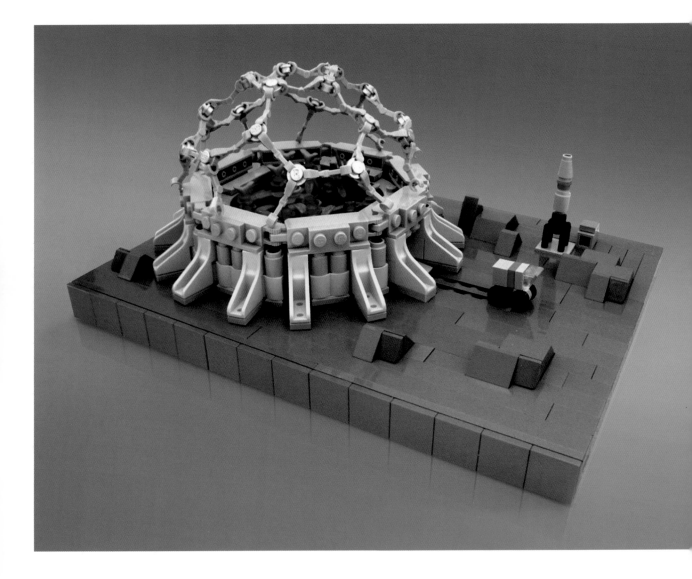

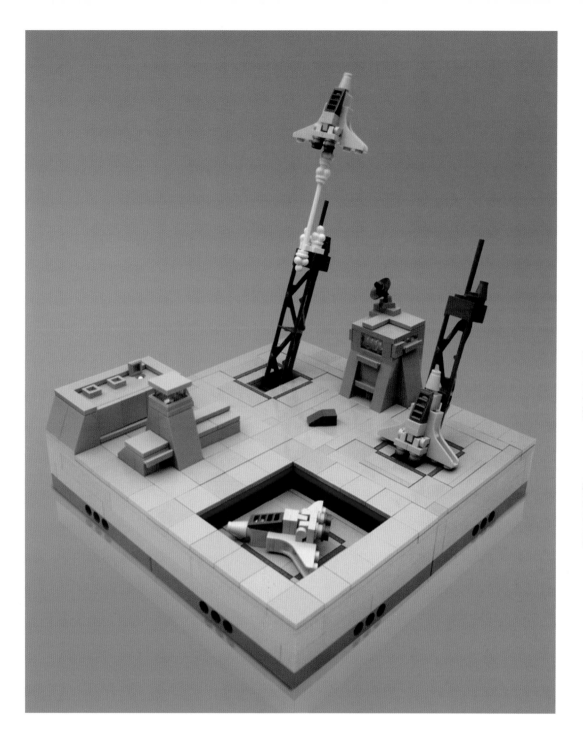

Rod Gillies

(opposite) Tranquility Biodome 2011
(above) Starfighter Command 2011

Striders

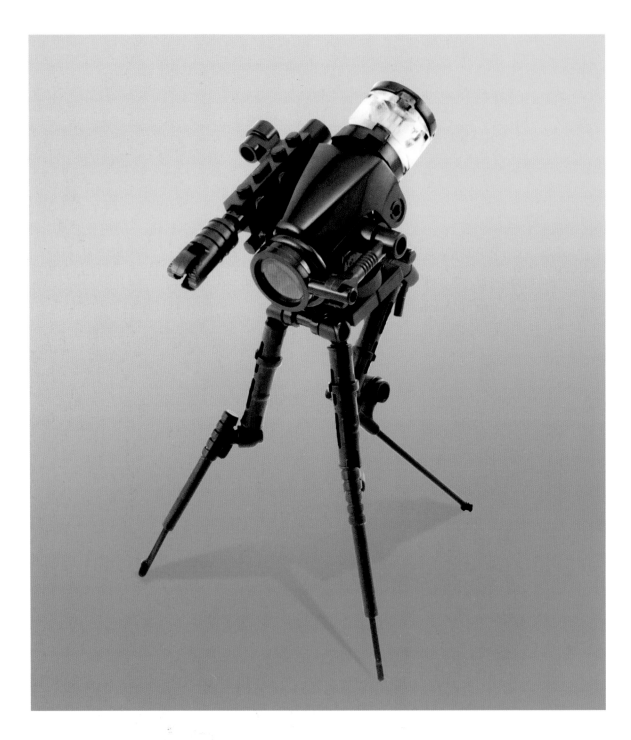

Theo Bonner

(above) 昆虫 2011
(opposite top) Köhs-Class H-4 Battle Tank 2010
(opposite bottom) J-9 Tanusu All-Terrain Attack Mech 2010

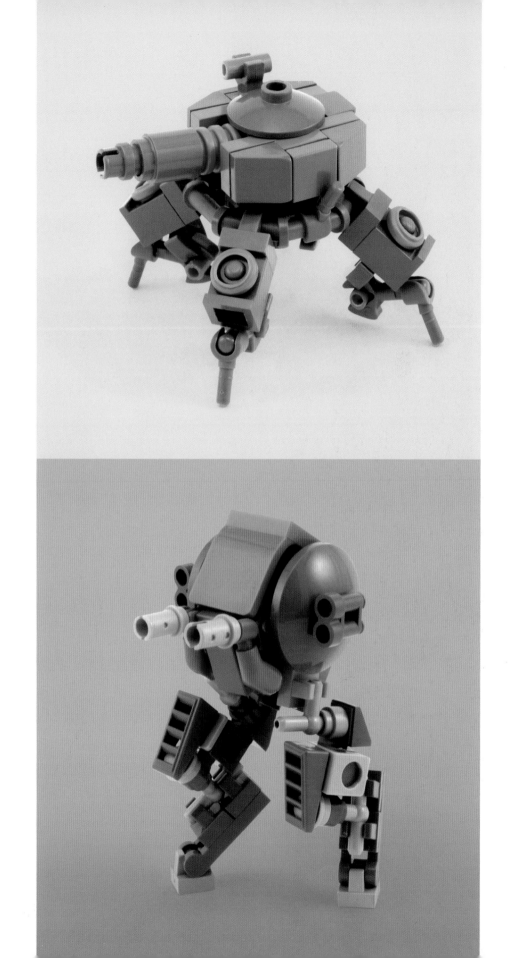

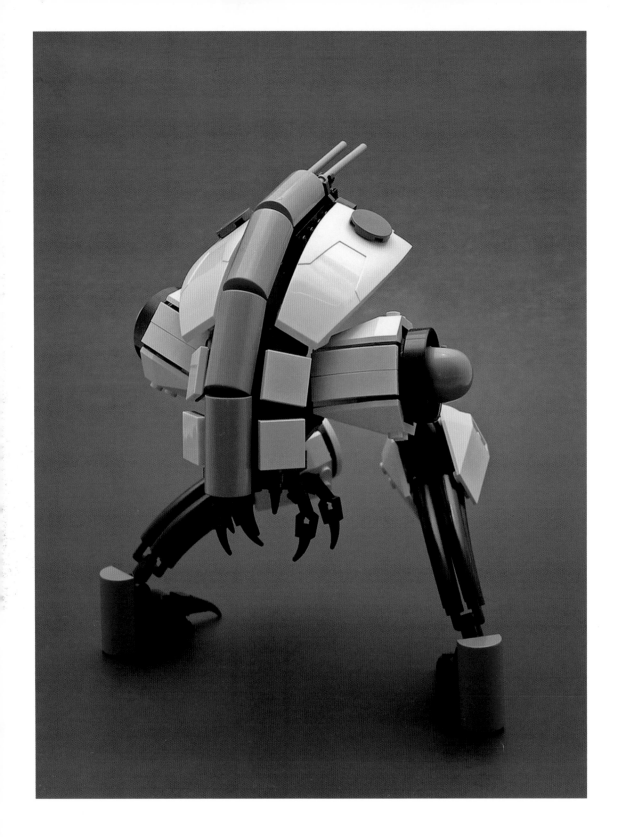

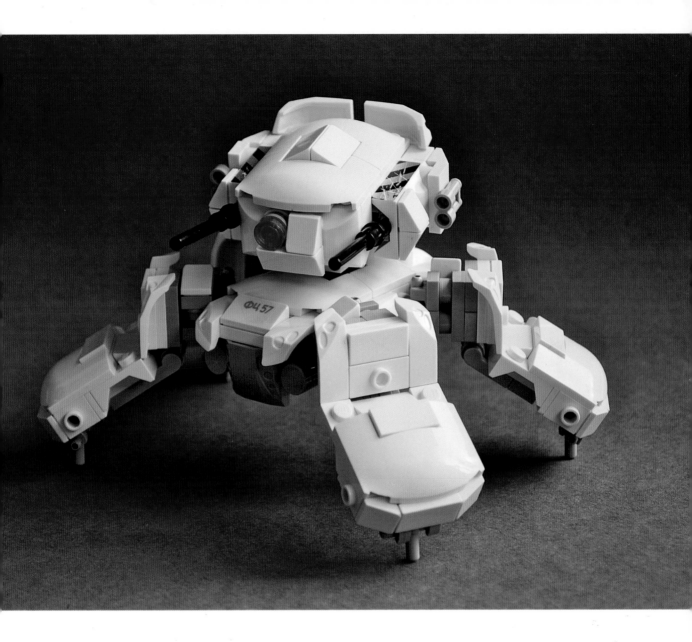

(opposite)
Tyler Clites
Bio-mechanical Strider 2011

(above)
Christophe Charre
AD57 / Light Aqua Walker 2012

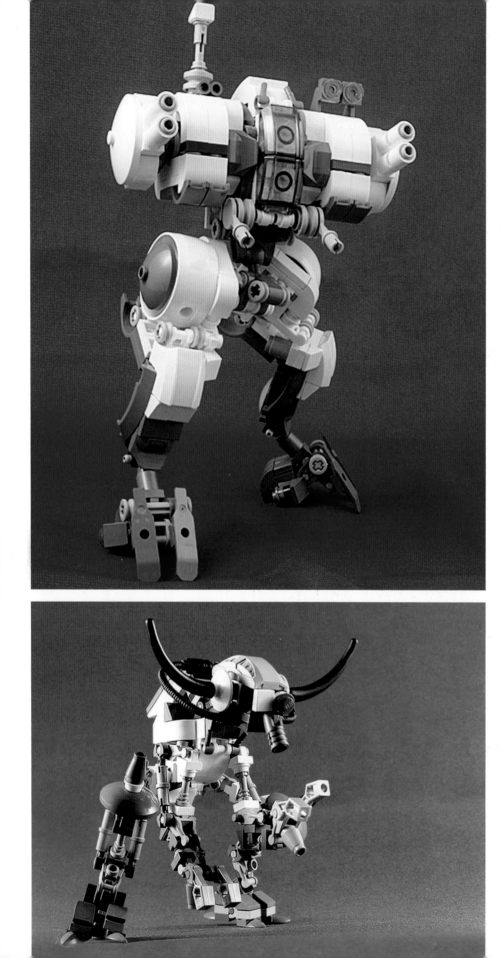

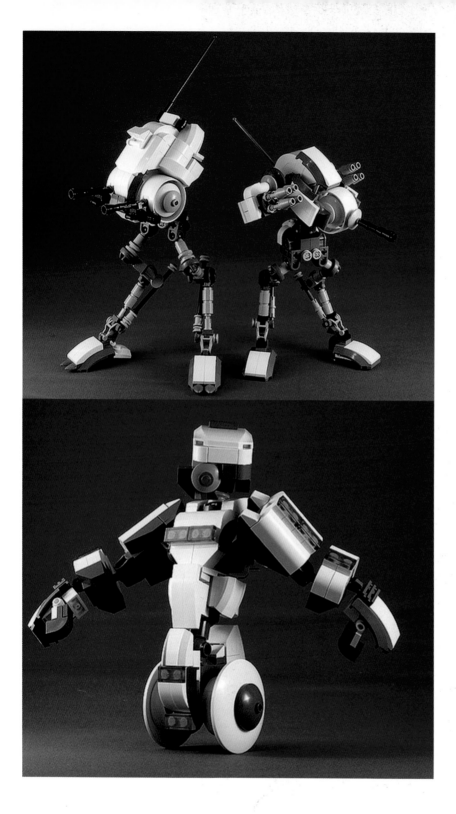

A. Anderson

(opposite top) Light Infantry Vehicle 2010
(opposite bottom) Gremlin 2008
(top) Striders 2004
(bottom) Medical Bot 2009

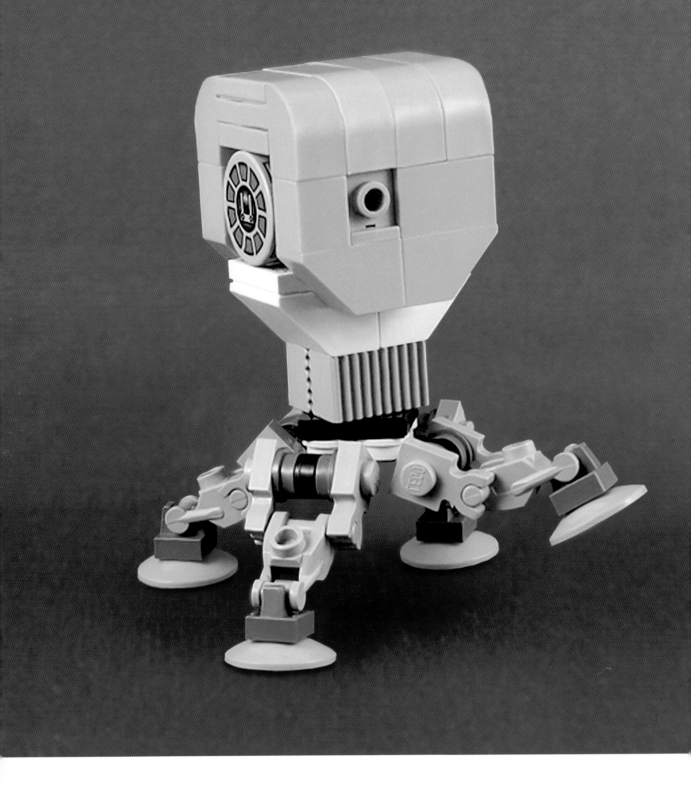

A. Anderson

(above) Knobby 2011
(opposite top) Sentinel 2011
(opposite bottom) Friends 2010

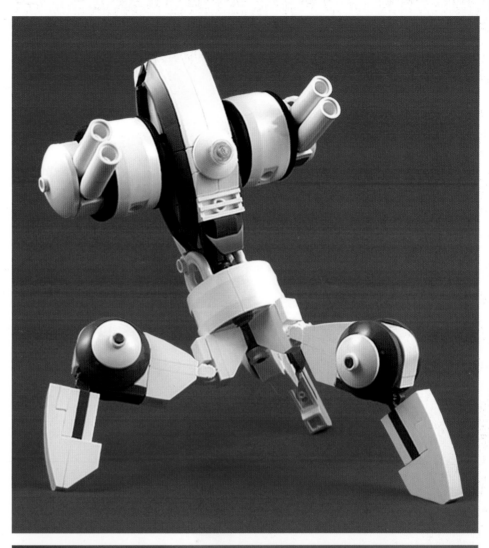

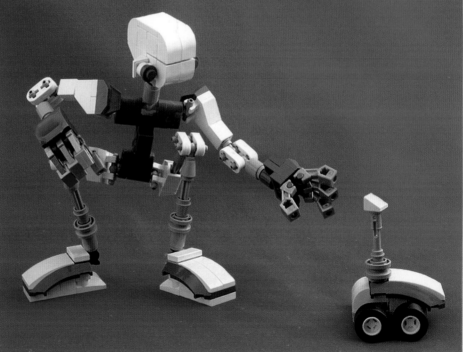

MicroBots by Bodo Elsel

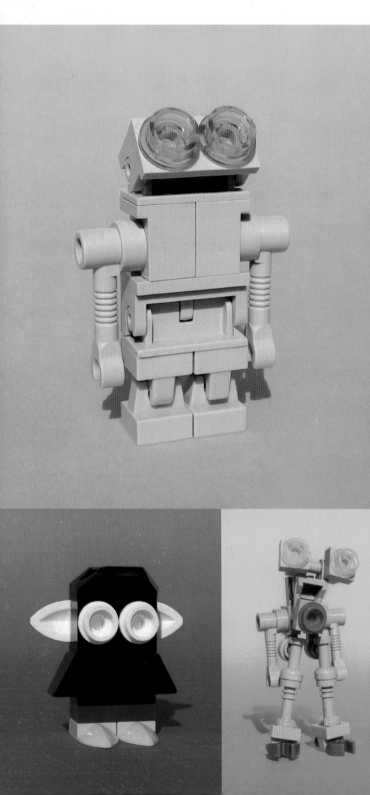

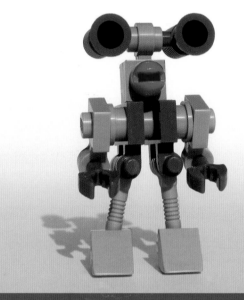

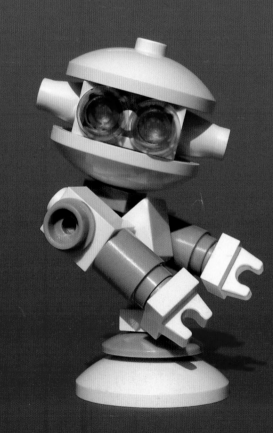

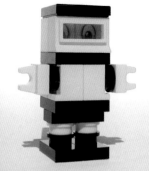
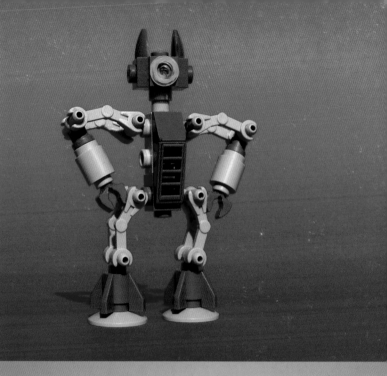
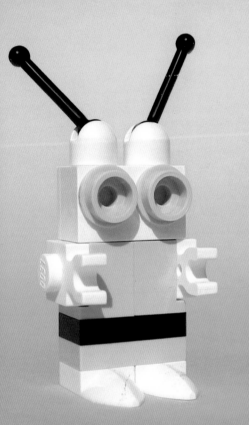
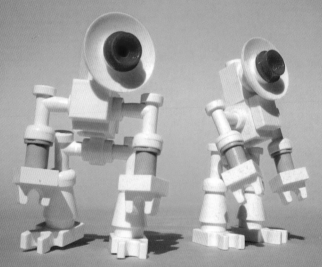
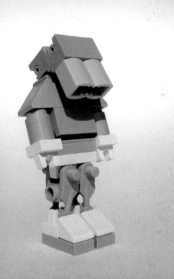
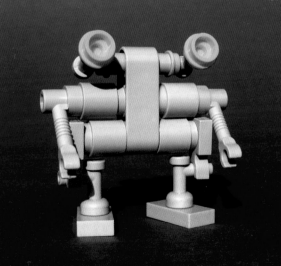
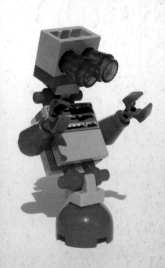

Meta by Cole Blaq

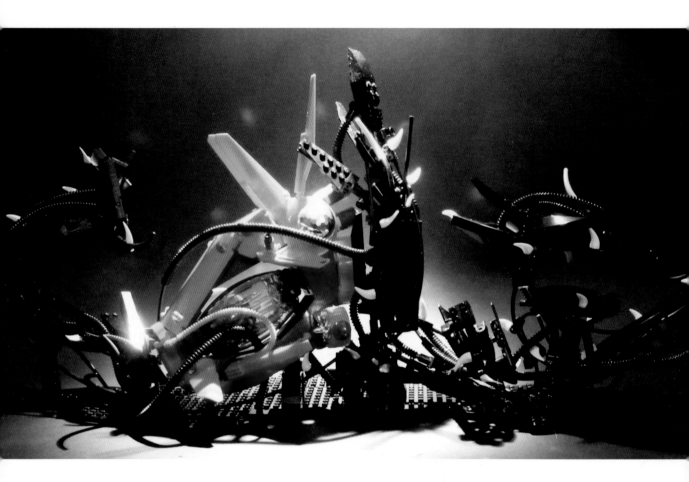

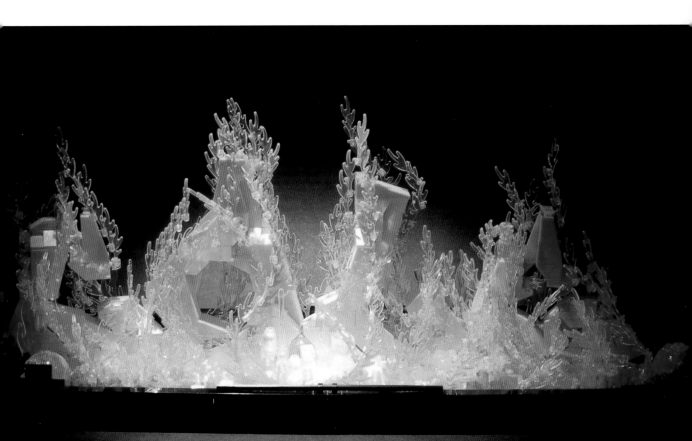

(opposite) S.O.S. 2010 (above) The Burn 2010

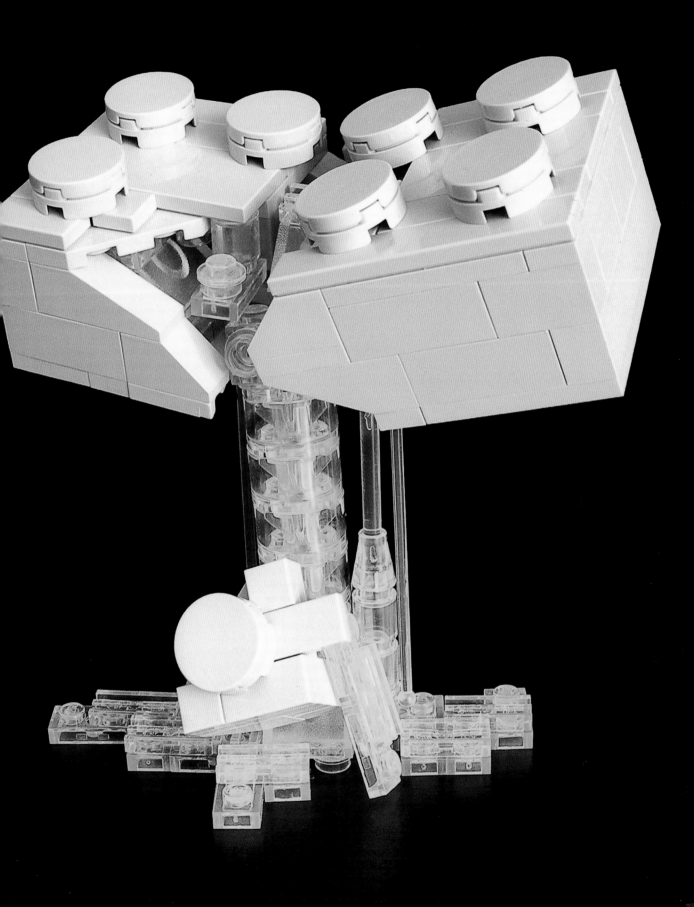

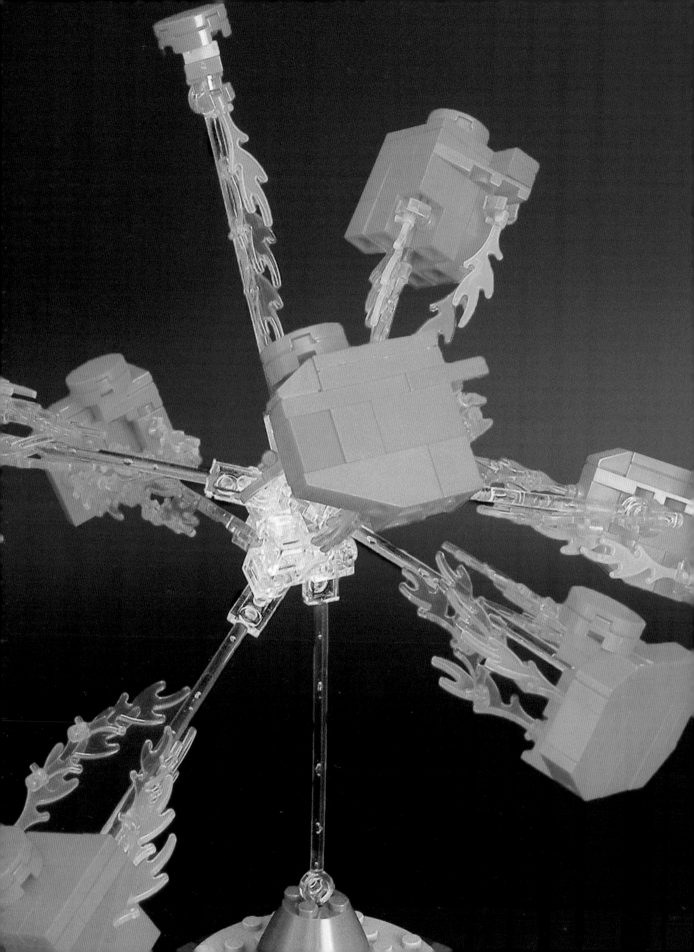

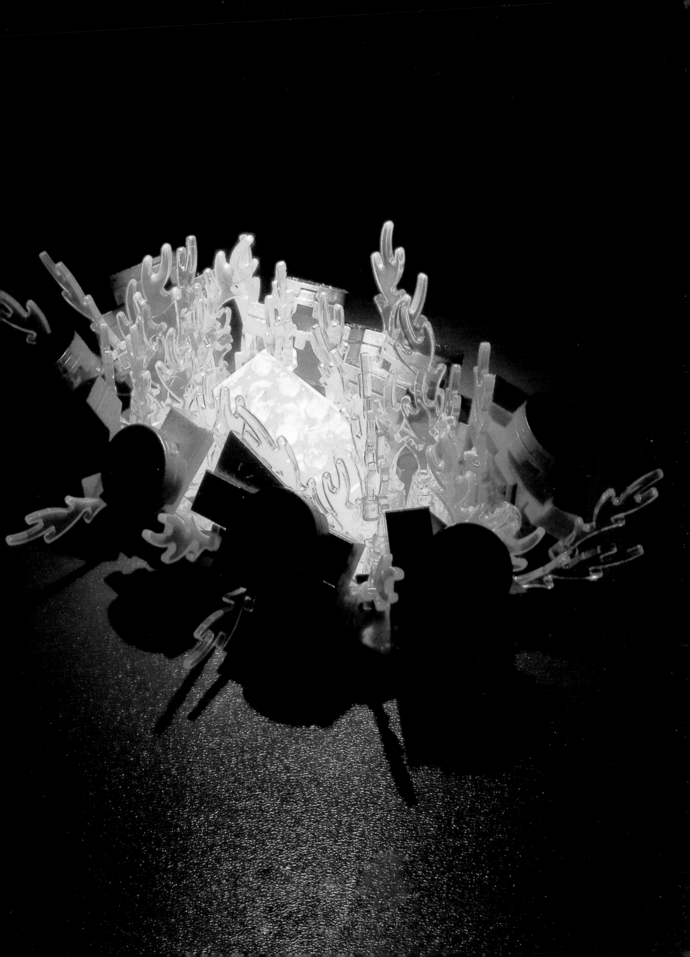

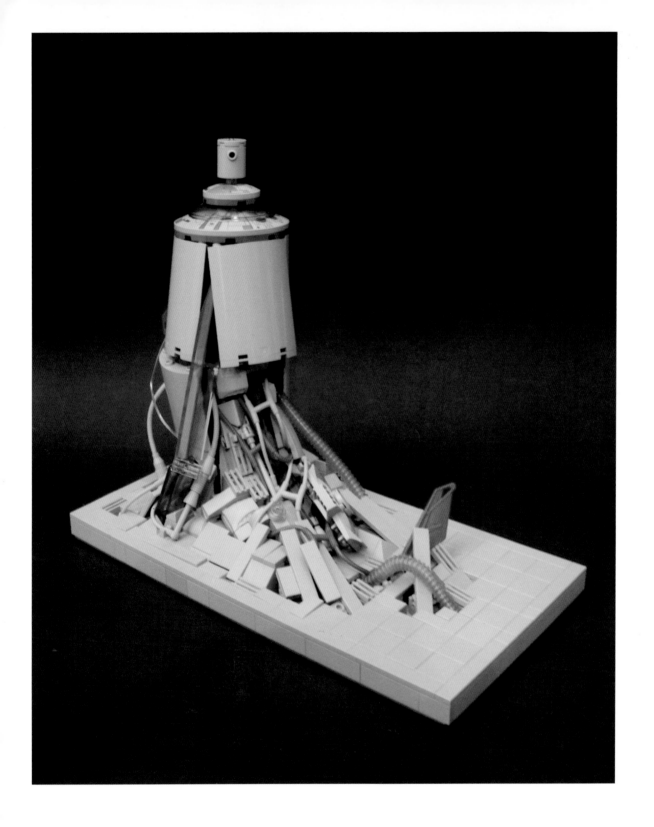

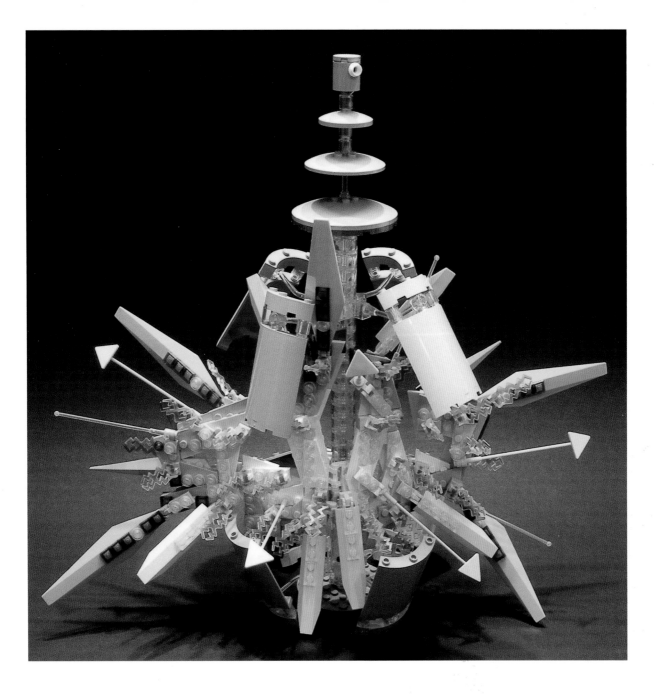

Enter the Brick Series

Inside the Spraycan Series

Bad Days

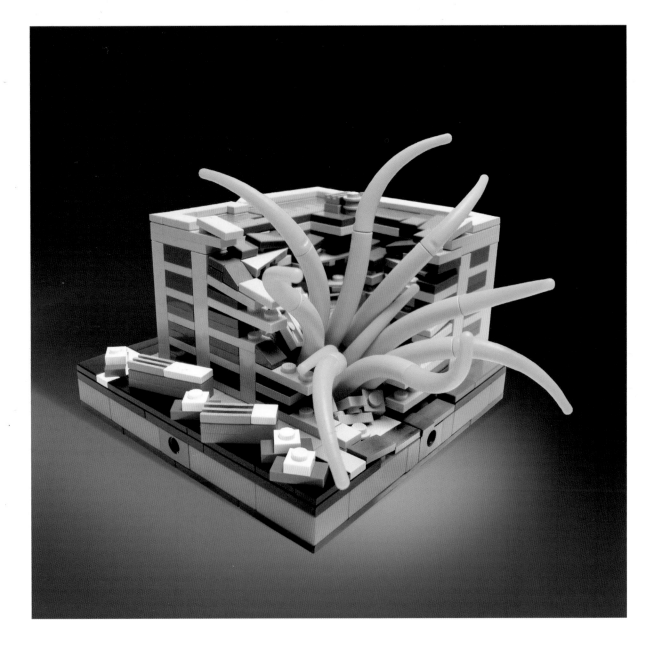

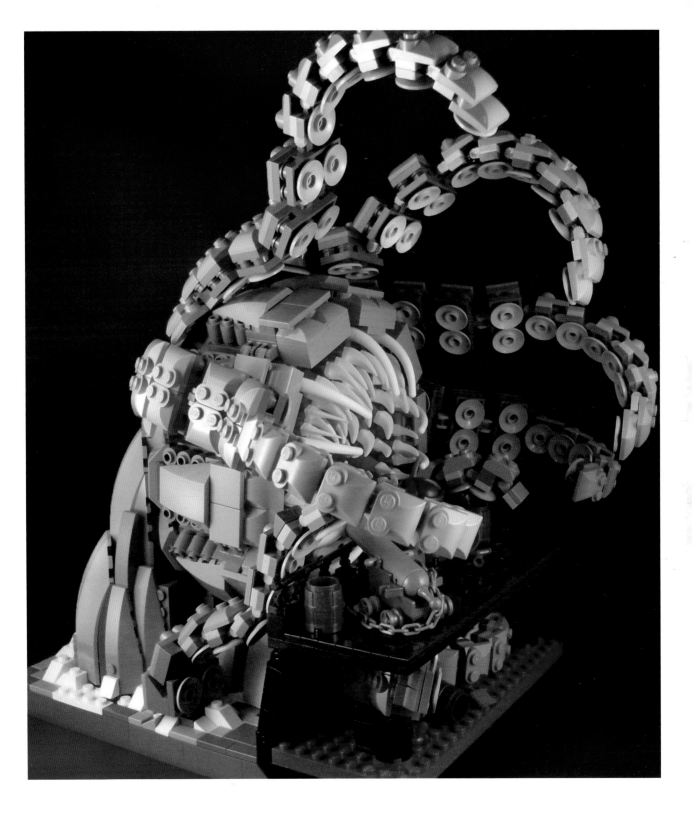

(opposite)
Paul Lee
It Came from BELOW!!!! 2009

(above)
Gabriel Bremler
Hello Beastie (Pirates of the Caribbean) 2011

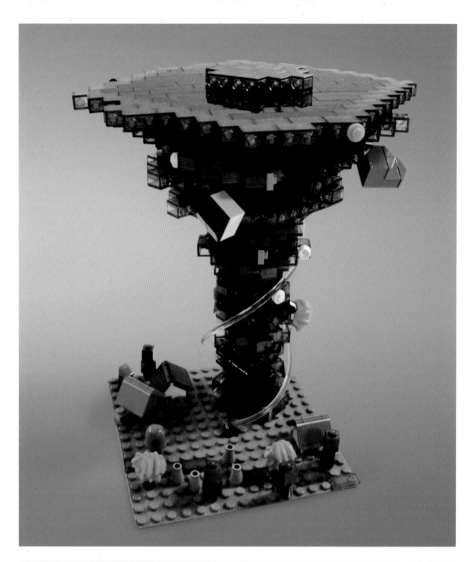

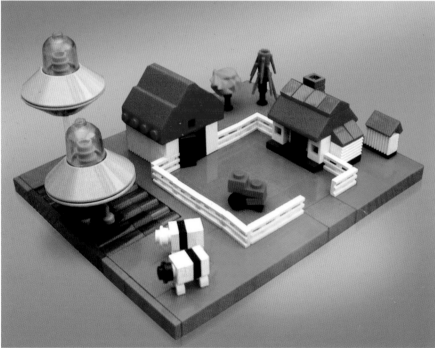

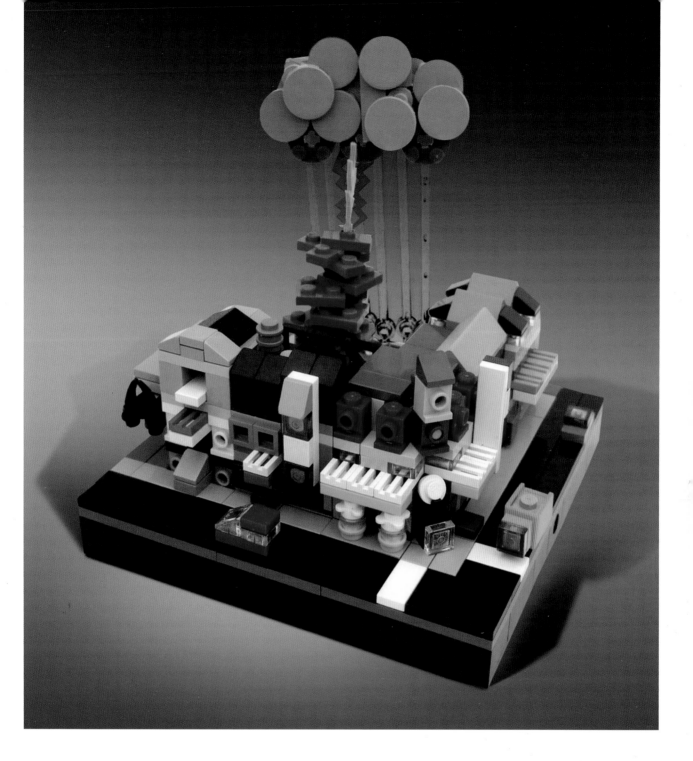

(opposite top)
Blake Baer
Tornado Alley 2011

(opposite bottom)
Rod Gillies
Mars Wants Burgers 2011

(above)
Tim Goddard
A Bad Day in Micropolis 2009

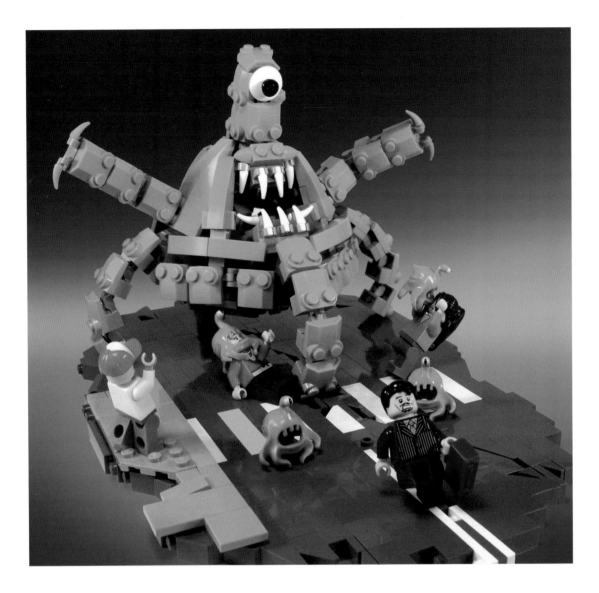

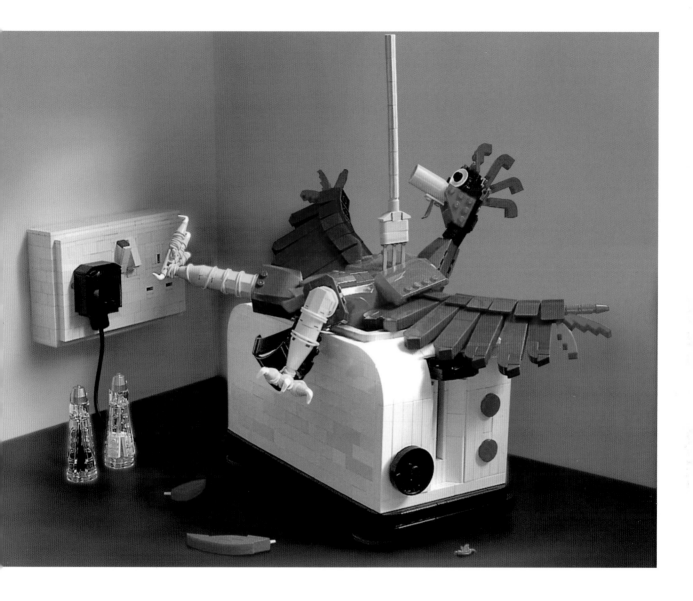

(opposite)
Gabriel Bremler
Attack of the Aliens! 2012

(above)
Barney Main
The Curious Incident of the Chicken in the Night-Time 2012

Iain Heath

I've enjoyed noodling with LEGO bricks since I was a kid. But it was only when I introduced LEGO to my own children that I realized the extent to which "mini-figs" diminish the creative building experience.

As a response to this, I started creating "brick built" characters. And in doing so, I discovered it was also a great way to generate public interest in the LEGO fan movement. People seem to really get a kick out of seeing their most beloved (or reviled) characters from fact and fiction re-created as LEGO models!

Over the years that "mission" has evolved into an obsession with sculpting the most lifelike, organic, and accurate models possible. The subjects I choose are characters that either personally inspire me or are just very popular at that moment. Getting a big public response to one of my models is certainly rewarding, but it's the creative process itself—figuring out how to create something from nothing—that I find most satisfying.

"Fried Chicken!" 2011

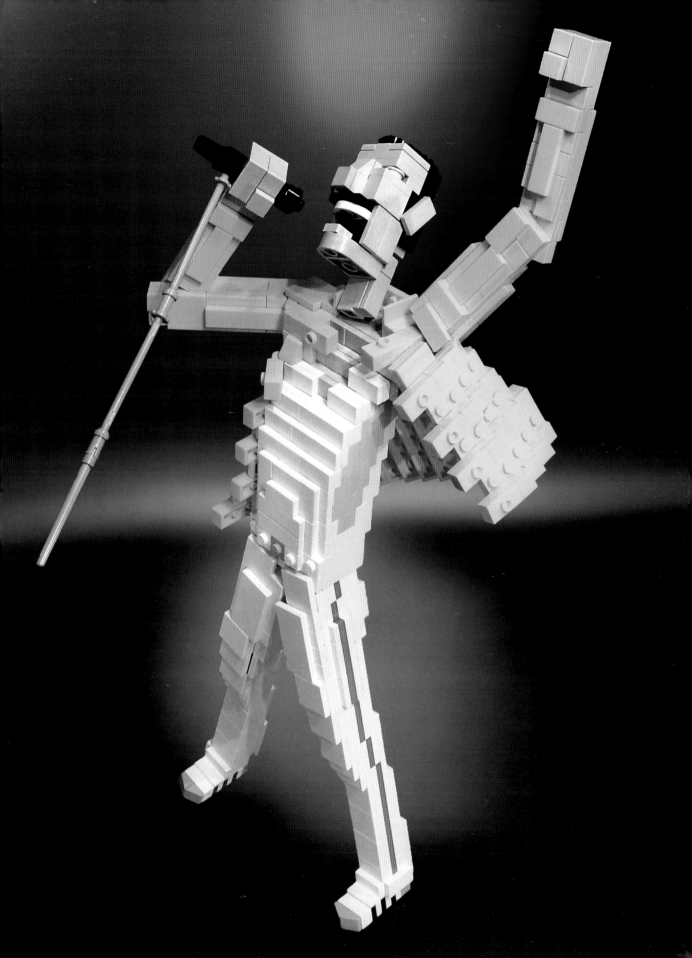

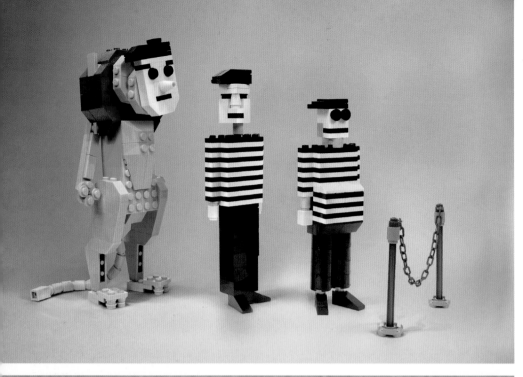

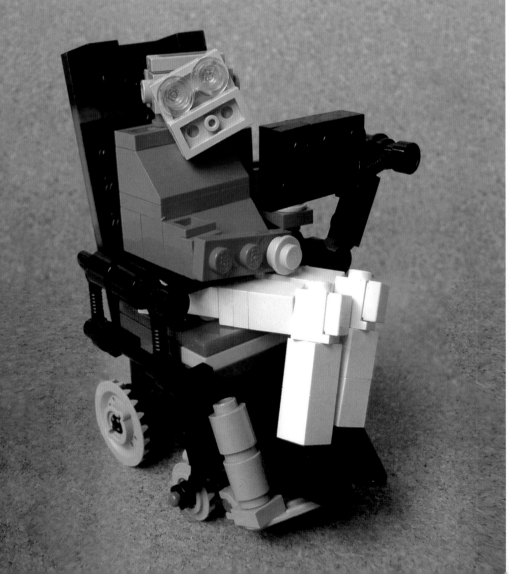

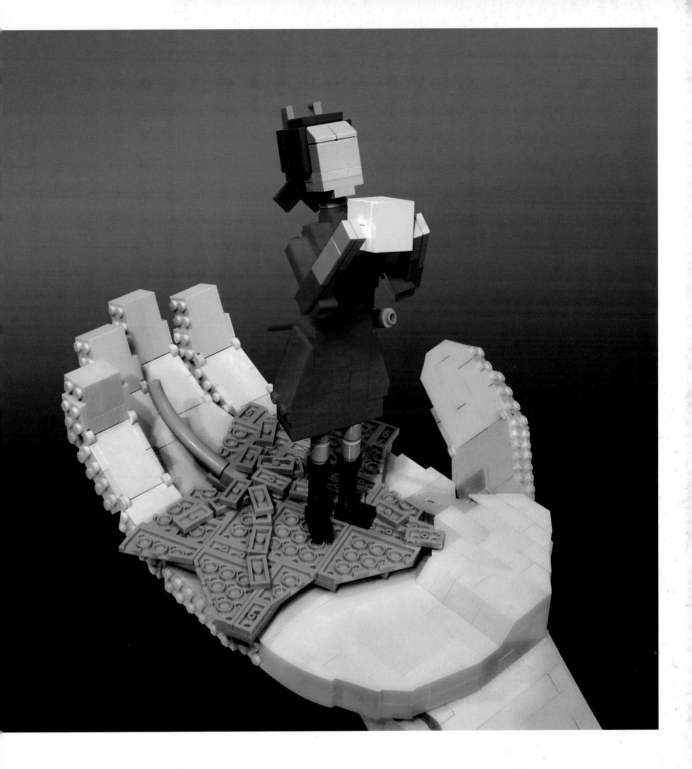

(opposite top) Tastes Like Zebra 2010
(opposite bottom) Stephen Hawking 2007

(above) Arietty the Borrower 2012

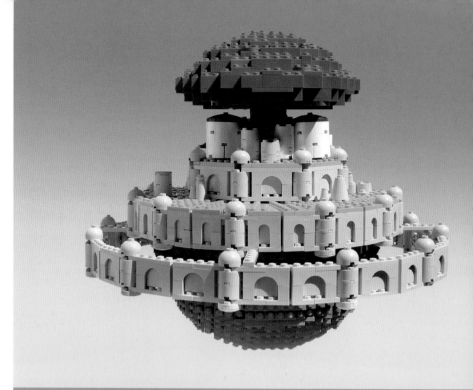

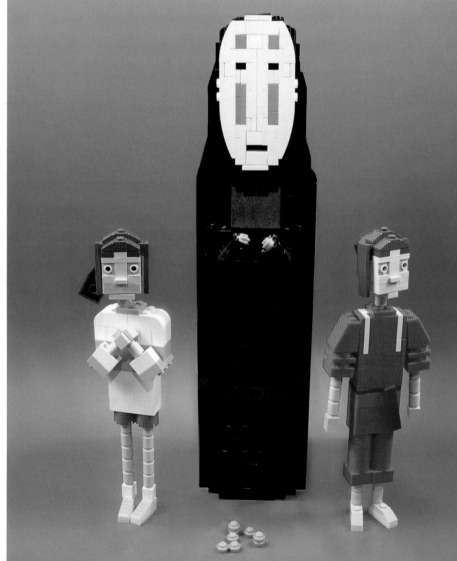

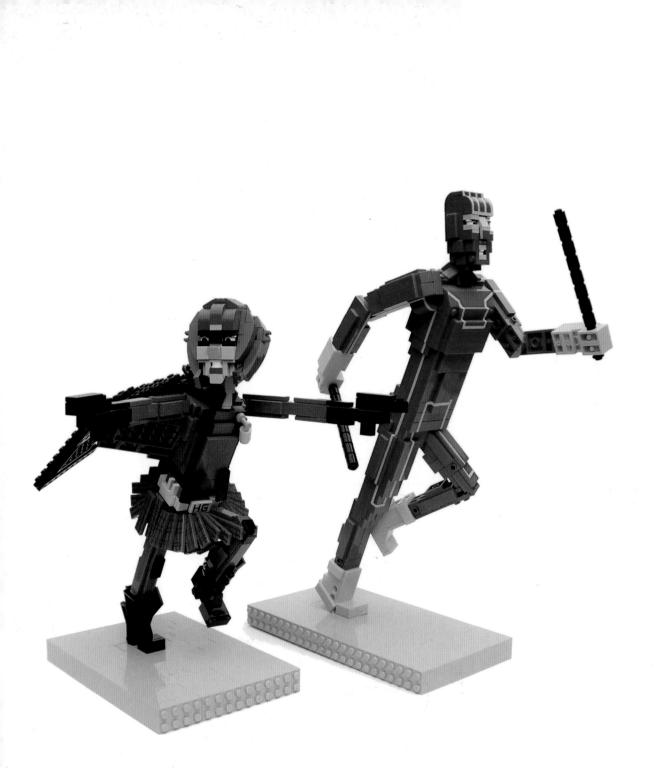

(opposite top) Castle in the Sky 2010
(opposite bottom) Spirited Away 2010

(above) Kick Ass & Hit Girl 2011

Pythonscape by Iain Heath

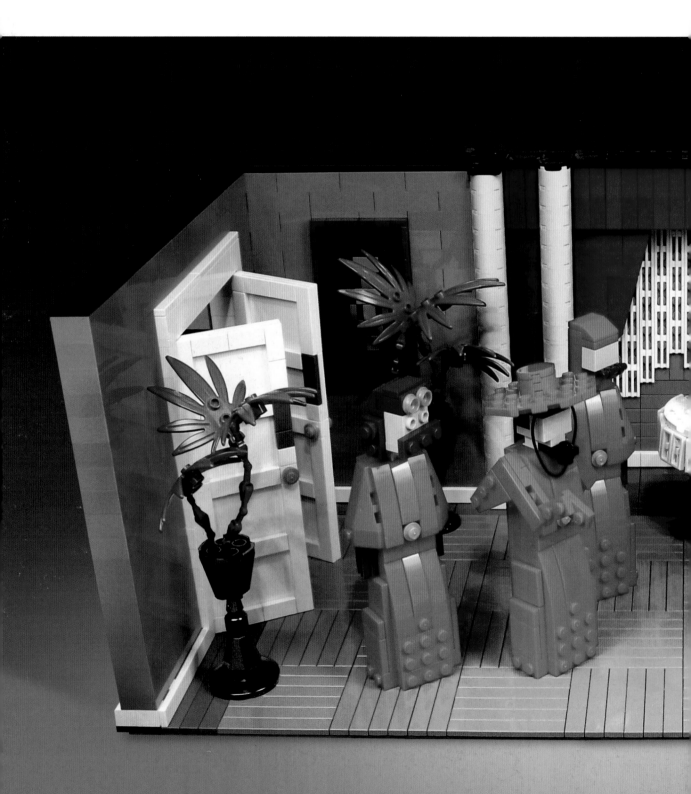

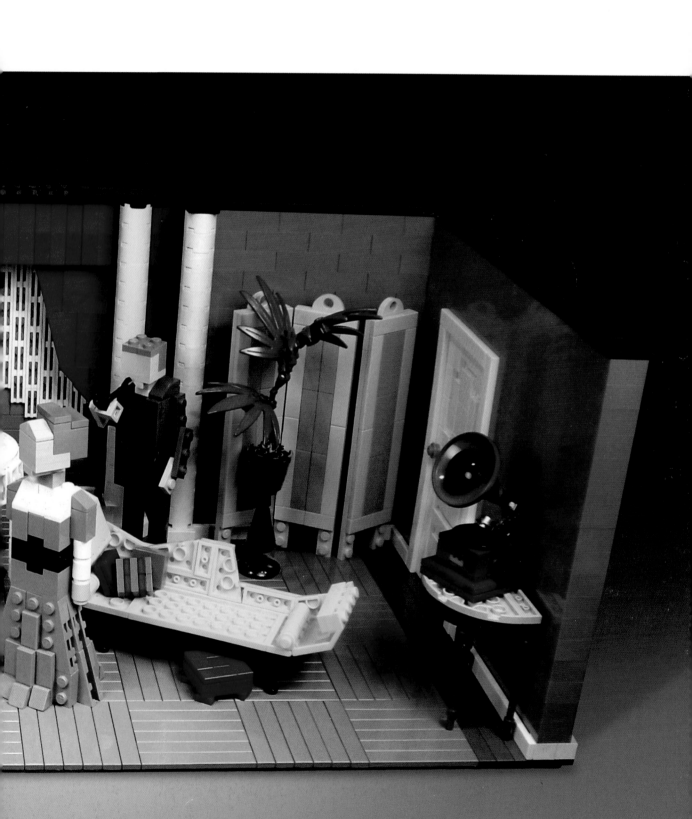

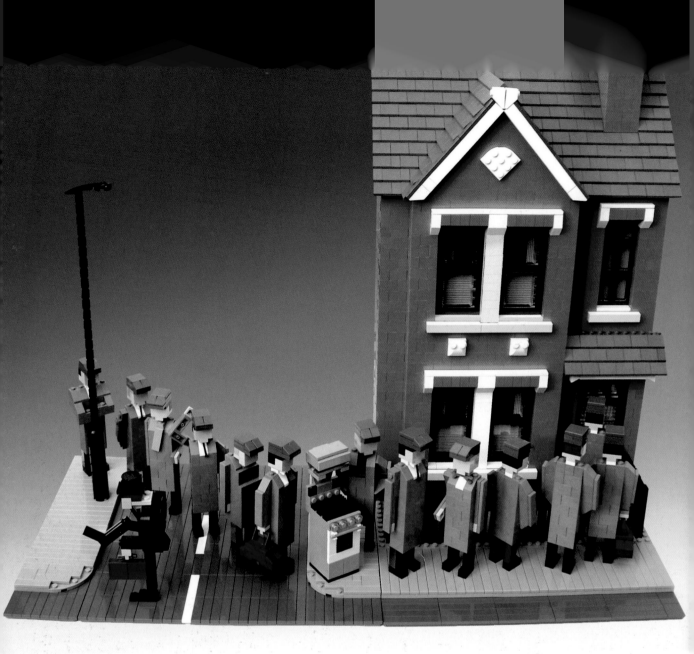

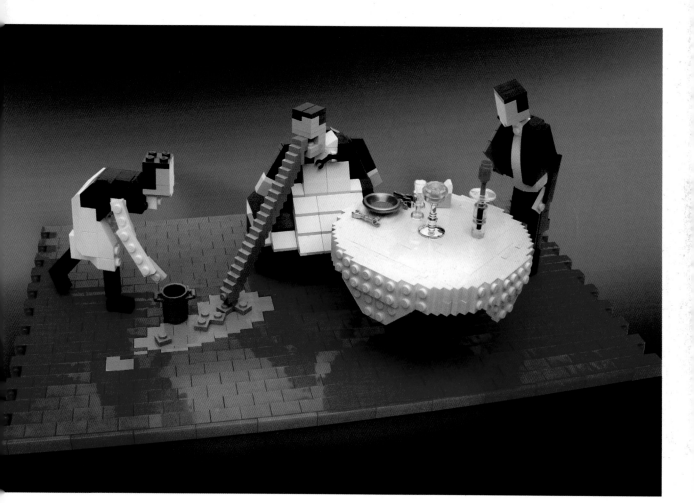

(previous spread)
"Nobody Expects . . . The Spanish Inquisition!" 2011

(opposite) New Cooker Sketch 2011
(above) Mister Creosote 2011

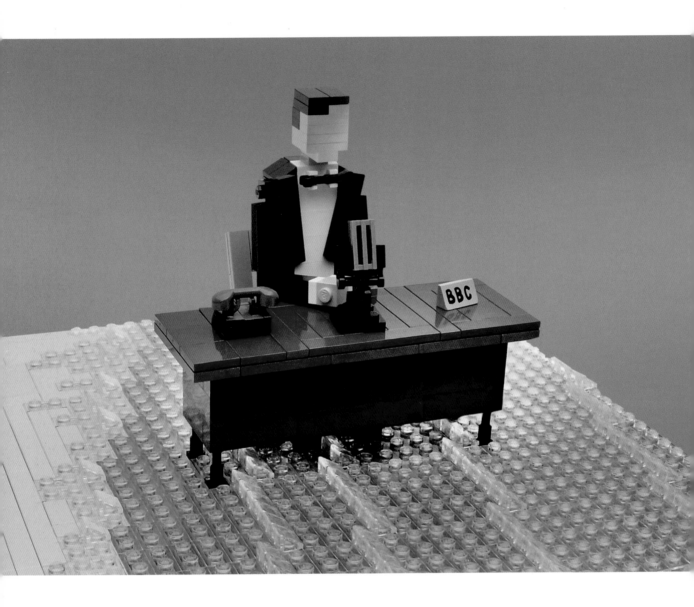

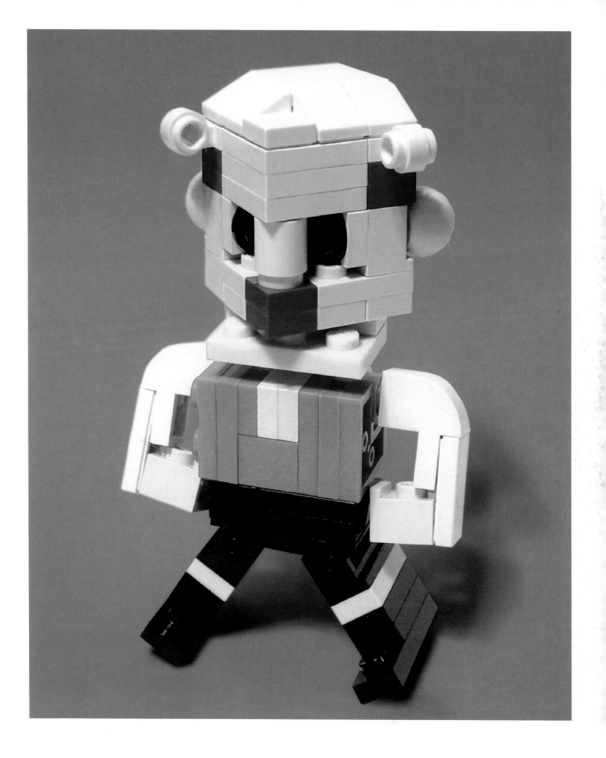

(opposite) "And now for something completely different" 2011
(above) CubeDude GUMBY 2009

Faraway Lands

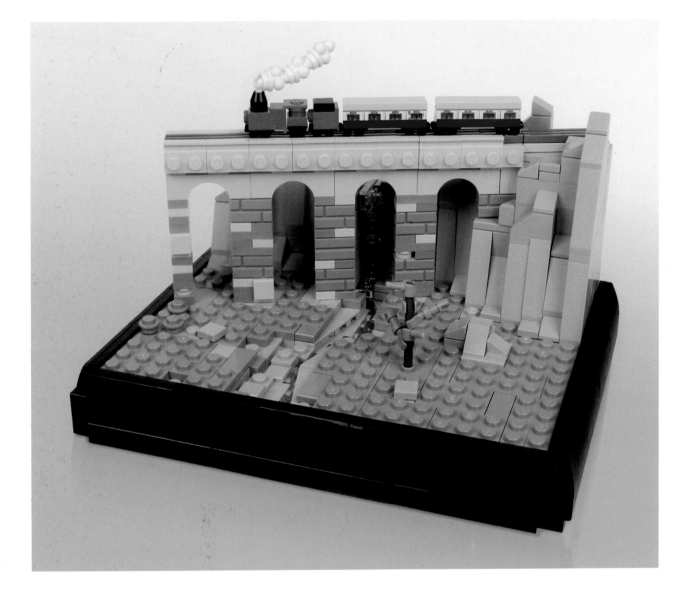

(opposite)
Tim Goddard
The Golden Age of Ice Cream 2013

(above)
Stefan Eeckman
Galleon at Anchor 2011

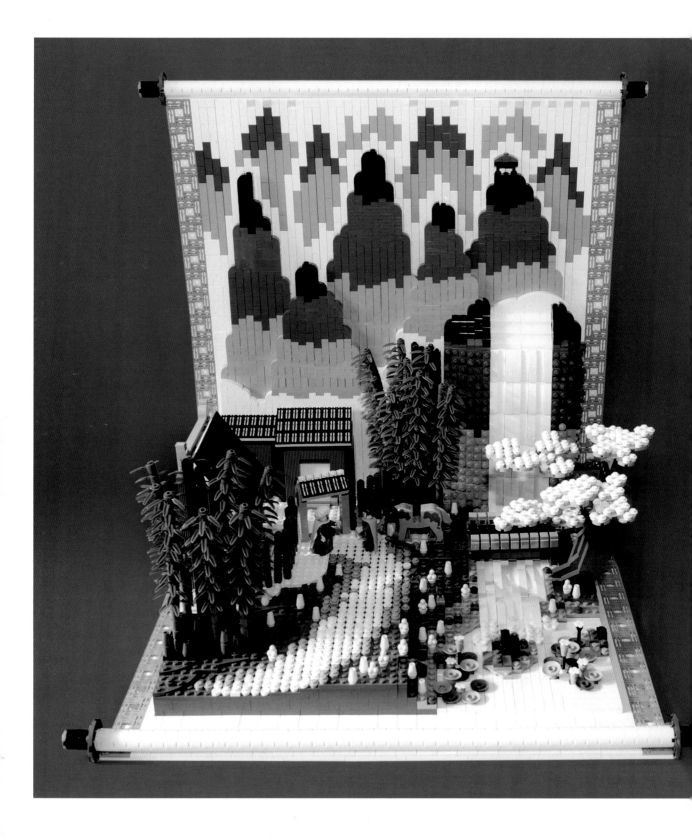

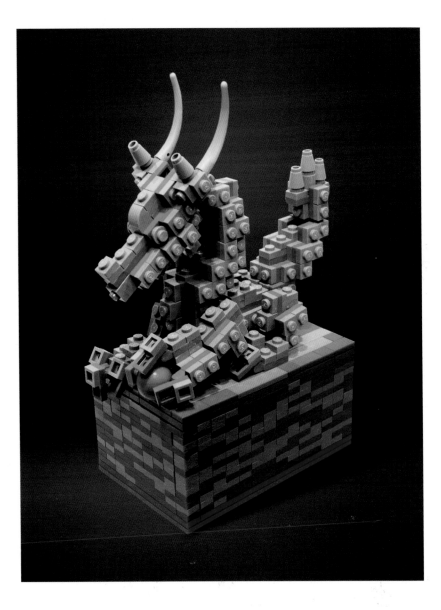

Eric Mok

(opposite) Chinese Landscape Painting 2012
(above) Signet, Dragon Jade Seal 2012

Contributors

All photographs are copyright their respective owners.

Alfaro Marcilla, Ramón and Amador ("Arvo Brothers"), *http://arvobrothers.com*: Alien (2007), 7; Alien Chestburster (2007), 8–9; Calypso (2007), 6; Diving Mask (2007), 13; The Doll (2008), 4–5; Headphones (2007), 2; Hermit Crab (2008), 12; Iron Man (2007), 11; Minimoog (2011), 3; Pacifier (2009), 12; Polaroid (2007), 18; Reading Lamp (2007), 13; Snake (2009), 10; Typewriter (2006), 13

Anderson, A. ("rongYIREN"), *http://flickr.com/47062214@N00*: Alien Cyborg Astronaut (2010), 59; Friends (2010), 229; Gremlin (2008), 226; Knobby (2011), 228; Light Infantry Vehicle (2010), 226; Medical Bot (2009), 227; Mort (2010), 101; Pierre, Of Course (2010), 101; Sentinel (2011), 229; Striders (2004), 227

Anderson, Peter ("Shadow Viking") *http://flickr.com/shadowviking*: Olympus (2010), 152

Armstrong, Matt ("monsterbrick"), *http://flickr.com/monsterbrick*: Antique Phone (2011), 23; Camera (2011), 22; Candlestick Phone (2011), 23; Look Who Fell Through the Keyhole (2010), 38; Morse Code Key (2011), 23; Sewing Machine (2011), 22; Telescope (2011), 22; Typewriter (2011), 23

Baer, Blake ("Blake's Baericks"), *http://flickr.com/baericks*: Tornado Alley (2011), 244

Becraft, Andrew ("Dunechaser"), *http://brothers-brick.com*: Pit Viper-Class Fuel Tanker (2012), 210; U.E.F. Battle Fleet (2011), 212–213

Berkoff, Micah ("Arkov"), *http://flickr.com/arkov*: Nintendo Entertainment System (2009), 19

Bessa, Marcos ("Marcosbessa"), *http://flickr.com/marcosbessa*: Alvis TA28 (2011), 178

Blaq, Cole, *http://cole-blaq.com*: Advanced Metamorphosis (2010), 240; Astral Body (2011), 236; The Burn (2010), 233; Color Control (2011), 235; Crack Link (2011), 234; Escape Gravity (2011), 238; Free the Studs (2011), 234; Hot Matrjoschka (2011), 239; Plastic Surgery (2011), 236; S.O.S. (2010), 232; Special Ingredient (2011), 237; Trans Objective (2011), 235; Under Pressure (2011), 241. Photos courtesy of Aran J.-Hudson.

Bonner, Theo ("Titolian"), *http://flickr.com/tito0o0o*: 昆虫 (2011), 222; Invidia (2011), 209; J-9 Tanusu All-Terrain Attack Mech (2010), 223; Köhs-Class H-4 Battle Tank (2010), 223; La Guêpe (2011), 206; "Mola" Recon Probe (2011), 207; Orthrus (2011), 208

Bonsch, Thorsten ("Xenomurphy"), *http://flickr.com/xenomurphy*: Spider-Man vs. Green Goblin - A Tribute to Frank Dillane (2012), 135

Bremler, Gabriel ("Skrytsson"), *http://flickr.com/55631421@N03*: Attack of the Aliens! (2012), 246; Hello Beastie (Pirates of the Caribbean) (2011), 243

Brugman, Duco ("bloei"), *http://flickr.com/bloei*: The Voice of Evil (2012), 140–141

Charre, Christophe ("Ironsniper"), *http://flickr.com/ironweasel*: AD57 / Light Aqua Walker (2012), 225

Clites, Tyler ("Legohaulic"), *http://flickr.com/legohaulic*: Alice in LEGOLAND (2009), 41; Bio-mechanical Strider (2011), 224; Do You Play Croquet? (2009), 43; Grandpa! You better not be using my loofah again! (2012), 92; Great White Nautilus (2009), 80; 'mere Brucy (2012), 93; Midnight Snack (2012), 74; Mirage (2012), 162–163; Paradise Frost (2012), 50; Sometimes It Sucks to Be a Ghost (2012), 105; Tower of Torment (2008), 147

Conquest, Edward, *http://mocpages.com/home.php/3222*: Queen of Hearts Castle (2009), 43

Constantino, Eric ("Edubl31216"), *http://designby31216.com*: Big Eyed LEGO Duck (2006), 77; Big Eyed LEGO Peacock (2011), 77; LEGO Desserts (2010), 14; LEGO Treats (2010), 15

DeCastro, Nathan ("nate_decastro"): CAMM-103 YMIR (2012), 199; CAMM-119 DESERT FOX (2012), 194; FCM-112 THYLACINE (2012), 195; Strahl J-60 "Bluthund" (2011), 214

Doyle, Mike, *http://mikedoylesnap.blogspot.com*: Contact 1: The Millennial Celebration of the Eternal Choir at K'al Yne, Odan (2013), 126–127, 128, 129; Dawn's Light Residential Tower from Contact 1: The Millennial Celebration of the Eternal Choir at K'al Yne, Odan (2013), vi; The Power of Freedom: Iraq (2012), 124, 125; Three Story Victorian with Tree (2011), 115, 116, 117; Two Story with Basement (2010), 118–119; Victorian on Mud Heap (2011), 120–121, 122, 123

Eeckman, Stefan ("SEBEUS I"): Galleon at Anchor (2011), 261

Elsel, Bodo: Robots (series) (2012), 230–231

F., Logan ("∞CaptainInfinity∞"): Ma.K Fireball with Diorama (2012), 200; Ma.K Melusine (2012), 200; Ma.K Raccoon (2012), 200

Fieschi, Pierre-E. ("Pierre"), *http://flickr.com/47881312@N04*: "Breacher" Light Assault Cruiser (2011), 216; Laser Artillery Frigate (2012), 216; Sobani Field Command Ship (2010), 211; "Spark-Class" Carrier (2010), 215; "Tempest" Bombardment Platform (2012), 210

Flor, Heath ("kik36"), *http://mocpages.com/home.php/25189*: Smolny Cathedral (2012), 130

Fojtik, Alex ("BrickFX"): The Hatchery (2009), 52–53

Geers, Jasper Joppe: Muntstraat Police HQ (2011), 131

Gillies, Rod ("2MuchCaffiene"), *http://empireofsteam.blogspot.com*: Mars Wants Burgers (2011), 244; Starfighter Command (2011), 221; Tranquility Biodome (2011), 220

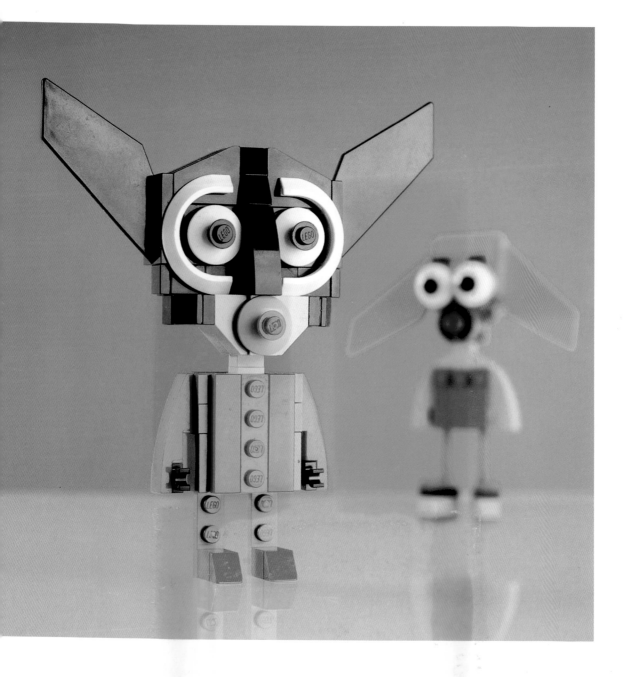

Peteris Sprogis
Batty & Co 2011